INGRES

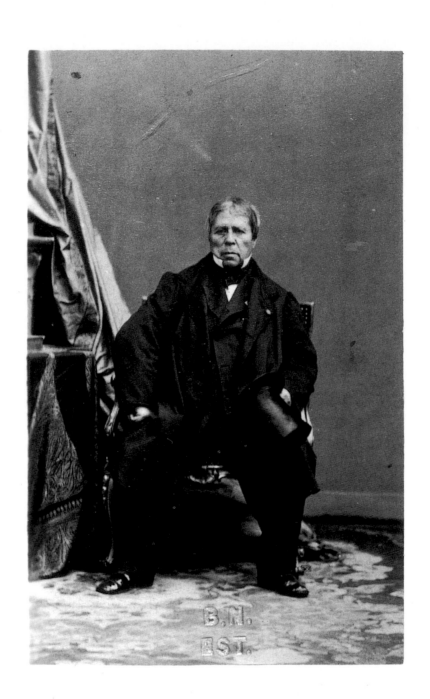

JEAN-AUGUSTE-DOMINIQUE

INGRES

TEXT BY

ROBERT ROSENBLUM

Professor of Fine Arts, New York University

THAMES AND HUDSON

Originally published by Harry N. Abrams, Inc., New York

First published in Great Britain in 1990
by Thames and Hudson Ltd, London

This is a concise edition of Robert Rosenblum's *Ingres*,
originally published in 1967

Printed and bound in Japan

CONTENTS

FOR US TODAY, no less than for his nineteenth-century contemporaries, Ingres's art presents a number of paradoxes that raise vexing questions of analysis and evaluation. How can we explain, for one, the astonishing diversity of his styles? Like Picasso in our century, Ingres can assume multiple historical guises and yet always remain himself, whether he is reincarnating the intense descriptive realism of the Flemish primitives, the elegant linear purity of Greek vase painting, the grandiose symmetries of Raphael, or the sophisticated ambiguities of the Mannerists. And how, too, can we reconcile this flexibility with Ingres's official position as the bigoted champion of Classical ideals throughout a long life-span that began in 1780 and ended in 1867, during which time he propagated the Classical faith both as a youth of twenty-four, fresh from David's studio (fig. 1), and as an old man of seventy-eight, the venerated recipient of academic and official honors (fig. 2)? And, given Ingres's historical role as a conservative defender of the Classical tradition for two-thirds of the nineteenth century, how can we account for the fact that his art reveals startling heresies, that it could become a foundation not only for academic painting of the later nineteenth century, but also for progressive currents in the modern tradition, from Degas, Renoir, and Seurat to Matisse, Picasso, and Gorky? And there is even the puzzling question of the discrepancy between Ingres's evaluation of his own art and posterity's judgment of it, for, rightly or wrongly, his portraits have come to be esteemed more highly than his subject paintings, even if Ingres himself would have found such a critical judgment an outrage to his own standards.

Part of the confusion surrounding Ingres's position in nineteenth-century art has been generated by the black-and-white historical categories of Classicism and Romanticism, a pairing of two ostensibly antagonistic aesthetic beliefs that locates Ingres as the stubborn defender of Greco-Roman art and subject matter against the Romantic rebel Delacroix, who presumably preferred color to line, the Middle Ages to classical antiquity, passion to reason, Rubens to Poussin. Such a theoretical polarity between these two artists and their respective artistic faiths is by no means a complete historical fiction, and the Classic-Romantic controversies of the 1820's and 1830's, the lifelong enmity between Ingres and Delacroix, attest to an essential truth in this simple opposition. Ingres did consider drawing superior to color; he did expend his greatest intellectual energies perpetuating classical themes and styles; he did prefer the conceptual lucidity of Raphael and Poussin to the fleshy sensuality of Rubens, whose art he found smacked of the butcher shop; he did believe that the personal marks of brushwork, so important to Delacroix, should be invisible, only the means to deliberated ends.

Yet such a clear aesthetic position, in which traditional values of ideal classical beauty would be maintained, has never seemed to correspond adequately to the actual variety of Ingres's subject matter and style. Even the most casual observer of his art will notice that his themes are culled not only from Greco-Roman myth and history, but, as often as not, from the Romantic repertory of Near Eastern exoticism; from imaginative medieval, Renaissance, and modern literature (from Dante to Ossian); from medieval, Renaissance, and even eighteenth-century historical legend and fact; and from more traditional Christian iconography. And his capacities to resuscitate the styles and conceptions of earlier artists are no less diverse and far-reaching, quoting as he does from antique and medieval art, from Giotto, Van Eyck, Botticelli, Holbein, Raphael, Titian, Bronzino, or Poussin, and ranging as he does from the abstract remoteness of Greek deities and Christian saints to the quasi-photographic realism of contemporary portraiture.

Critics have always been perturbed by these seeming contradictions. In his youth, Ingres was often accused of practicing a "Gothic" style, that is, of willfully reverting to curious stylizations of intense realism, of archaic line and perspective that were then being newly discerned in art before Raphael. Later in the nineteenth century, Théophile Silvestre expressed the difficulties of pigeonholing Ingres by referring to him as a "Chinese who was lost in the streets of Athens" (*Histoire des Artistes Vivants*, Paris, 1856, p. 39).

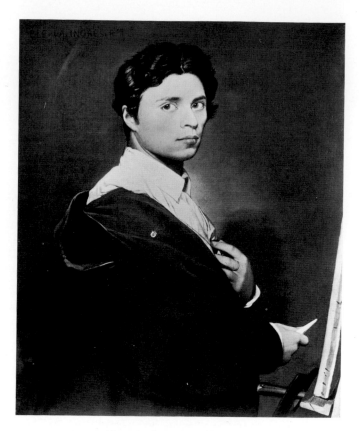

Figure 1. Ingres. SELF-PORTRAIT.
1804. Oil on canvas, 30¾ × 26″.
Musée Condé, Chantilly

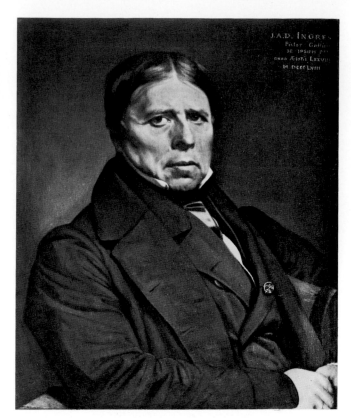

Figure 2. Ingres. SELF-PORTRAIT.
1858. Oil on canvas, 24⅜ × 20⅛″.
Uffizi Gallery, Florence

And twentieth-century critics have at times tried to take Ingres's multiplicity into account by categorizing him as a "Romantic Classicist," that is, a theoretically Classical artist who trespassed onto Romantic territory.

The clearest explanation of Ingres's position, however, remains that made in 1857 by his most understanding and articulate critic, the writer Théophile Gautier: "Ingres, although he may seem Classical to the superficial observer, is by no means so: he goes directly to the basic sources, to nature, to Greek antiquity, to sixteenth-century art, and nobody is more faithful than he to *local color*. His *Dauphin Entering Paris* (colorplate 24) resembles a Gothic tapestry; his *Paolo and Francesca* (colorplate 22) looks as though it were taken from one of those precious illuminated manuscripts on which the artists exhausted their fullest patience; his *Roger and Angelica* (colorplate 29) has the chivalric grace of Ariosto's poem; his *Sistine Chapel* (colorplate 19) could be signed 'Titian'; and as for the antique subjects, such as the *Oedipus* (colorplate 11), the *Apotheosis of Homer* (colorplate 27), the *Stratonice* (colorplate 31), the *Venus Anadyomene* (colorplate 33), one couldn't conceive their being painted in another way by Apelles, Euphranor, or Zeuxis. And his odalisques (colorplates 20, 30) would make the Sultan of the Turks jealous, so familiar does the artist seem to be with the secrets of the harem. Nor has anybody expressed contemporary life better; witness that immortal portrait of M.

Bertin de Vaux (colorplate 28), which is the physiology of a particular person and the history of an epoch. If he knows admirably well how to fold a Greek drapery, M. Ingres arranges a cashmere shawl with no less skill, and he extracts wonders from modern fashions: his female portraits prove this. Thus, whatever subject he treats, Ingres brings to it a rigorous exactness, an extreme fidelity of color and form, and in no way does he obey the stale formulas of the Academy" (*L'Artiste*, n.s. I, 1857, p. 5).

In viewing Ingres not as a Classical artist, whose frequent excursions into un-Classical regions are puzzling aberrations from a fixed norm, but rather as an artist who wishes to seek out appropriate, accurate means of rendering a wide variety of themes, whether Greek or Turkish, thirteenth-century Italian or nineteenth-century French, Gautier can help us to explain the diversity of Ingres's styles, a diversity which was in fact hardly unique to Ingres, but was characteristic of many Western artists from the late eighteenth century down to Picasso. Ingres's own master, Jacques-Louis David, showed a similar awareness of the need to alter one's style drastically for different subjects, and of the possibility of choosing from the bounty of the historical past the style most relevant to the problem at hand. His *Oath of the Horatii* (1784), a scene of patriotic rigor in the stoic ambiance of archaic Rome, is painted in a lean and astringent Poussinesque mode that evokes a world of firm will and intellect;

his *Coronation of Josephine* (1805–7), a scene of imperial pomp and pageantry in Napoleonic Paris, is painted in a lush Rubensian manner that revives the glittering monarchic splendor of Rubens' own *Coronation of Marie de' Medici*.

The most familiar example, however, of this new awareness of a growing variety of historical styles, and the need for one artist to adopt different modes on different occasions, is found in architecture of the late eighteenth and the nineteenth centuries. In commissions ranging from garden pavilions to public monuments, architects of these years could choose among a widening repertory of historical and exotic vocabularies, often selected for associative relevance to the character of the building designed—Greek for a museum of antiquities; Roman for a Napoleonic imperial triumphal arch; Gothic for a cathedral; Near Eastern for a synagogue; Egyptian for a cemetery; French Renaissance for a French city hall. Ingres's attitude was closely allied to this nineteenth-century architectural viewpoint, which has usually been termed, and not always with approbation, Eclecticism or Historicism. Like a nineteenth-century architect, he was acutely aware of the problem of choosing a style that suited his subject. If he painted an official religious painting, like *Virgin with the Crown* (fig. 3), he felt that the ideal beauty and symmetry of Raphael's Madonnas provided the most pertinent model to imitate; if he painted an historical event that took place in sixteenth-century Brussels, like *The Duke of Alba at St. Gudule*, he found that the miniaturist scale and exquisite detail of Northern late Gothic painting offered an appropriate visual prototype; if he painted *Vergil Reciting from the Aeneid* (fig. 4), he chose the measured calm and marmoreal whiteness of classical statuary as the relevant stylistic language; if he painted the landscape around Rome, he followed the lucid pictorial examples established by the French Classical landscape tradition.

Similarly, Ingres spared no pains to assure absolute accuracy of detail in his pictorial reconstructions of the facts of the world about him (so that from the precision of costume and *décor* alone, one can easily situate his portraits, unlike those of Delacroix, at a particular moment in the nineteenth century), as well as the facts of other worlds more remote in time or in space. To re-create in paint the martyrdom of St. Symphorian at Autun in A.D. 179 (fig. 28), Ingres felt he had to study closely the Roman Porte St. André in that Burgundian city; to provide accessories of costume for the occupants of his harems and Turkish baths, he consulted exotic costume books like the *Recueil de Cent Estampes qui Représentent Différentes Nations du Levant* (Paris, 1714–15); to ensure historical exactitude in such classical scenes as *The Apotheosis of Homer* (colorplate 27) or *Antiochus and Stratonice* (colorplate 31), he sought out the erudite advice of archaeologists and architects like Raoul-Rochette, Hittorff, and Victor Baltard for problems of inscriptions, of iconography, of the Greek and Roman use of polychromy; to represent famous historical figures, whether Aesop, Dante, Charles V,

Raphael's beloved Fornarina, or Poussin, he looked for accurate portraits in books and museums; to illustrate a literary text, whether Homer or Plutarch, Dante or Ariosto, Lady Montagu or Ossian, he scrupulously respected the author's factual descriptions.

Characteristically for the nineteenth century, Ingres's range of iconographic and stylistic possibility was enormous, for the variety of subject matter as well as the knowledge of both Western and non-Western styles had increased greatly since the mid-eighteenth century. Thus, he was not only aware of the traditional masterpieces of Greek and Roman sculpture and painting and the fundamental repertory of Renaissance and modern artists—Raphael, Michelangelo, Titian, Poussin, even Watteau—but he could also, like other adventurous contemporaries, explore the fresh byways offered in what were then little-known artistic domains—the painting of the Flemish and Italian primitives; Greek vase painting; medieval statuary, manuscripts, and stained glass; and even Indian and Persian art. His thematic scope was comparably broad. To be sure, he continued to use many traditional iconographic sources—the Bible, Homer, Plutarch—but most of his subjects, including many

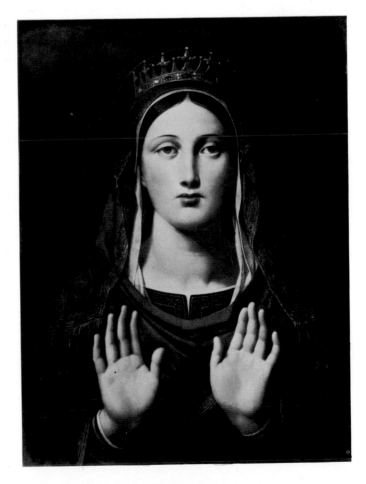

Figure 3. Ingres. THE VIRGIN WITH THE CROWN.
1859. Oil on canvas, 27⅛ × 19⅛".
Collection Bessonneau, Paris

9

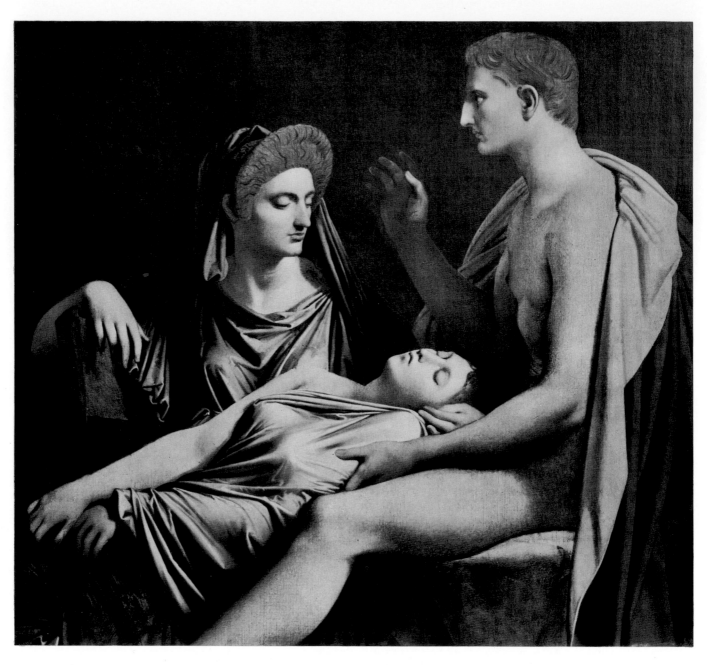

Figure 4. Ingres. VERGIL RECITING FROM THE AENEID. 1819. Oil on canvas, 54⅜ × 55⅞'.
Musée Royal des Beaux-Arts, Brussels

of his classical ones, were new to the art of the late eighteenth and early nineteenth centuries. In particular, Ingres's fascination with the data of history was responsible for an abundance of paintings that illustrated episodes, from the heroic to the domestic, culled from the lives of any number of famous people from the Middle Ages (Paolo Malatesta, Charles V, Joan of Arc); the Renaissance (Francis I, Raphael, Tintoretto, Pietro Aretino); the seventeenth and eighteenth centuries (Louis XIV, Pope Urban VIII, Philip V of Spain); and even, if one includes his images of Pope Pius VII in the Sistine Chapel (colorplate 19), of Napoleon as First Consul and as Emperor (colorplates 3, 7), or of the newly crowned Charles X (fig. 47), from the nineteenth century.

Again, Ingres was in no way singular in this. A glance at the titles of the paintings exhibited at the Paris Salons throughout his lifetime indicates that, especially after the Bourbon Restoration in 1815, when a Christian, monarchic past was venerated instead of suppressed, such themes were common coin. Thus, at the Salon of 1817, one could have seen Merry-Joseph Blondel's *Death of Louis XII*, Louis Couder's *Death of Masaccio*, Ary Scheffer's *Patriotic Devotion of the Six Burghers of Calais*, Mme. Servières's *Louis XIII and Mlle. de Lafayette*, Antoine Ansiaux's *Cardinal Richelieu Presenting Poussin to Louis XIII*, Jean-Baptiste Mallet's *Education of Henry IV*. In this context, it is hardly remarkable that in 1817 Ingres could paint the charming anecdote of the solemn

Figure 5. Ingres. HENRY IV
PLAYING WITH HIS CHILDREN.
1817. *Petit Palais, Paris*

Figure 6.
Richard Parkes Bonington.
HENRY IV AND THE SPANISH
AMBASSADOR. Salon of 1827.
Wallace Collection, London

Figure 7. Ingres. MOLIÈRE DINING WITH LOUIS XIV AT VERSAILLES.
1857. Oil on canvas, 19⅞ × 27⅛'. Musée de la Comédie Française, Paris

Figure 8.
After Jean-Léon Gérôme.
MOLIÈRE DINING WITH LOUIS XIV
AT VERSAILLES. Engraving of
painting exhibited at the
Salon of 1863

Spanish ambassador who has come to see the beloved French king, Henry IV, only to discover him playing pig-a-back with his children (fig. 5); and that, in fact, this scene was often painted by Ingres's contemporaries, including such foreign ones as the Englishman Richard Parkes Bonington (fig. 6). Similarly, when, toward the end of his career, Ingres in 1857 painted another homely historical event in the life of a great French king—Louis XIV receiving Molière at his table, much to the irritation and jealousy of the courtiers who had disdained the lowly playwright (fig. 7)—he was painting a subject that would be illustrated by other artists of the Second Empire, like Jean-Hégésippe Vetter and Jean-Léon Gérôme (fig. 8).

Indeed, in terms of its range of subject matter, Ingres's art offers little that distinguishes it from that of his contemporaries of either a presumably Neoclassic or Romantic persuasion. If he painted scenes from Homer rarely illustrated before, so too did countless other students of David's and other artists all over the Western world, inspired as they were by John Flaxman's outline engravings and the Neoclassic veneration of this primary Greek text. If he painted and drew imaginative, even bizarre episodes from Dante, Ariosto, Ossian, so too did many other late eighteenth- and nineteenth-century artists, from Blake, Koch, and Girodet to Cornelius, Doré, and Dyce (fig. 9). If he painted odalisques and harem scenes, so did Delacroix and any number of lesser masters, from Frenchmen like Jalabert and Bénouville (fig. 10) to Englishmen like William Daniell and John

Frederick Lewis (fig. 11). If he painted traditional religious subjects, from *Christ Delivering the Keys to St. Peter* (fig. 24) to *Jesus among the Doctors* (fig. 23), so too did many other Neo-Christian artists of the nineteenth century, whether Germans like the Nazarenes, Englishmen like the Pre-Raphaelites, or Frenchmen like the Lyonnais. And even if he often descended from the lofty heights of mythological, historical, religious, and literary subjects in order to record the faces, feelings, and costumes of the people of his own century, so too did his master, David, as well as such other students of David's as Gérard and Girodet, and such later subject painters as Delacroix, Scheffer, Gérôme, and Cabanel.

Yet, despite the fact that Ingres's flexibility of style and subject is a typical reflection of the art-historical environment in which he and so many other artists painted for two-thirds of the nineteenth century, his art remains uniquely his, its qualities as immediately recognizable as Picasso's throughout an almost equally prodigious variety of work. This distinctive genius, which separates Ingres from his contemporaries who painted the same themes and who were inspired by the same historical styles, can be felt from the very beginning of Ingres's career as an ambitious student who had left the Toulouse Academy in 1797, as a youth of seventeen, to enter David's atelier in Paris. His early academic efforts, like the studio nudes (colorplate 1) and the prize-winning *Ambassadors of Agamemnon* of 1801 (colorplate 2), already reveal the young artist's singular sensibilities; but it

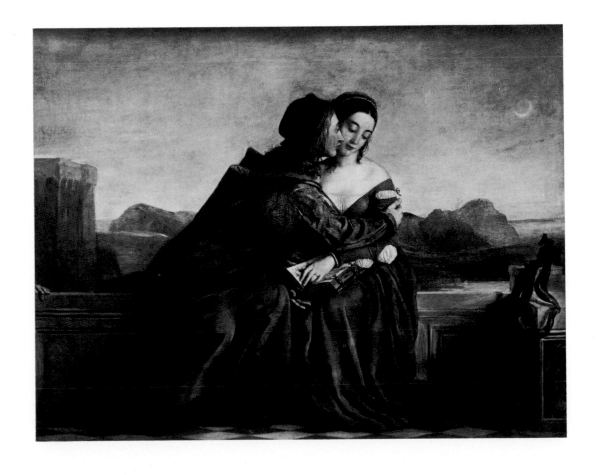

Figure 9. William Dyce.
PAOLO AND FRANCESCA. 1837.
*The National Galleries of
Scotland, Edinburgh*

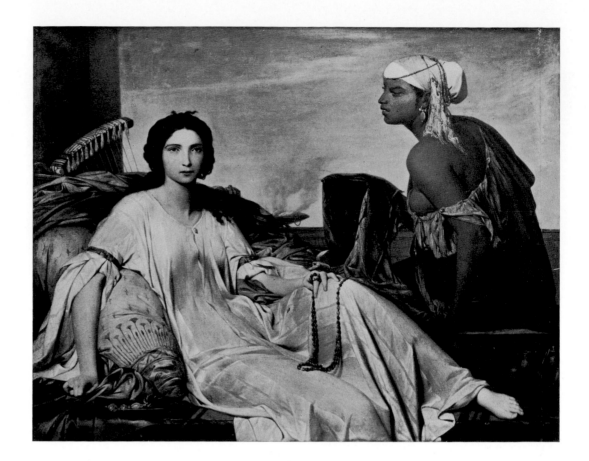

Figure 10. Léon Benouville.
ODALISQUE. 1844.
Musée des Beaux-Arts, Pau

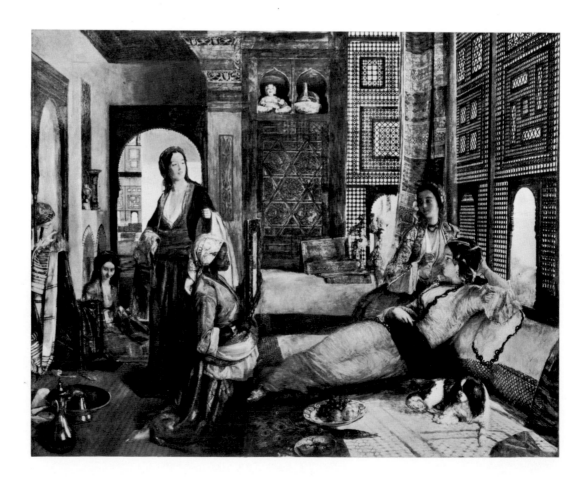

Figure 11. John Frederick Lewis.
THE HAREM. *City Museum and Art
Gallery, Birmingham, England*

is above all the slightly later *Venus Wounded by Diomedes* (fig. 12), an astonishing tour de force of youthful experiment, that translates David's lessons into a personal realm of pictorial order and expressive inflection that are immediately identifiable as Ingres's. It is also a painting that, more generally speaking, carries the most radical currents within the Davidian orbit to unfamiliar extremes.

In the late eighteenth century, artists were haunted by the idea of regeneration, of reducing art to the simplest visual and expressive statements that might be inspired by the increasingly archaic examples culled from the earliest phases of artistic cycles. Thus, David himself, in his *Sabines* of 1799 (fig. 13), felt that his more Roman and realistic style of the 1780's needed to be purified in the direction of a so-called Greek mode that would simplify his composition to a flatter, more friezelike clarity, and suppress the anatomical detail conspicuous in his earlier work in favor of more abstract and fluent surfaces and contours. Many of his own more refractory students, especially that radical sect known, appropriately, as the "Primitifs," pursued this primitive direction even further, seeking out in both classical and post-classical art those works that offered a kind of *tabula rasa*. In the earliest and simplest Greek vase painting and reliefs, in *quattrocento* masters like Perugino, they found images of refreshing flatness and linear purity, of lucid geometric stylizations that offered the visual equivalent to their literary taste for the stark drama, the vigorous grandeur, the legendary remoteness of Homer, Aeschylus, and Ossian.

Ingres's *Venus Wounded by Diomedes* provides an acutely personal interpretation of these youthful dreams about the exquisitely pure dawn of art. To realize a painting stylistically and historically consonant. with this Homeric vision, Ingres was assisted by the new abundance of late eighteenth-century engravings that reproduced in an exclusively linear

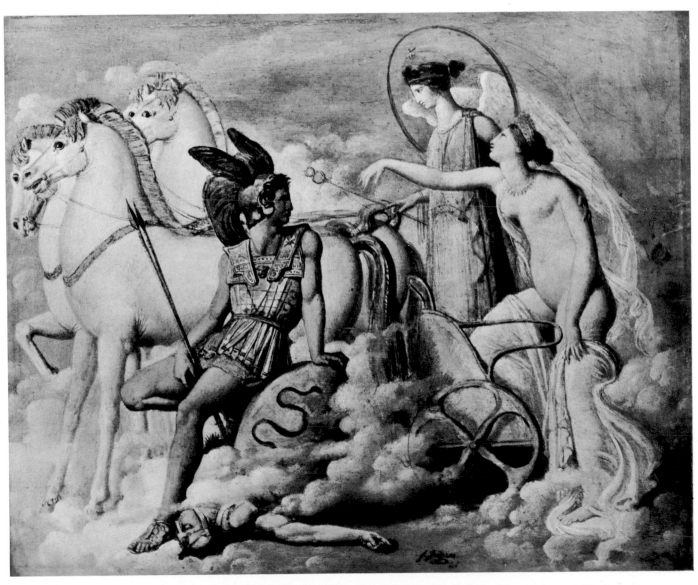

Figure 12. Ingres. VENUS WOUNDED BY DIOMEDES. c. 1803. Oil on canvas, 10⅝ × 13′. *Collection Baron Robert von Hirsch, Basel*

Figure 13. Jacques-Louis David. THE SABINES. 1799. *The Louvre, Paris*

Figure 14. Bénigne Gagnereaux.
VENUS WOUNDED BY DIOMEDES.
From *Dix-huit estampes au trait
. . . par Gagnereaux*, Paris, 1792

vocabulary on a flat white ground not only compilations of works of art neglected or ignored by earlier generations (Greek vase painting and Italian primitives), but also original compositions in this chastely abstract style, such as the classical literary illustrations of Bénigne Gagnereaux (fig. 14) and John Flaxman. Ingres, in fact, surely used an engraved reproduction of a quadriga on a Greek vase (fig. 15) for archaeological exactitude in his *Venus Wounded by Diomedes,* and the theme itself may have been suggested by its treatment in pure outline compositions by Gagnereaux and Flaxman. Such sources, however, have been thoroughly assimilated in a painting that deliberately attempts to contradict Renaissance and Baroque spatial illusionism in favor of an image whose drastic two-dimensionality and stiff geometries would evoke the origins of classical art. Thus, the cloud-covered background, instead of suggesting extension in depth, becomes an opaque, unyielding plane in front of which the quadriga and the mythological personages are compressed to a degree of flatness that far transcends anything in David's work, or, for that matter, in the work of any Western painter from the Italian Renaissance until the advent of such reformatory artists of the late eighteenth and early nineteenth centuries as William Blake, Asmus Jakob Carstens, or Ingres himself. The word flatness, however, is particularly inexact in describing the character of Ingres's contracted spaces, for the surface has a delicately modeled quality that approximates the shallow relief effect of an exquisitely carved antique cameo. Indeed, in 1803 Ingres had drawn just such a cameo in the Empress Josephine's collection at Malmaison, and exhibited it, in engraved form, at the

Salon of 1804 (fig. 16). Thus, although the horses, chariot, and figures are restricted to almost Egyptian profile and frontal views and are arranged in layers of nearly eggshell thinness, they nevertheless have gently swelling surfaces of

flesh, armor, and drapery that create a sensuous ripple across the ostensible flatness of the picture plane. The minute deviation from strict parallelism in the angle of Mars' javelin, which casts a fine shadow against the flank of the foremost horse, is characteristic of these subtle irregularities and pressures, as is the slight turn of Venus' head from a rigorous profile view. In fact, the more one studies this painting, which attempts to conjure up an ancient and primitive pictorial language of flattened images, incisive outlines, and severe geometric stylizations, the more elegant and complex it becomes. The horses, rather than suggesting the archaic grandeur of animals that might have fought in the Trojan Wars, have a wooden, rocking-horse frailty and weightlessness, and their diminutive preciosity is all the

ABOVE:
Figure 17. John Flaxman.
PAOLO AND FRANCESCA.
Illustration for *La Divina Comedia di Dante Alighieri*. Rome, 1802

RIGHT:
Figure 18. Ingres. JUPITER AND THETIS (detail). 1811.
Musée Granet, Aix-en-Provence

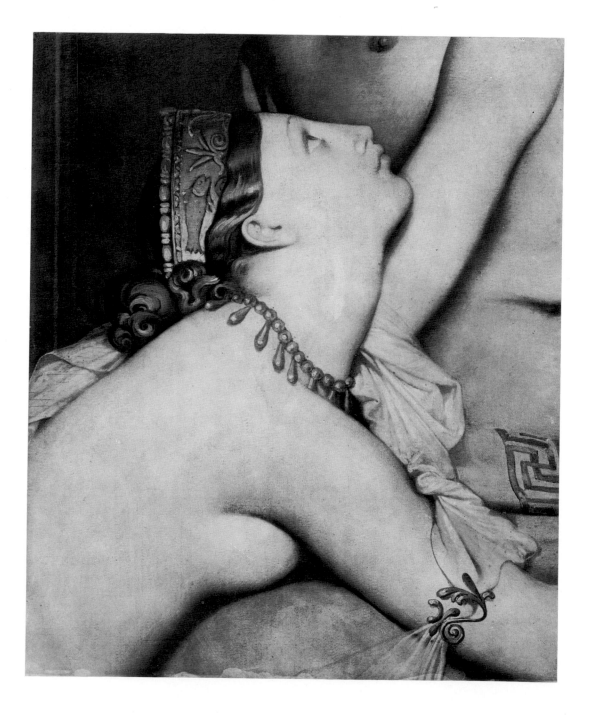

LEFT:
Figure 19. The Kleophrades Painter.
MAENAD. C. 500 B.C.
Museum Antiker Kleinkunst, Munich

BELOW:
Figure 20. Pablo Picasso. GUERNICA (detail).
1937. *On extended loan by the artist to the
Museum of Modern Art, New York*

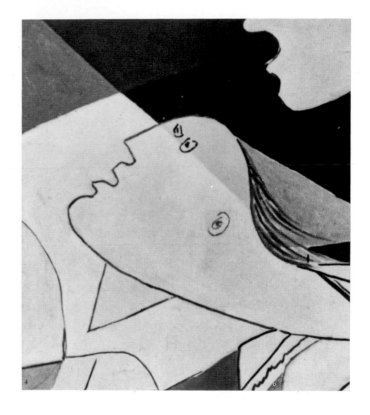

more accentuated by Ingres's addition of gold leaf to their
manes and chariot, an extraordinary pictorial device that
revives, like Blake's use of gold, the spaceless, abstract realm
of pre-Renaissance art.

But it is above all the heroine of this Homeric scene who
betrays Ingres's special sensibilities in both formal and psy-
chological terms. Having tried to help her son Aeneas in
the Trojan Wars, she has been wounded in the hand by
Diomedes and is seen here being carried back to Olympus in
Mars' cloud-borne chariot, assisted by Iris. Pitifully help-
less, the goddess of love is interpreted by Ingres as a creature
of fantastic malleability, whose limp, outstretched hand and
tapered fingers begin a circuit of linear fluency that contin-
ues around the elongated left shoulder, is then cushioned by
the fragile pressure of Iris' own hand, and finally winds slow-
ly downward to join the contours of the buttocks and the
last intricate flourish of the drapery folds that veil her legs.
This sinuosity of contour, echoed in the curving patterns of
clouds, wings, and veils, of chariot and shield, carries with it
a highly charged eroticism, as if the edges and surfaces of the
female form were being expanded and contracted in an
active, caressing way. In fact, this early image of Venus was
to dominate Ingres's lifelong conception of feminine beauty,
whether in terms of other re-creations of the goddess of love,
like his *Venus Anadyomene;* other voluptuous heroines in
distress, like Thetis, Angelica, Francesca da Rimini; the oc-
cupants of harems and Turkish baths, whose lives are fully
devoted to the arts of love; or their nineteenth-century
counterparts, the gallery of modern women whose por-
traits Ingres painted as if these sitters, too, were sequestered
in the pampered confines of an exclusively erotic domain.

Prophetic, too, is Ingres's daring freedom to impose an
autonomous pictorial order of abstract contour and tensely
flattened surfaces upon the realistic data of light, space, and

texture that had been mastered in the great tradition of
Renaissance and Baroque painting of which he was the heir.
From cues provided in Italian *trecento* and *quattrocento* art and
Greek vase painting, or in their reincarnation in Flaxman's
outlines to Dante (fig. 17) or Homer, Ingres developed
his own interpretation of the insistent planarity, the space-
less images, the precise drawing of these anti-illusionistic
styles. In *Venus Wounded by Diomedes* the contours may be
archaically rigid and angular, as in the heads and legs of the
horses and the profiles and necks of Iris and Mars, or seduc-
tively supple, as in the figure of Venus; but in all cases they

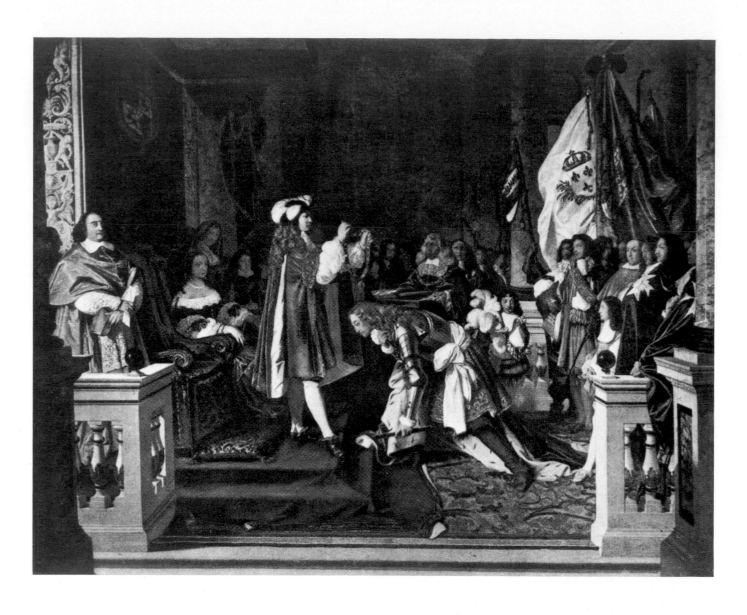

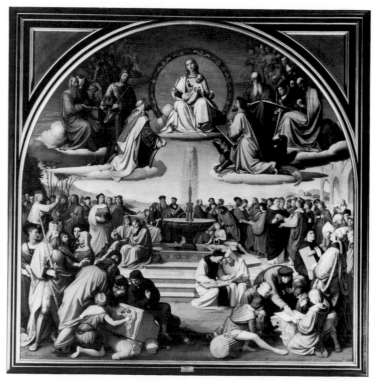

ABOVE:
Figure 21. Ingres. KING PHILIP V OF SPAIN
INVESTING THE MARSHAL OF BERWICK WITH THE GOLDEN
FLEECE AFTER THE BATTLE OF ALMANZA. 1818.
Oil on canvas, 34⅝ × 42⅞″.
Collection H.H. the Duke of Alba, Madrid

RIGHT:
Figure 22. Friedrich Overbeck.
TRIUMPH OF RELIGION IN THE ARTS. 1840.
Staedelsches Kunstinstitut,
Frankfurt

live an intensely abstract life that molds anatomy to their own pictorial purposes. The resulting distortions are among the most famous in the history of art, bizarre in terms of nineteenth-century aesthetics, whether those of classical idealism or modern realism, and precocious in terms of the twentieth century's even greater willingness to emphasize abstract pictorial demands at the expense of truth to nature. Himself an inventor of fantastic creatures, Odilon Redon remarked: "But it is Ingres who has made monsters!" (M. Denis, *Théories, 1890–1910*, Paris, 1920, p. 101). And indeed, looked at from a realistic viewpoint, Ingres's anatomy, whether of nineteenth-century ladies or mythological heroines, can be grotesque.

Perhaps the most famous of these "monsters" is the supplicating nymph Thetis, whose head in particular (fig. 18) has been singled out by modern critics not only for praise as an example of prescient abstraction, but even for comment by a French endocrinologist, who explained the goitrous swell of Thetis' neck in terms of an improperly functioning thyroid gland (*Aesculape*, XIX, March, 1929). But such strange distortions, ubiquitous in Ingres's work, are not to be explained in too single-minded a way, for they result from complex and varied interactions of both formal and psychological impulses of which Ingres himself may often have been unconscious. Thus, the angular and rounded stylizations of Thetis' forehead, nose, and neck are in part inspired by the schematic linear profiles commonly found in Greek vases (fig. 19) as well as among angels in Italian medieval painting, and correspond to Ingres's love of sleek and continuous contours that seem to bend and twist at will the objects they contain. At the same time, this abstract pliability conforms here to the character of the subject, a nymph whose full body, from the tips of her cloud-borne left toes to the ends of her wriggling fingers, is extended heavenward in seductive and desperate entreaty to the omnipotent Jupiter on Olympus (colorplate 13). Picasso, in *Guernica*, could use such

Figure 23. Ingres. JESUS AMONG THE DOCTORS. 1862. Oil on canvas, 104¼ × 126″. *Musée Ingres, Montauban*

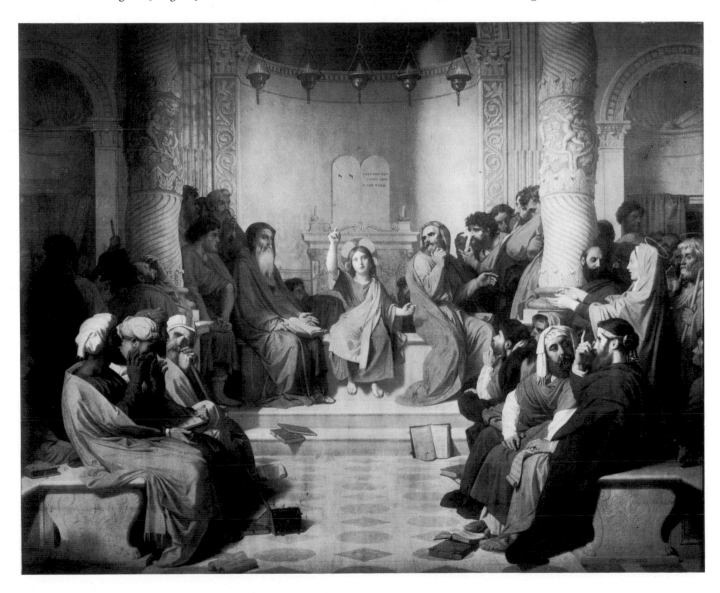

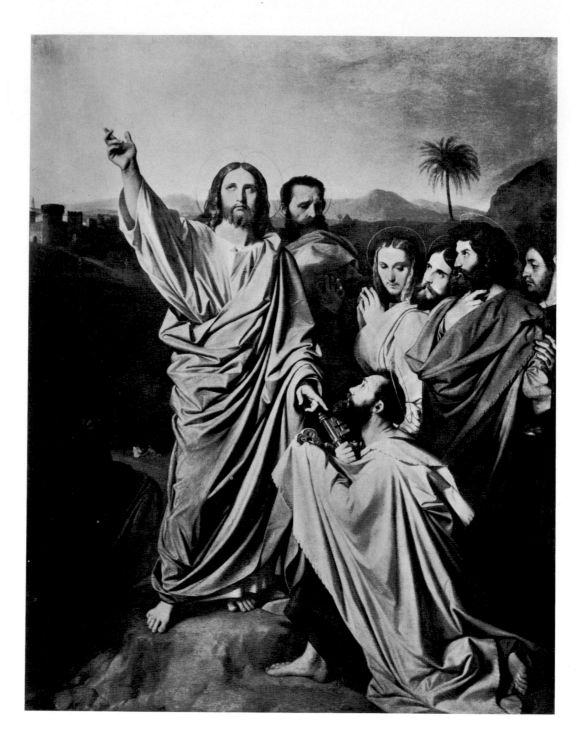

Figure 24. Ingres.
CHRIST DELIVERING THE
KEYS TO ST. PETER. 1820.
Oil on canvas, 110¼ × 85½".
Musée Ingres, Montauban

a form for his own abstract and expressive purposes, when he paraphrased Thetis' strained posture and gaze of supplication in the Spanish woman whose neck, eyes, and arms stretch upward, dazed, to the malevolent heavens (fig. 20). In the case of Ingres, however, this extraordinary ductility pertains most often to a voluptuous interpretation of the female form, as in the odalisques or in the more sensual portraits; at times, however, as in the case of the portrait of M. Bertin (colorplate 28), these contractions and expansions of flesh and bone are related to a mood of tense virility and alertness. And these malleable anatomies are often justified in almost exclusively formal terms, maintaining as they do

an animate dialogue between the sculptural volumes of the figures and a taut continuity of two-dimensional pattern. But what in all cases makes these distortions so singular, and ultimately so acceptable, is the sheer genius of Ingres's formal sensibility, which creates so immutable an abstract order that the incredibility of the resulting images, as judged from the standpoint of realism, becomes a peripheral issue.

Nevertheless, the character of these distortions is different from those of either the Greek vase painter or Picasso, for whom the language of abstraction is explicit and conscious enough to prevent our applying the criteria of realism. For what is so striking about Ingres's art is the equally high pro-

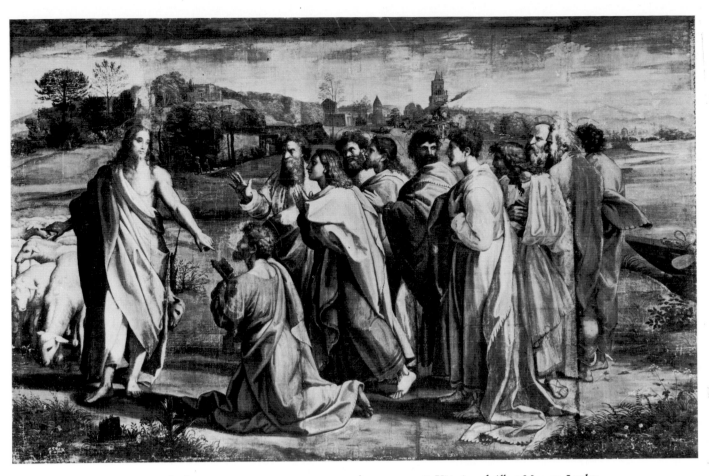

Figure 25. Raphael. CHRIST DELIVERING THE KEYS TO ST. PETER. 1515–16. *Victoria and Albert Museum, London*

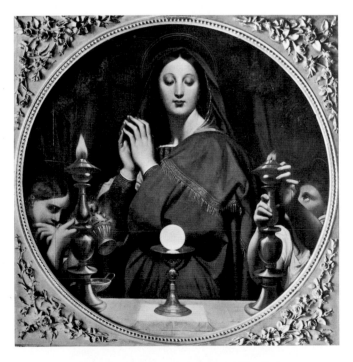

Figure 26. Ingres. THE VIRGIN WITH THE HOST.
1854. Oil on canvas on panel, diameter 44½".
The Louvre, Paris

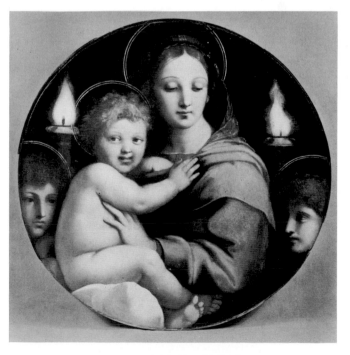

Figure 27. Raphael and school.
THE MADONNA OF THE CANDLESTICKS. C. 1514.
The Walters Art Gallery, Baltimore, Md.

23

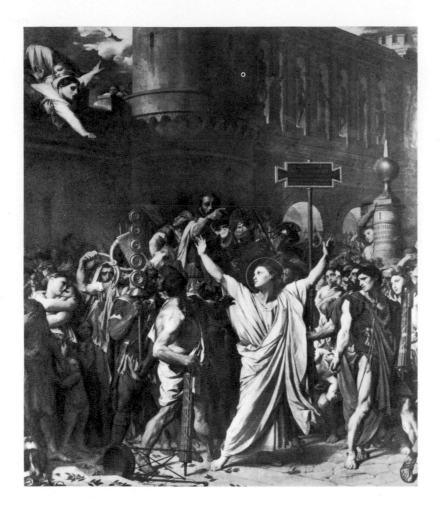

LEFT:
Figure 28. Ingres.
MARTYRDOM OF ST. SYMPHORIAN. 1834.
Oil on canvas, 160¼ × 133½'.
Cathedral, Autun

BELOW:
Figure 29. Ingres. LORENZO BARTOLINI.
1806. Oil on canvas, 38½ × 31½'.
Private collection, Aix-en-Provence

portion of an intense, quasi-photographic realism, which at times is so strong that the untutored eye will often mistake Ingres's portraits for unadulterated replicas of reality. At first consideration this descriptive realism, which would record the most refined textural variations of metal, wood, and jewelry, and even the tiny reflections of windows on polished surfaces, appears to contradict the abstract linear component of Ingres's vocabulary, for how can one reconcile pictorial styles as antagonistic as Greek vase painting and Netherlandish realism? Yet, rather than being irreconcilable, these extremes in Ingres's art are better seen as two sides of the same coin. Both pictorial modes reject the illusionistic tradition of later Renaissance and Baroque painting in favor of, on the one hand, an archaic style of pure and flat outline, and on the other, an equally archaic style of a kind of hyperrealism that is best exemplified by the art of Jan van Eyck. When Ingres's critics complained that his early work was "Gothic," they meant that he was reviving either or both of these archaic styles, for at times he was compared to the Italian primitives in his abstract outline and harsh local color, and at times to the Flemish primitives in terms of his painstaking and static description of surface detail. It is fitting that Ingres's own collection of paintings included both a predella

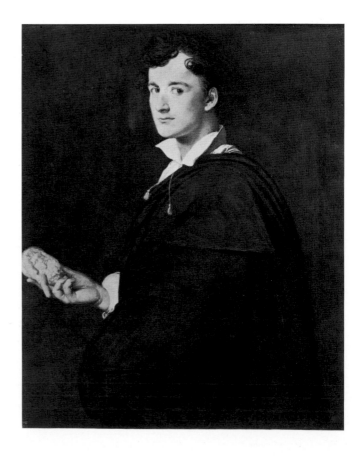

24

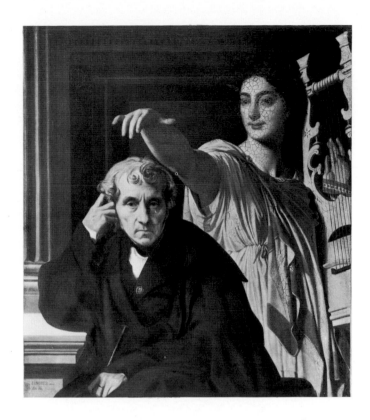

panel by Masolino and a portrait from the school of Van Eyck, acquisitions most precocious for the early nineteenth century, when such works were generally considered only historical curiosities that marked the first faltering steps which led to the venerable masters of the sixteenth, seventeenth, and eighteenth centuries.

In his insistent extremes of abstraction and realism, Ingres opposed, even more radically than did his master David, the painterly tradition of masters like Titian, Tintoretto, Rembrandt, Rubens, Watteau, and Fragonard, although he could, in fact, admire and even borrow from the work of some of these artists who had perfected the means of describing, in an abbreviated, virtuoso manner, the shimmering movement of forms in light and shade. Ingres's images, on the contrary, are frozen and immobile, precious objects in a pictorial amber that fixes them for eternity through the abstract precision of taut contours and the realistic precision of minutely described surfaces. Again, Ingres's effort to regenerate nineteenth-century art upon the purest, most primitive pictorial sources was hardly unique. In his own generation the German Nazarenes, who first painted in Rome during Ingres's own sojourn there and then returned to the North, similarly revived both the intensely abstract and intensely realistic components of the Italian and the Northern primitives, so that their art, like that of Ingres, may seem to borrow at times from masters like Bellini and Perugino and at times from masters like Schongauer and Dürer. And later in the century, in 1848, another group of artists, the British Pre-Raphaelites, attempted a comparably drastic purification of pictorial style by reviving the same components culled from fifteenth-century Italian and Northern primitives, so that their art, like that of the Nazarenes or of Ingres, often seems to veer between extremes of linear stylization and of microscopic observation of the variegated surfaces of reality. But, once more, Ingres's art is to be distinguished from that of his contemporaries not so much in terms of kind as in terms of quality, for his command of these two stylistic archaisms reached degrees of virtuosity seldom attained by other nineteenth-century artists motivated by the same reformatory currents and inspired by the same historical sources.

In some ways Ingres's art may be considered a continual dialogue between these two complementary modes of vision, and his triumphs as well as his failures can in part be explained by the precarious proportioning of the abstract and realistic components of his style. In his subject paintings, in particular, one often senses an imbalance between these pictorial forces. Thus, many of the smaller, anecdotal scenes of medieval and Renaissance history, like *Molière Dining with Louis XIV at Versailles* (fig. 7), *Henry IV Playing with*

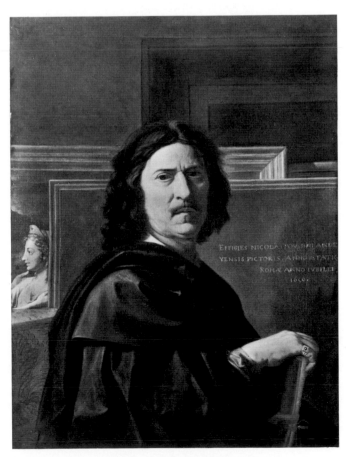

Figure 31. Nicolas Poussin.
SELF-PORTRAIT WITH ALLEGORY OF PAINTING.
1650. *The Louvre, Paris*

His Children (fig. 5), *King Philip V and the Marshal of Berwick* (fig. 21), have passages of almost indiscriminate realistic detail which seem uncontrolled by the abstract order of fluent contour and surface arabesque that mark Ingres's

work at its finest. And no less frequently, a predetermined abstract form, usually borrowed from an already existing work of art which Ingres admired, is repeated without sufficient freshness of observation to sustain its vitality. This

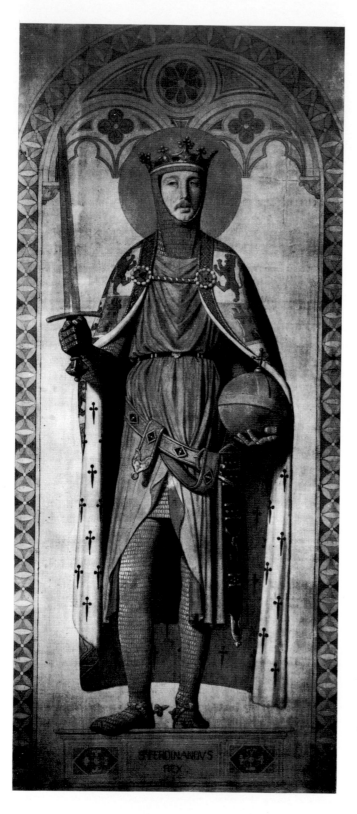

Figure 32. Ingres. ST. FERDINANDUS. 1842.
Cartoon for a stained-glass window, 82¾ × 36¼".
The Louvre, Paris

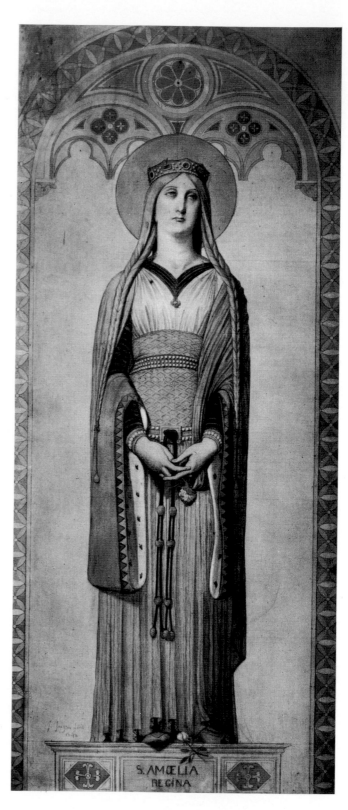

Figure 33. Ingres. ST. AMOELIA. 1842.
Cartoon for a stained-glass window, 82¾ × 36¼".
The Louvre, Paris

somewhat uncomfortable visual experience is especially evident in Ingres's many resurrections of masterpieces by Raphael, whose art Ingres venerated with devout passion, and whose presumed ashes were among his most cherished possessions. Like many of his contemporaries, from a German Nazarene like Friedrich Overbeck (fig. 22) to Italians such as Tommaso Minardi and Francesco Podesti, Ingres often attempted to re-create within his own pictorial realm the spacious and harmonious symmetries of the High Renaissance master, from such works of the 1820's as *The Vow of Louis XIII* (colorplate 26) and *The Apotheosis of Homer* (colorplate 27) to the late *Jesus among the Doctors* of 1862 (fig. 23). Thus, when he was commissioned in 1817 to paint *Christ Delivering the Keys to St. Peter* for the Roman church of S. Trinità dei Monti (fig. 24), Ingres chose to depend upon the timeless and certain pictorial values offered by Raphael's canonical formulation of this Christian theme (fig. 25), and achieved problematic results that are at once too ideal and too real. On the one hand the fluent and simple rhythms of Raphael's composition are hardened by Ingres's firm draftsmanship, so that they become, as it were, stillborn abstractions, even more remote from reality than the original forms. On the other hand there are constant intrusions of

Figure 35. François Gérard. PORTRAIT OF A WOMAN.
c. 1805. *Musée des Beaux-Arts, Nancy*

Figure 34. François Gérard.
COMTESSE REGNAUD DE SAINT-JEAN D'ANGELY.
1798. *The Louvre, Paris*

naturalistic passages that are neither pervasive nor consistent enough to invigorate the whole. The wrinkled forehead and neck of St. Peter; the disturbingly transparent halos and heavy metal keys; the palm tree that, with nineteenth-century factual precision, locates the scene in the Holy Land —such literal details create a curious oil-and-water combination in which Ingres's ideal pictorial realm is juxtaposed rather than fused with his capacities for exquisite realistic observation. Similarly, *The Virgin with the Host* (fig. 26), especially when seen beside its Raphaelesque source (fig. 27), creates a disquieting, if fascinating, imbalance between the deliberate abstraction of the pure circular geometries and the almost clandestine passages of photographic reality in the rendering of the draperies, the flames, and the candlesticks. And, too, the facial expressions of Ingres's Neo-Raphaelesque figures often adulterate the innocent and simple piety of their sources by an overt sentimentality or a covert sensuality that smacks more of the nineteenth century than of Raphael. These odd paraphrases of Raphael often resemble those of Raphael's own students, like Giulio Romano, whom Ingres also admired immensely, for they upset the master's classical equilibrium of form in favor of chilly and dissonant imbalances of meticulous detail and abstract contours, and complicate his emotional clarity and equilibrium with strange undercurrents of eroticism.

The consistent success of Ingres's art is also challenged by

other problems of style and conception. The very incisiveness of Ingres's drawing tends to isolate individual figures. As a result, his multifigured compositions often have a synthetic, pastiche quality, so that we focus our attention on the parts and not the whole, a problem Ingres avoids in his portraits of a single sitter or in the single nudes. Even in such exquisite paintings as *Roger and Angelica* (colorplate 29) and *Antiochus and Stratonice* (colorplate 31) we may suddenly discover that we have excerpted the heroines from the other figures for particular visual scrutiny, as Ingres himself had done in related drawings and paintings, and that the total pictorial balance may be upset by the unique quality of a single figure. Moreover, Ingres's keen sensitivity to the preservation of a continuous pattern upon the picture surface created similar tensions in complex figure compositions. A revealing case in point is the large *Martyrdom of St. Symphorian* (fig. 28), whose severe critical reception at the Salon of 1834 was largely responsible for Ingres's leaving Paris for the Directorship of the French Academy in Rome. The critics, however, were not entirely unjustified in their complaints, for they saw, as we still do today, a scene of bewildering congestion, in which multitudes of figures appear

ABOVE:
Figure 36. François Gérard.
THE BARONNE DE PIERLOT.
Collection De Pierlot

RIGHT:
Figure 37. Ingres.
MME. AYMON ("LA BELLE ZÉLIE").
1806. Oil on canvas, 23¼ × 19⅜".
Musée des Beaux-Arts, Rouen

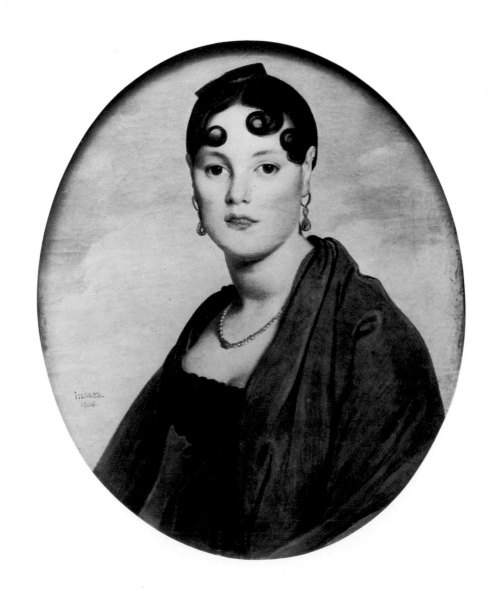

Figure 38. Joseph Chinard. MME. RÉCAMIER.
1802 or 1805. *Musée des Beaux-Arts, Lyons*

tions and plagued by the ghosts of moribund classical and Christian prototypes that Ingres could not always reincarnate from antiquity and from Raphael. As for most of his portraits, however, as well as for most of his nudes, modern criticism has been unanimous in its judgment, acclaiming them among the supreme masterpieces of Western art. Ingres himself would have been dismayed by this verdict, for, like his enemy Delacroix, he believed in a traditional French academic hierarchy of subject matter according to which portrait painting, by its very nature as a literal record of contemporary, empirical fact, could never achieve the heights of painting that recorded the noble deeds of man. Yet, ironically, Ingres painted and drew portraits throughout his life—sometimes as personal mementos of friends and family, as in the portraits of the artist himself, his father, his first and second wives, his artist friends Granet and Bartolini (fig. 29); sometimes, especially in his youth, to make money, as in the hundreds of portrait drawings he produced to sell to those foreigners who sat for him in Rome and Florence; sometimes to fulfill State commissions, as in his portraits of Napoleon, Charles X, or the Duc d'Orléans; and sometimes, particularly in his late years, to comply with the insistent demands of the most elegant and wealthy aristocracy of the July Monarchy and the Second Empire that they be im-

Figure 39. Hippolyte Flandrin. MME. OUDINÉ.
1840. *Musée des Beaux-Arts, Lyons*

cramped in a shallow, airless space that creates ambiguous collisions of heads, torsos, and limbs, all fighting desperately, as it were, to maintain contact with the picture plane. Against such a seething throng, even the Raphaelesque clarity of the saint's desperate gesture of farewell to his mother, who encourages his heroic action from the ramparts, can barely impose either a visual or a narrative sense of major and minor focus upon the whole. These spatial and dramatic paradoxes, which recall those of many sixteenth-century Mannerist paintings, recur constantly in Ingres's work, although not always to its disadvantage. At times this irrationality can take on the positive qualities that the twentieth century has learned to enjoy in Bronzino and Parmigianino, as it has in its own painting. Thus, *The Turkish Bath* (colorplate 40), with its puzzling elisions of foreground and background planes, its abrupt changes in scale that suddenly enlarge or diminish figures, its contradictions of sculptural volume and weightlessness, can correspond to a twentieth-century taste not only for the taut and ambiguous surface patterns that Cubism achieved by destroying traditional perspective systems, but even for the Surrealist sensation of a quasi-photographic image of an impossible phenomenon.

Nevertheless, to modern eyes many of Ingres's subject paintings appear defective, marred by disjointed composi-

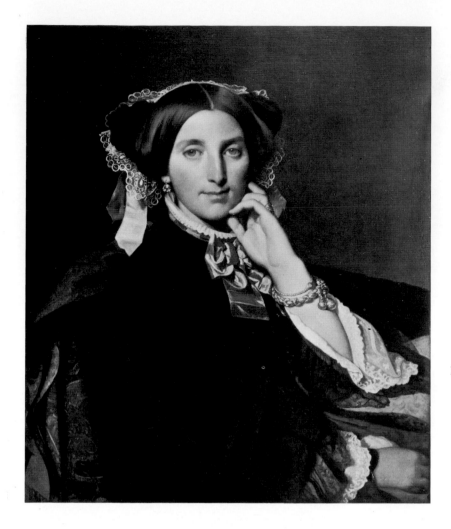

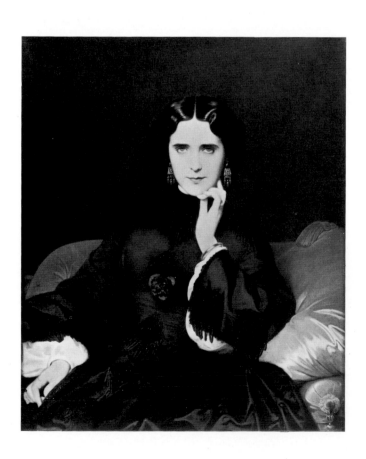

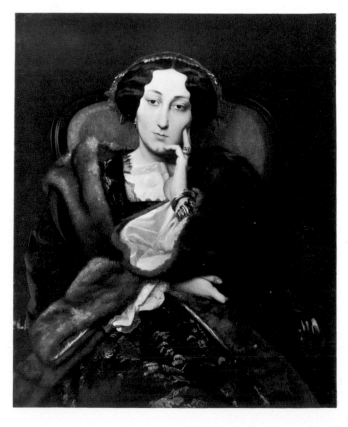

LEFT:
Figure 40. Ingres. MME. HENRI GONSE.
1852. Oil on canvas, 28 × 24".
Musée Ingres, Montauban

BELOW LEFT:
Figure 41. Eugène-Emmanuel-Pineu Amaury-Duval.
MME. DE LOYNES. 1862. The Louvre, Paris

BELOW RIGHT:
Figure 42. Jean-Léon Gérôme.
PORTRAIT OF A LADY. 1851.
The Art Institute of Chicago.
Wyler Foundation, restricted gift

Figure 43. Jean-Marie-Bienaimé Bonnassieux.
MEDITATION. Marble after original plaster of 1851.
Ministère des Affaires Culturelles, Paris

Figure 44. POLYHYMNIA.
Roman copy of a Greek statue
of c. 200 B.C. *The Louvre, Paris*

mortalized in a full-dress portrait by the incomparable Ingres.

With the exception of the portraits of close friends and family, this intrusion of the prose of nineteenth-century life into the timeless poetic realm of classical beauty that he wished to inhabit was a constant irritation to Ingres. He was insulted when a visitor in Rome came to his door and asked to see the "man who drew those little portraits," answering, "It's a painter who lives here"; nor did he feel that his painted portraits were any worthier of his own artistic ambitions. Almost all of his great society portraits of the 1840's and 1850's involved a terrible struggle—first, for the sitter to persuade Ingres to accept the highly paid commission; and second, for the artist to complete the work, angry as he was that portraiture was so much more demanding and time-consuming than the history painting he felt he should be creating in its place. Still, for us, Ingres's art is almost inconceivable without his portraiture; indeed, far from being separate from his subject paintings, the portraits remain inextricably related to the basic issues of his style, his conception of art, and his relation to other nineteenth-century artists.

Even more fully than his subject painting, Ingres's portraits set into tension the fundamental duality of his art—its

constant veering between the most close-eyed record of the data of perception and the imposition of an ideal formal order upon these empirical data. Occasionally in his portraiture these different realms of the real and the ideal are literally separated, as in the portrait of Cherubini (fig. 30). Partly inspired by Poussin's *Self-Portrait with Allegory of Painting* (fig. 31), Ingres has here represented the composer with the same scrupulous observation of hair, wrinkles, and veins that characterizes the unmitigated realism of the portrait of M. Bertin (colorplate 28), whereas above the sitter, the muse of lyric poetry, an ideal classical creature, hovers weightlessly. This brusque juxtaposition of two different visual and conceptual modes is even more startling in some of the cartoons of saints that Ingres made for the stained-glass windows at the Chapel of St. Ferdinand in Neuilly and at the Royal Chapel at Dreux. Although these figures of saints tend to conform to an abstract, nearly Byzantine ideal of hieratic stiffness and verticality, Ingres has turned several of them into allegorical portraits of members of the Orléans family, with the Duc d'Orléans himself in the guise of St. Fernandus (fig. 32) and his mother, Marie-Amélie de Bourbon, in the guise of St. Amoelia (fig. 33). Here the abrupt contrast between the close likenesses of nineteenth-century

personalities and the schematic geometries of the halos, architectural ornament, and incisive figure drawing produces an unbridgeable stylistic gulf.

Yet such disturbing schisms are relatively exceptional in Ingres's portraiture, if less so in his subject painting. For it is in his portraits, above all, that Ingres achieves the most complete, indissoluble fusion of the multiple and often contradictory components of his art. For one thing, his portraits permitted him to explore to the fullest his uncommonly acute awareness of the most minute phenomena of the visible world. As if looking through a lens of magical intensity and clarity, Ingres scrutinized the visual facts of nineteenth-century people, costume, and *décor*, and with the patience and technical mastery of a Van Eyck or a Ter Borch was able to record the tiniest details that might pinpoint a unique perception for all time. A wayward strand of hair, the transparency of black tulle, the irregular fringe on a cashmere shawl, the gleam of light reflected on gold, porcelain, pearl, or mahogany—nothing escaped his searching eye and nothing transcended his power to translate it into paint on canvas. Yet at the same time this uncannily sharp visual focus, that appears to accept the multifold data of reality as passively and as indiscriminately as a camera, is governed by a sense of abstraction that chisels surfaces, that extends and compresses contours to its own will. The sharp outlines and flat planes of Greek vase painting, Flaxman, and the Italian primitives; the supple contours of David's figure drawing; the impeccably smooth polish of classical marbles—such ideal abstractions are wedded to Ingres's realist vision to produce, in his portraits, an astonishing synthesis of opposites that seems both unbelievably real and unreal, as if the objective, glassy data of a mirror image were miraculously transposed into a still and timeless world of immutable perfection.

Moreover, Ingres's portraits, far from forming a separate category in his art, constantly absorb conceptions that are explored in his subject painting and must often be seen in relation to it. Thus, the voluptuous and cushioned indolence of *Mme. de Senonnes* (colorplate 21) is the more prosaic nineteenth-century equivalent of the seductive languor of the *Grande Odalisque* (colorplate 20); and the contemplative reverie of the *Comtesse d'Haussonville* (colorplate 32) is the modern translation of the antique mysteries of *Stratonice* (colorplate 31). Indeed, the emotional range of Ingres's portraiture is extraordinarily wide, perhaps even wider than that of his subject painting, for it is continually enlivened by the artist's perception of a particular personality, even when we may agree with Baudelaire's criticism in *Le Peintre de la Vie Moderne* that Ingres, in his portraits, imposed a preconceived ideal upon the sitter. Thus, in Ingres's portrait gallery, one can find the youthful, dramatic intensity of the painter Granet (colorplate 9), the businesslike directness of the journalist Bertin (colorplate 28), the aristocratic aloofness of the Count de Gouriev, the devastating charm of the

Baronne de Rothschild (colorplate 34), the seasoned wit of the Comtesse de Tournon, the cloistered melancholia of Mme. Marcotte de Sainte-Marie. And at times, as in the 1856 portrait of Mme. Moitessier (colorplate 38), Ingres can even elevate the personality of the sitter to Olympian heights by viewing it through the lens of classical prototypes.

Like his subject paintings, Ingres's portraits are better understood when seen in the context of contemporary works that seek out the same formal and psychological ideals. For example, his early female portraits belong to the same mode of lean but sensual elegance that characterized feminine fashion under the Directoire and Empire, and that may be found in the work of other students of David's. Many portraits by the Baron François Gérard, in particular, offer sources for, as well as echoes of, such Ingres portraits as those of Mme. Rivière and her daughter (colorplates 5, 6). Thus, in Gérard's portraits of the Comtesse Regnaud de Saint-Jean d'Angély (fig. 34) and of an unidentified woman (fig. 35), one finds a comparable taste for the slow, undulant rhythms of shawls and boas; the punctilious description of curls, jewelry, fabrics; the attenuated anatomies of tapered necks, limbs, and fingers; the enameled smoothness of pliant, boneless flesh. In less elaborate portraits, too, like

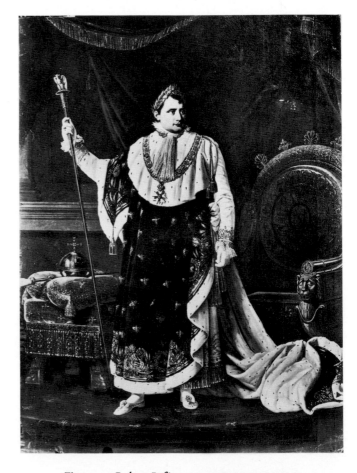

Figure 45. Robert Lefèvre. NAPOLEON I AS EMPEROR. 1811. *Musée National, Versailles*

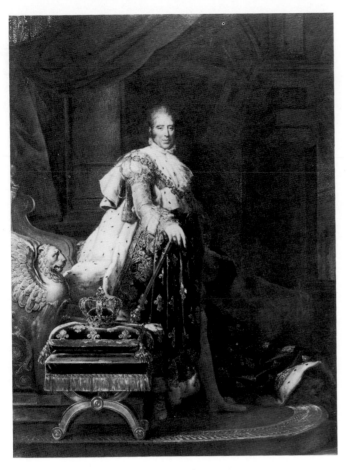

Figure 46. François Gérard. KING CHARLES X.
1825. *Musée National, Versailles*

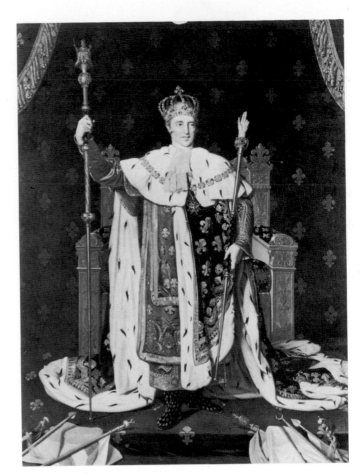

Figure 47. Ingres. KING CHARLES X IN HIS CORONATION ROBES.
1829. Oil on canvas, 50¾ × 35½". *Musée Bonnat, Bayonne*

Gérard's *Baronne de Pierlot* (fig. 36), these feminine ideals find their counterpart in such early Ingres portraits as that of Mme. Aymon, the so-called Belle Zélie (fig. 37) who, like the Baronne, presents an elegantly simple silhouette on a flat ground, but discreetly animates this simplicity with spiraling locks of hair, the shimmer of pearls, the sinuous twist of a shawl. And in contemporary sculpture, too, like Joseph Chinard's marble portrait of Mme. Récamier (fig. 38), the same predilection for the exquisitely detailed adornment of a pure and coolly modeled form can be seen.

Similarly, Ingres's later female portraits share the formal and expressive qualities of works by other portraitists of the time. In keeping with the change of costume and *décor* that marked the styles of the mid-nineteenth century, Ingres's portraits of the 1840's and 1850's, as well as his late subject paintings, are marked by a new density and weightiness that contrast with the thin, attenuated delicacy of the early portraits in much the same way that the heavy, overstuffed furniture of the Second Empire rejects the spare geometries of First Empire furniture. Psychologically, too, the mood changes from the overt and youthful seductiveness of the early female portraits to more remote and even sphinxlike personalities that conceal somber or perplexing mysteries. This new ideal of a female portrait as an image of a goddess

at whose shrine one worshiped was hardly unique to Ingres's late portraiture. Thus, the stark frontality that deifies Mme. Moitessier in her portrait of 1851 (colorplate 35) was already prefigured in the even more austerely iconic symmetry of such portraits as that of Mme. Oudiné (1840) by a student of Ingres's, Hippolyte Flandrin (fig. 39). And the no less disquieting pose of a sitter supporting her chin and cheek with a delicately curled thumb and forefinger, as if in silent, enigmatic concentration, was also familiar to mid-century conceptions of female portraiture. If Ingres used it in his portraits of, among others, the Comtesse d'Haussonville (colorplate 32) and Mme. Gonse (fig. 40), so too did such contemporaries as Eugène-Emmanuel-Pineu Amaury-Duval (fig. 41), Jean-Léon Gérôme (fig. 42), and even the sculptor Jean-Marie-Bienaimé Bonnassieux, whose statue, *Meditation* (fig. 43), stands halfway between the original classical source for this pose, a statue of Polyhymnia (fig. 44), and its translation into these mid-nineteenth-century images of woman as a disconcerting *femme fatale*.

Ingres's male portraits, too, are best understood in terms of more general issues of nineteenth-century portraiture, particularly in the matter of the search for new pictorial formulas that might ennoble the new generations of emperors, kings, counts, and dukes in a modern, secularized

33

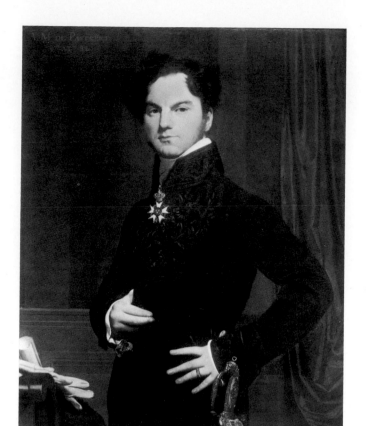

society that challenged what, in earlier centuries, was a pre-ordained permanence and grandeur intrinsic to the aristocracy. Ingres was more inventive than his contemporaries in finding solutions to this nineteenth-century problem. To represent Napoleon as emperor, a lesser artist like Robert Lefèvre simply depended upon a paraphrasing of the Bourbon splendors of a Baroque portrait formula that might have served for Louis XIV (fig. 45), whereas Ingres attempted to aggrandize the new emperor in terms of a remote, hieratic glory that conjures up the symmetrical images of Christian and classical deities that predate French monarchical history (colorplate 7). Similarly, in representing King Charles X, an artist like Gérard merely revived a seventeenth-century formula of sweeping curtains, crackling drapery, and tumbling light (fig. 46), whereas Ingres, confronted with the same problem, invested the new nineteenth-century monarch with a fascinating aura of stiffness and symmetry that evokes the precious sanctity of a medieval relic (fig. 47).

For less imperial or regal circumstances, Ingres could find other solutions that would breathe new life into the waning traditions of aristocratic portraiture. In particular, he was drawn to Mannerist portraits as sources for an image of chilly, immobile decorum. Holbein and especially Bronzino provided such prototypes, as may be seen by comparing Ingres's portrait of the Comte, later Marquis, de Pastoret (fig. 48) with a Bronzino portrait (fig. 49). Like the foppish young Italian, Ingres's aristocrat creates a fashionable effigy of aloofness and propriety, a taut silhouette of studied gestures fixed against a flattened background of lean and elegant geometries. Even the walleyed gaze, so common in Bronzino, recurs constantly in Ingres's painted and drawn portraiture, a disquieting device that rebuffs, in psychological terms, the spectator's efforts to penetrate too closely behind the sitter's masklike composure, and that also creates, in formal terms, a shifting of surface activity away from what might otherwise be too intense a point of visual focus. This flattening of psychological and visual depth in the interests of intricate surface patterns was explored extensively by Ingres in his more aristocratic commissions; witness one of the many versions of the portrait of the Duc d'Orléans (fig. 50). Here the haughty, attenuated pose, locked into place by such formal conceits as the repetition of the elliptical curve of the left arm in the tail of the lion sculpture just visible at the lower right, achieves an image of commanding aristocracy that later official commissions, like Hippolyte Flandrin's portrait of Napoleon III (fig. 51), could only emulate at the

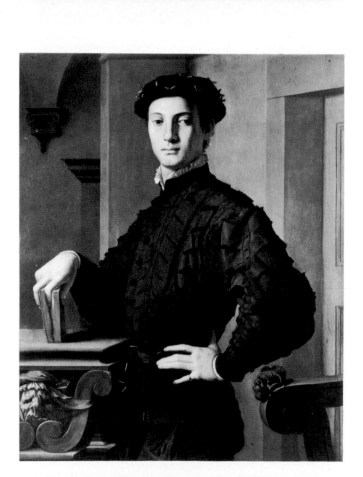

Figure 49. Agnolo Bronzino. PORTRAIT OF A YOUNG MAN. c. 1535–40. *The Metropolitan Museum of Art, New York. The H.O. Havemeyer Collection. Bequest of Mrs. H.O. Havemeyer, 1929*

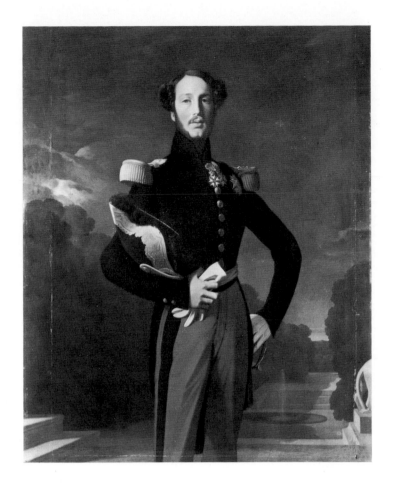

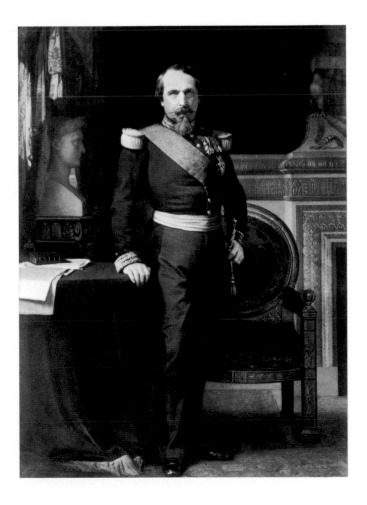

distance that separates the genuine master from disciples.

The genius of Ingres's portraits, however, should not obscure the fact that, historically, his art must be considered as a whole—the complex manifestation of a more unified aesthetic belief that, especially during his lifetime, could be supported by himself and by his disciples with a moral, quasi-religious fervor. Ingres's copious writings are full of inflexible affirmations of traditional artistic values, stubbornly reasserting such French academic beliefs as the unchallengeable supremacy of antique art, the secondary position of color as a minor embellishment to a drawn form, the need to conceal the evidence of manual labor as revealed in sketchy, impetuous brush strokes. First sensing the growth and then seeing the fruition of nineteenth-century assaults upon these values, Ingres relentlessly pitted his art against that of the younger infidel, Delacroix, a battle that began with the aesthetic collision of major paintings by the two artists at the Salons of 1824 and 1827, and reached a full-scale confrontation in the separate galleries devoted to retrospective exhibitions of these then venerable artists' works at the Paris Exposition Universelle of 1855 (figs. 52, 53). The violent antagonism between these two masters, which gave rise to numerous incidents of barbed wit and overt hostility ("I smell sulphur," Ingres remarked when Delacroix entered the same room), reinstated the traditional French controversy between the apostles of Poussin and those of Rubens,

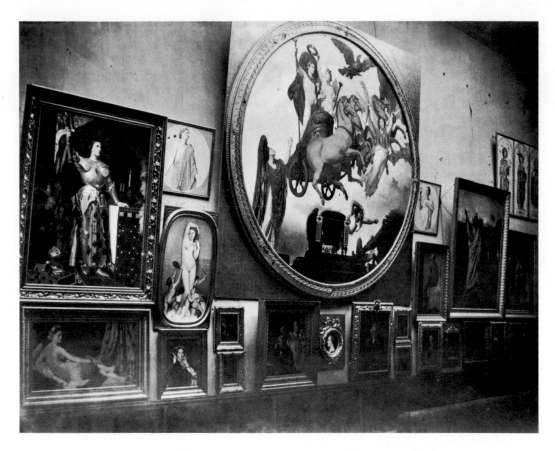

Figure 52. Part of the Ingres exhibition at the Exposition Universelle of 1855, Paris

Figure 53. Part of the Ingres exhibition at the Exposition Universelle of 1855, Paris

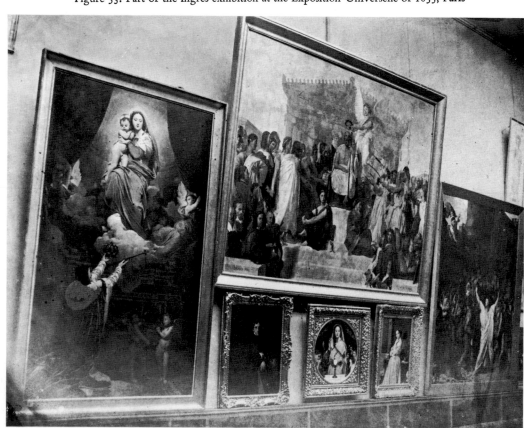

between the *anciens* and the *modernes;* and one heard again the familiar aesthetic oppositions of drawing versus color, intellect versus feeling, deliberation versus impulse, finished paintings versus sketches, classical beauty and serenity versus modern aberrations of the ugly and the morbid. Yet, as modern criticism has observed more easily, the gulf between Ingres and Delacroix is not always unbridgeable; and the simple aesthetic polarities that separate them should not blind us to the actual qualities of their art. It would be foolish, for instance, to claim that Ingres was not as great a colorist as Delacroix, for, again and again, in works ranging from the early portrait of Mlle. Rivière (colorplate 6) to the late portrait of the Princesse de Broglie (colorplate 36), he invented astonishing chromatic harmonies that, for exquisite, silvery coolness, are perhaps rivaled only in Vermeer. Nor should his official pose of classical idealism prevent us from perceiving the almost morbid voluptuousness

that underlies, even if unconsciously, his manipulations of the female form, a refined eroticism that revives the perversities and attenuations of sixteenth-century Mannerist nudes, especially those of the School of Fontainebleau (fig. 54), and that forms a close counterpart to the more overt sensuality of Delacroix's *Sardanapalus.*

In their choice of subject, too, Ingres and Delacroix could overlap, with Delacroix occasionally exploring such classical themes as the death of Marcus Aurelius and Ingres venturing into the exotic torpor of the harem; and in one place, the Royal Chapel of the Orléans family at Dreux, the two artists actually contributed to the same medievalizing commission for stained-glass windows, with Delacroix illustrating the thirteenth-century battle of Taillebourg, and Ingres a series of saints. But, more broadly speaking, the two artists were united in their general conception of subject matter; for both Ingres and Delacroix may be said to

Figure 54. School of Fontainebleau. THE BIRTH OF CUPID. 16th century, second half.
The Metropolitan Museum of Art, New York. Rogers Fund, 1941

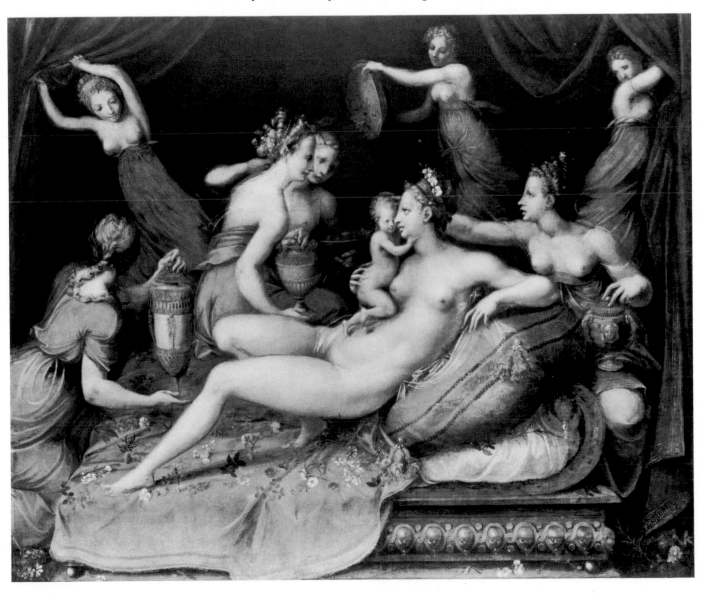

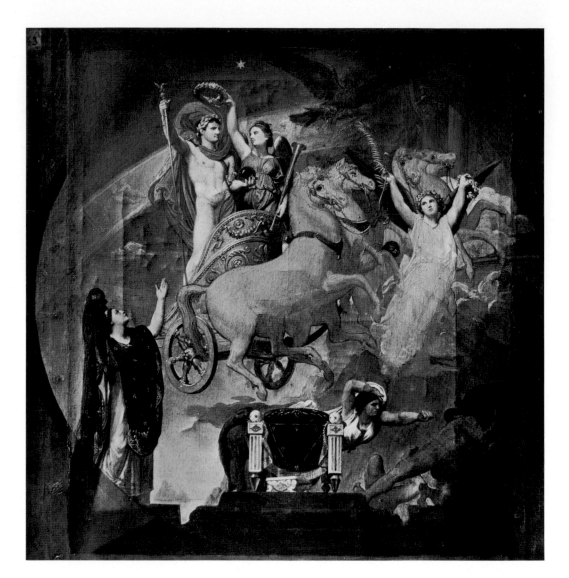

represent the last vigorous, if not always successful, attempt
to maintain the vitality of the Western tradition's crumbling
hierarchy of grandiose themes. Throughout their careers,
they both perpetuated the Renaissance belief that the proper
subject for painting was man in his most dramatic and noble
guises. Still-life painting, landscape, genre, which were to be
elevated to the highest stature by great artists from Courbet
on, remained for Ingres and Delacroix negligible or irrele-
vant in the face of the challenges of history, mythology,
literature, and Christianity, which provided lofty themes
that both artists were content to repeat, over and over
again, from youth to old age; and even their nudes, exotic or
modern, are saturated with the idealism of classical and
Renaissance Graces and Venuses. Moreover, both Ingres and
Delacroix clung to the traditional Renaissance language of
ideal, allegorical creatures, convincing us at times that their
angels, their personifications of liberty or victory, their
muses of inspiration still have the life that they had in
Raphael, Titian, and Rubens, and that they would lose so

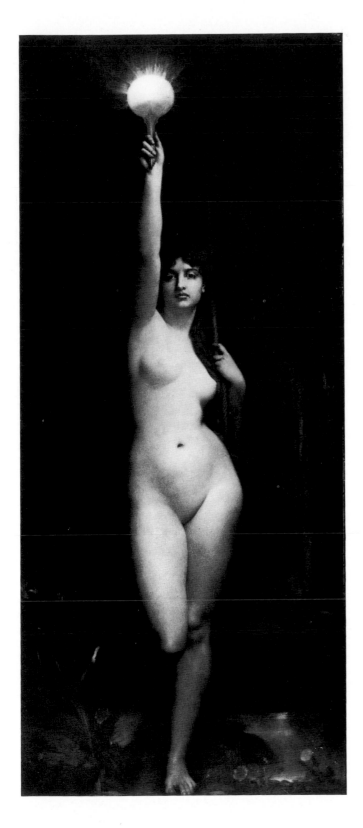

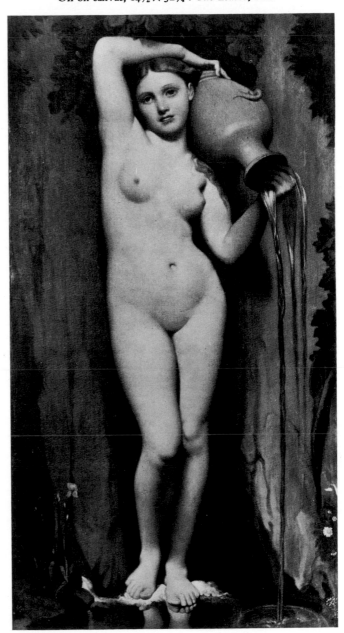

LEFT:
Figure 57. Charles-Victor-Eugène Lefebvre. TRUTH.
Salon of 1859. *Musée de Picardie, Amiens*

BELOW:
Figure 58. Ingres and pupils. LA SOURCE. 1856.
Oil on canvas, 64½ × 32¼′. *The Louvre, Paris*

irrevocably through the Realist revolutions of Courbet and Manet in the 1850's and 1860's.

It is fitting that in the early 1850's, both Ingres and Delacroix, old masters by then, were commissioned to decorate ceilings of the Paris Hôtel de Ville with complex allegorical subjects that would have been impossible for a later generation of modern painters, rooted in empirical fact, to illustrate. Ingres, in the Salon de l'Empereur, represented *The*

Apotheosis of Napoleon I, with a repertory of such symbolic figures as France, Fame, Nemesis chasing Crime and Anarchy, and a Victory bearing a laurel wreath; whereas Delacroix, in the Salon de la Paix, represented the realm of Peace, who chases Discord and brings the bounties of the harvest, as personified by Ceres. Destroyed by fire in 1871, these ceiling decorations are known to us only through drawings and small painted studies that, for all their com-

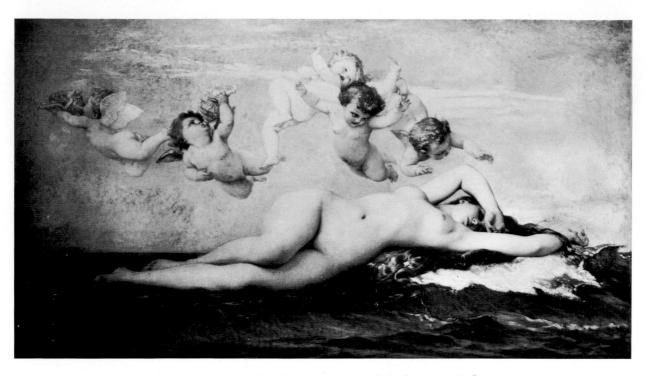

Figure 59. Alexandre Cabanel. BIRTH OF VENUS. Salon of 1863. *Musée d'Orsay, Paris*

Figure 60. Gustave Courbet. SLEEPING NUDE. 1862. *Collection Hatvany, Budapest*

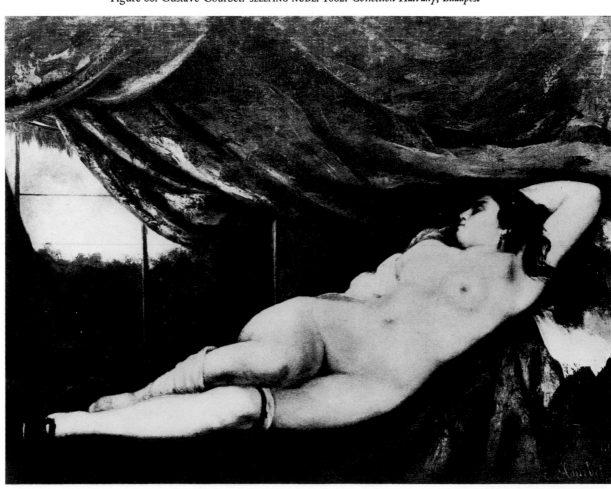

Figure 61. Hippolyte Flandrin. THESEUS RECOGNIZED BY HIS FATHER. 1832. *École des Beaux-Arts, Paris*

mon conceptual effort to breathe life into the symbolic language of the old masters, vividly restate the opposition between Delacroix and Ingres (figs. 55, 56)—on the one hand, a swirl of impetuous brush strokes that dissolves the identity of individual forms in a turbulent and nearly illegible drama of color and energy; on the other, a crystalline compilation of quotations from Greek and Roman art, exquisitely and deliberately delineated with cameolike precision on a painted surface of enameled smoothness. For the nineteenth century, as well as for posterity, such works offered a sharp contrast of unlike pictorial viewpoints, as drastic as Wölfflin's later categories of Renaissance versus Baroque, stylistic alternatives that modern artists could embrace, reject, or at times even reconcile.

In the case of Ingres, probably even more than of Delacroix, the authority of individual paintings as well as of an entire aesthetic has remained a living force from the nineteenth century until our own time, but a force that was so complex in its potential that the roster of painters directly inspired by him must include an abundance of artists whose styles, intentions, and quality could hardly be more varied and contradictory—from official academic masters like Cabanel and Bouguereau to more eccentric and imaginative ones like Gustave Moreau; from Impressionists and Post-Impressionists like Degas, Renoir, and Seurat, to such formal innovators of the early twentieth century as Matisse and Picasso; and more recently, since World War II, from Abstract Surrealists and Expressionists like Arshile Gorky and Willem de Kooning to such figurative and Pop artists as Larry Rivers, Martial Raysse, and Alain Jacquet.

In the mid-nineteenth century, however, Ingres's perpetuation of a Classical doctrine through his official position at the École des Beaux-Arts in Paris and at the French Academy in Rome meant that it was above all his students and those Salon painters of an academic persuasion who reflected the master's art. In many cases, Ingres's inventions provided prototypes that could lead to almost literal imitation in the hands of lesser artists. Thus, Charles-Victor-Eugène Lefebvre's *Truth*, at the Salon of 1859 (fig. 57), simply paraphrases Ingres's *La Source* of 1856 (fig. 58), itself in

tury were quick to incorporate Ingres's nudes into their repertory, often pushing the warring idealist and naturalist components of the master's style to ludicrous or lascivious extremes. Ingres's own students, however, paid more respectful homage to the themes and forms that he had invented, usually beginning their education with such attempts to sustain the master's Greek ideals as Hippolyte Flandrin's Prix de Rome-winning painting of 1832, *Theseus Recognized by His Father* (fig. 61), and then moving on to works of varying degrees of originality. Thus, the serene beauty of the *Bather of Valpinçon* (colorplate 10), which Ingres himself had often reinterpreted in subsequent paintings, could continue to inspire faithful disciples like Armand Cambon (fig. 62) and Amaury-Duval, who also chronicled the activities of Ingres's atelier. The latter's *Study of a Young Girl*, of 1864 (fig. 63), offers a modest and charming commentary upon Ingres's great nude, though one that compromises Ingres's prototype by unbalancing its tense equilibrium between the real and the abstract in favor of photographic verisimilitude. Ingres's example could also inspire among his students a

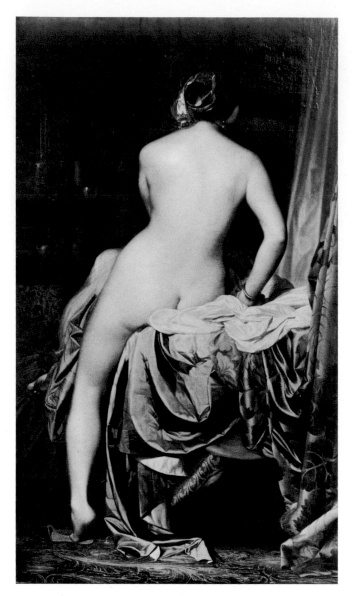

Figure 62. Armand Cambon. GALEL.
Salon of 1864. *Musée Ingres, Montauban*

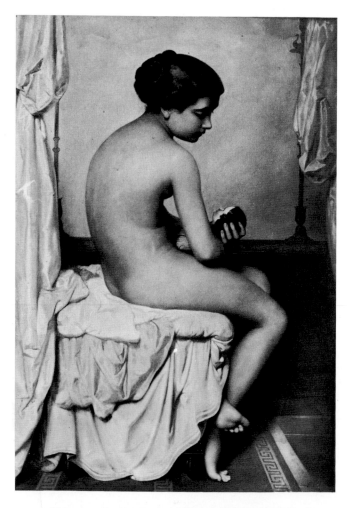

Figure 63. Eugène-Emmanuel-Pineu Amaury-Duval.
STUDY OF A YOUNG GIRL. Salon of 1864.
Formerly Musée du Luxembourg, Paris

part the work of pupils, as is suggested by the dark and inert shadows and the less than incisive modeling that mar the painting's quality. Similarly, Alexandre Cabanel's famous *Birth of Venus* (fig. 59), the painting bought at the Salon of 1863 by the Emperor, who was shocked by the indecency of Manet's *Déjeuner sur l'Herbe* at the Salon des Refusés of that year, restates more slackly the taut surfaces and razor-sharp contours of the odalisque that Ingres had perfected and himself restated in many works (colorplate 30). And at the same time even the leader of the Realist opposition, Gustave Courbet, echoed this ideal paradigm in his *Sleeping Nude* of 1862 (fig. 60), which both parodies and respects the academic authority against which he rebelled by translating Ingres's abstract invention into the coarse indolence of a naked girl who has fallen asleep before removing her stockings.

The academic Salon painters of the mid-nineteenth cen-

new surge of religious painting, especially in decorative murals commissioned for many churches in Paris and Lyons. In particular, the brothers Hippolyte and Paul Flandrin, whose own portrait drawings closely reflect their master's (fig. 64), were responsible for extending Ingres's admiration for the Italian primitives and for earlier medieval art into what amounted to an important chapter in that history of nineteenth-century Pre-Raphaelitism which includes the Nazarenes and the British Pre-Raphaelite Brotherhood. Hippolyte Flandrin's friezes for the nave of Lepère and Hittorff's church of St. Vincent-de-Paul, Paris (fig. 65), are typical extensions of Ingres's own love for the archaic stiffness, linear clarity, and abstract ground planes of much medieval art, a passion that the master clung to even a week before his death when, on January 8, 1867, he made an outline drawing after Giotto's *Lamentation* fresco. Like Ingres's own designs for stained-glass windows (figs. 32, 33), Flandrin's solemn procession of saints creates, to modern eyes, a curious conflict between the otherworldly abstractness and geometry of such medieval sources as the Ravennate mosaics at Sant' Apollinare in Classe and the literalism of flesh and drapery detail that characterizes Flandrin's more empirically oriented portraits (figs. 39, 51). Flandrin's achievements, widely applauded by his contemporaries, established a paragon of medieval piety and abstract clarity that would continue to inspire such later nineteenth-century French muralists as Pierre Puvis de Chavannes and Maurice Denis.

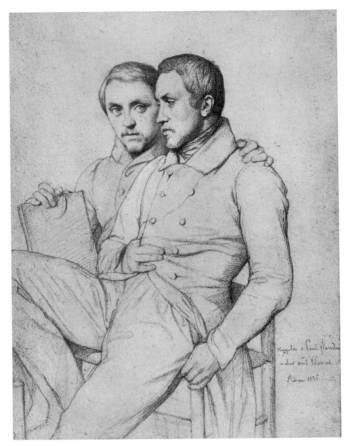

Figure 64. Hippolyte Flandrin. PAUL AND HIPPOLYTE FLANDRIN. 1835. *The Louvre, Paris*

Figure 65. Hippolyte Flandrin. PROCESSION OF SAINTS. 1849–53. *St. Vincent-de-Paul, Paris*

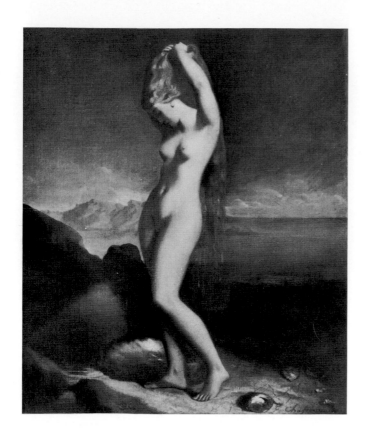

Some of Ingres's students even attempted to reconcile the lesson of their master with the seductive forces of the enemy, Delacroix, a goal attained most successfully by Théodore Chassériau. Like Prud'hon before him, Chassériau often viewed Neoclassic motifs through a Romantic lens of murky light and warm, resonant colors that, as in his *Venus Anadyomene* of 1838 (fig. 66), transforms an Ingresque figure of white, marmoreal perfection into a waxen creature of dark mystery. Similarly, his later scene of the tepidarium of a woman's bath near Pompeii (fig. 67) retains the lucid Neoclassic perspective construction of a frontally viewed, barrel-vaulted space, but injects its shadowy confines with an aura of languor that evokes simultaneously the exotic inertia of Delacroix's harems.

Other students of Ingres also tried, on occasion, to synthesize the contradictions of the Delacroix-Ingres polarity, especially in the realm of portraiture. Thus, Henri Lehmann's interpretation of the great Romantic composer

Figure 67. Théodore Chassériau. THE TEPIDARIUM. 1853. *The Louvre, Paris*

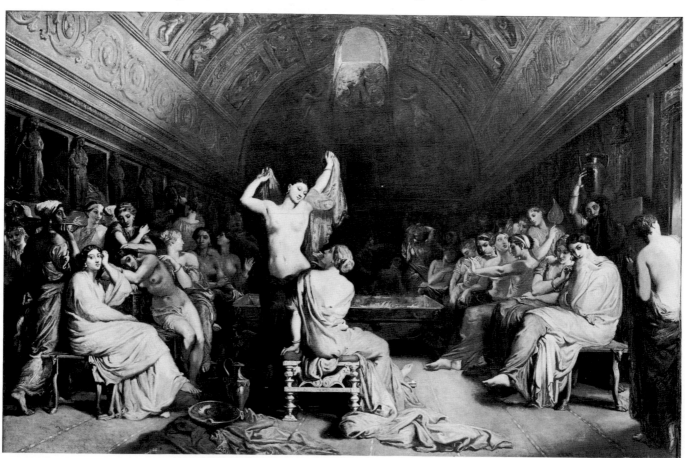

Figure 68. Henri Lehmann. FRANZ LISZT. Salon of 1840. *Musée Carnavalet, Paris*

Figure 69. Ingres. FRANZ LISZT. 1839. Pencil heightened with white chalk. *Private collection, Bayreuth*

Franz Liszt (fig. 68) follows clues offered by Ingres's male portraits, especially in the crisp, dark silhouette of the figure viewed against a paneled wall, but adds to this flattening formal device the overt psychological drama of an uncommonly intense gaze and a face half-concealed by shadow, a drama that makes explicit the covert passion of Ingres's own portrait drawing of Liszt (fig. 69) or of another great Romantic musician, Paganini.

In general, however, the legacy of Ingres to the tradition of modern painting was not to be found in the minor accomplishments of his own students, but rather in the position his art assumed for later generations of the nineteenth and twentieth centuries. Again and again, in periods of extreme formal experiment and crisis, the authority of Ingres provided vital solutions to the problems of the moment, a means of reconciling innovation and tradition. For a master like Degas, committed to the empirical record of the modern world, Ingres's taut draftsmanship and calculated silhouettes offered an abstract skeleton on which to construct new observations of contemporary fact. For the pictorial dilemmas of the 1880's, when the shimmering, colored light of Impressionism had dissolved familiar conceptions of artistic order, Ingres again presented the means

for a compromise solution. Thus, Renoir, in that decade, could attempt to fuse the warm, painterly styles of Delacroix and Impressionism with the linear and structural clarity of Ingres, paying simultaneous homage, like Chassériau before him, to the major pictorial alternates of nineteenth-century French painting; and Seurat, himself a pupil of an Ingres student, Lehmann, similarly attempted and achieved a synthesis of the modern vocabulary of Impressionism with the abstract lucidity that characterized Ingres's figure drawing.

The great pioneers of twentieth- no less than of nineteenth-century painting could also depend on the rigorous order of Ingres at points where the authority of an old-master solution was demanded. When Matisse, in 1905, had pushed his chromatic vocabulary to the abstract extremes of his Fauve paintings, he then turned to clues that would permit him to develop his linear vocabulary to a comparably abstract purity, clues that could be found, in good part, in the sinuous arabesques of Ingres's nudes. Thus, the great *Joy of Life* of 1905–6 (fig. 70) reincarnates with springlike freshness the linear and compositional order of Ingres's *Golden Age* (colorplate 39), harmonizing the authority of a Neoclassic past with the explorations of a twentieth-century

present. However, it is Picasso who, more than any other artist, has drawn upon not only the formal but the expressive potentialities of Ingres's art. In the stylistic dilemma that followed the high years of Cubism, Picasso could profit from the portrait drawings of Ingres, which offered, in traditional guise, both the intense realism and the intense abstraction that Picasso himself was juggling in his Cubist works. Indeed, for many critics and artists of a Cubist persuasion, Ingres's art appeared astonishingly modern, compressing as it did the traditional representation of volume into spaces whose shallowness rivaled that of Cubist painting itself. Later, in the 1920's and 1930's, Picasso could be equally fascinated by Ingres's conception of woman as an indolent creature of animal sexuality or even as a mysterious goddess of unfathomable enigmas (fig. 71). The sensual surrender of Ingres's odalisques, the sibylline remoteness of his late portraits are continually resurrected in both the Neo-classic and the Surrealist modes of these decades; and even in *Guernica* (fig. 20), Picasso could translate Ingres's extravagant anatomical distortions into vehicles of an expressive drama that, in this case, violently shatters the voluptuous, Arcadian environment that Ingres inhabited. For nineteenth- and twentieth-century artists, both conservative and progressive, pious and sensual, serene and tragic, the uncommon complexity of Ingres's art has never ceased to prove fertile. It offers interpretative possibilities that will continue to surprise us in the future, as they have in the past.

Figure 71. Pablo Picasso. WOMAN WITH BOOK. 1932. *The Norton Simon Foundation, Pasadena, Calif.*

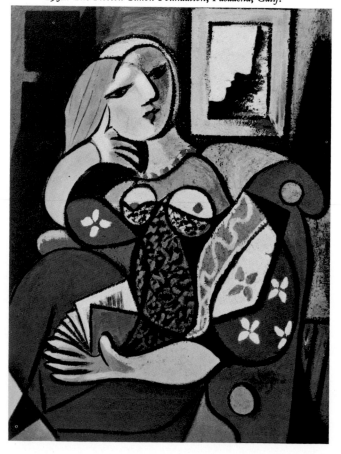

COLORPLATES

MALE TORSO

c. 1800

Oil on canvas, $39^3/_8 \times 31^1/_2'$

École des Beaux-Arts, Paris

In posing sessions like that recorded by Cochereau (fig. 72), David's students were trained in a close study of anatomy from the living model, as well as from works of classical art. Such mastery of the real and the ideal human figure was an essential part of a curriculum dedicated to a traditional belief in the superiority of painting that represented great men enacting the noble deeds recorded in classical history and mythology. Individual figure studies—the basic units from which these larger compositions would later be created—were often set up as student exercises for which prizes were awarded. Ingres's painting is one of these. Probably executed in December, 1800, it won the Prix de Torse on February 2, 1801, at the École des Beaux-Arts, where it is still to be seen today. But, far from being only a prize-winning document of Ingres's Neoclassic education in David's studio, it is also a memorable work of art by a twenty-year-old artist who could already put his personal stamp on the solution of a pictorial problem oriented toward winning an academic award.

Ingres's fusion of scrupulous realism and classical idealization is so complete here that the figure seems at once a noble classical hero, worthy of the race of Achilles or Oedipus, whom Ingres was soon to paint (colorplates 2, 11), and a studio model of palpable flesh and blood. The head, in particular, participates in this vivid reincarnation of classical beauty, for the static Greek profile and lofty gaze are vigorously enlivened by an animated tangle of Medusa-like hair. These realistic passages, however, are consistently subordinated to abstract formal patterns of unique sensibility. The surfaces and contours that describe skin, muscle, and tendons have a swift and fluent rhythm that can subtly unite the complex concavities and convexities of the right arm and chest; and the elegant turn of the entire body announces the sinuosity that Ingres was quickly to develop in his early portraits and ideal nudes. The very disposition of the figure against the background speaks, too, of Ingres's acute awareness of supple linear arabesques in the shallowest of spaces, for the posture compresses both frontal and profile views against a plane of continuous flatness. Most remarkably, the strong, clear studio light, which in the work of David usually produces a sense of fully three-dimensional figures in a stage space, is here manipulated to unexpectedly two-dimensional ends. Thus, the strong shadow at the right flattens the model's body to the point at which it merges with the background, whereas the brilliant illumination at the left creates a contour so sharp and crisp that it becomes almost a bright silhouette against the dark ground. For all its corporeality, then, the nude takes on the quality of a cameo relief restricted to a narrow space whose limits, defined by the strongly modeled hands and the lower part of the supporting staff, hardly seem adequate to contain the figure's bulk.

If this tense interplay between sculptural mass and linear surface pattern states a formal theme that Ingres would masterfully elaborate throughout his long career, the colors too are prophetic. The warmth of ruddy flesh is tempered in favor of pervasively cool, mercurial tones of silvery gray that lend the figure the kind of remote and icy sensuality soon to be explored in the great bathers and odalisques.

Figure 72. Mathieu Cochereau. INTERIOR OF DAVID'S STUDIO. Salon of 1814. *The Louvre, Paris*

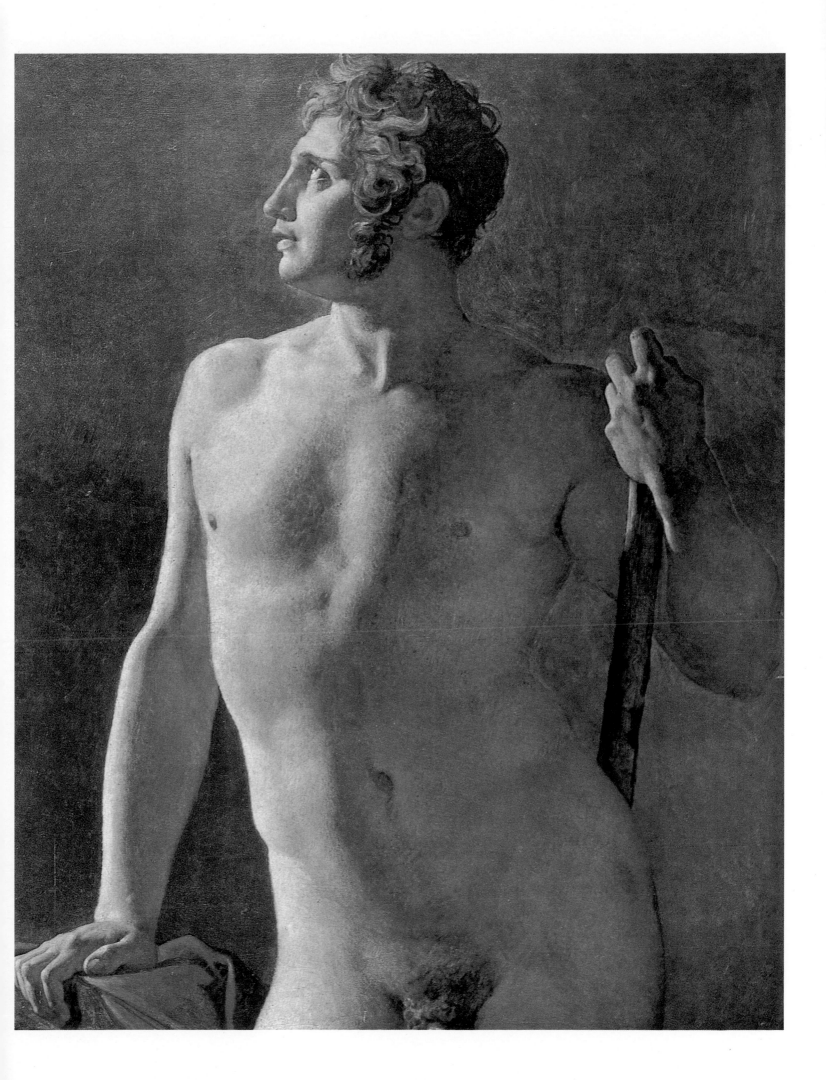

THE AMBASSADORS OF AGAMEMNON IN THE TENT OF ACHILLES

Signed and dated 1801

Oil on canvas, 43¹/₄ × 61'

École des Beaux-Arts, Paris

The ambition of every student in David's atelier was to win the first Grand Prix de Rome, which would permit him to continue his training at the French Academy in Rome, and to study there those antiquities known in Paris mainly through replicas and engravings. On September 29, 1801, Ingres achieved this honor with a painting illustrating the classical subject chosen by the Academy for that year's competition: the ambassadors of Agamemnon attempting to persuade Achilles to return to battle. As interpreted by Ingres, this scene from the *Iliad* provides a sharp contrast between the themes of peace and war, a dramatic opposition that splits the picture into two equal parts. On the left is the great warrior Achilles, temporarily withdrawn from battle and accompanied by his friend Patroclus; behind him, within the appropriately simple post-and-lintel structure, is a maiden who, if Ingres combined two separate episodes in the *Iliad*, may perhaps be identified as Briseis. Lyre in hand, his weapons cast aside, Achilles has been cultivating the arts of music and poetry by singing of the heroes' great deeds. On the right, this peaceful world is brusquely intruded upon by Agamemnon's deputies, led by Ulysses, who come to urge

him to take up once again the sword and shield just visible at the left. And in the far middle distance, as a narrative and visual transition between these two worlds, a group of Greek soldiers is seen relaxing from the ardors of battle by indulging in the pleasures of indolence or in such games as discus throwing.

Student works by great artists are always fascinating insofar as they reflect the styles of both the older master and the youthful prodigy. Thus, Ingres's painting, geared to satisfy authority, generally conforms to Davidian patterns of composition in which figures of statuary clarity and stillness are disposed within a shallow, stagelike space. Moreover, several of the figures offer learned allusions to classical statues, which would attest to the student's absorption of these paragons of ideal beauty. Thus, the figure of Ulysses is based upon the antique statue of the Athenian general Phocion (fig. 73), and the figure of Patroclus restates another classical marble, that of Ganymede. But, as in the case of his master, David, Ingres's classical quotations are constantly invigorated by a close knowledge of living anatomy. His Patroclus reflects not only the antique, but a comparable pose struck by a model studied by the artist (fig. 74); and his group of ambassadors betrays a number of intensely realistic observations that include sunburned hands and forearms, tendons, and muscles slackening with advanced age.

Within this student territory, however, Ingres's own sensibility can be strongly savored, already an exquisite variation on a Davidian theme. Extending further the more lithe and mannered figure style David had explored in the nude warriors of the *Sabines* (fig. 13), Ingres reveals a preference for proportions of attenuated sleekness and for contours of taut and supple precision. His feet and hands coiled like a fine spring, the long-legged Achilles is alert in confrontation; even the high-waisted maiden shares this tense fluidity. More relaxed, the figure of Patroclus contributes

RIGHT
Figure 73. PHOCION.
Roman copy of a
5th-century B.C. Greek statue.
Vatican Museum, Rome

FAR RIGHT
Figure 74. Ingres.
MALE NUDE. C. 1801.
Oil on canvas, 30¾ × 21⅝".
Musée Ingres, Montauban

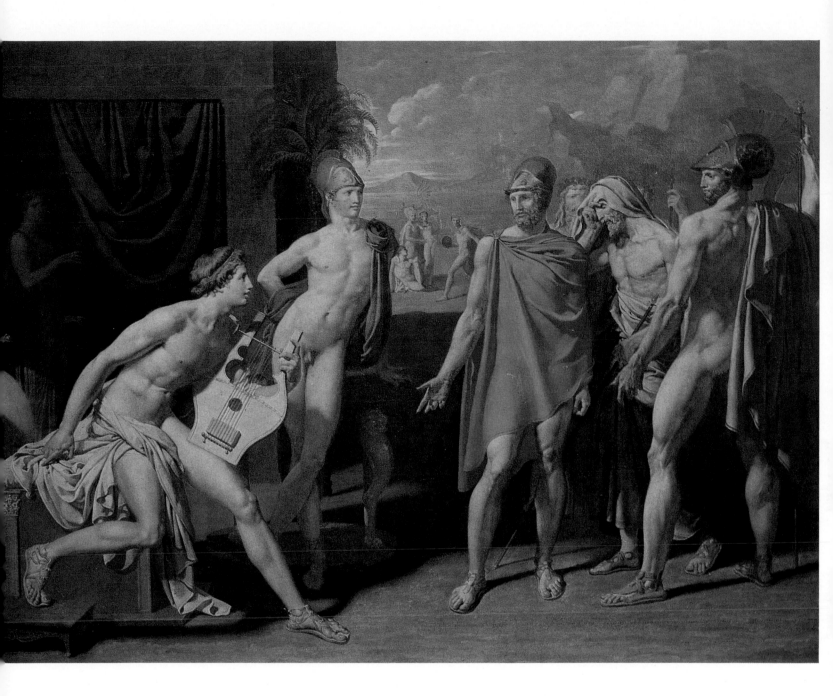

equally to this sinuous figural canon, reviving as it does the elongated proportions of Praxitilean sculpture, in contrast to the more robust anatomies of the warriors at the right. Ingres's attraction to decorative embellishment is also apparent here. The draperies that spill across Achilles' thigh or that wind more slowly around Patroclus' torso announce the linear intricacies of the shawls so prominent in Ingres's early portraits; and such complex rhythms are even borne out by the pairing of the spray of palm fronds above Patroclus' head with the crest of red plumes on the helmet at the right. The colors, too, reveal the latent preciosity of Ingres's style. Primary hues are generally replaced by elegant pastel tones of grayish blue, cherry red, mustard yellow; and the blue Mediterranean vista beyond has a cool and silvery cast.

Above all, Ingres's personal style is reflected in the extraordinary contraction of the space, which flattens near and far into a continuous surface arabesque. Thus, the ground plane rises so swiftly and steeply that the foreground figures become almost weightless and the diminutive group of distant soldiers, together with the curving prow of the boat, appear most startlingly to belong to the intricate network of connecting rhythms close to the picture plane. Even the remote mountains above, echoing as they do the rising and falling contours of the figure group below, flatten the upper right-hand corner rather than extending its illusory depth.

Such a penchant for compressing figure compositions into structures that approached the two-dimensionality of Greek bas-reliefs and vase painting was nourished not only by Ingres's youthful enthusiasm for these arts, but also by his attraction to the Homeric outline illustrations of the English artist John Flaxman, whose work was so often to inspire him. Small wonder, then, that when Flaxman visited Paris in 1802, he claimed that he saw nothing there so beautiful as Ingres's *Ambassadors of Agamemnon*.

COLORPLATE 3

BONAPARTE AS FIRST CONSUL

Signed and dated An XII (1804)

Oil on canvas, 89 × 56³/₄'

Musée des Beaux-Arts, Liège

Napoleon's rise to power was accompanied by a tremendous artistic production that glorified his personage, his conquests, and his acts of benevolence in paintings and sculptures that ranged from the documentary reportage of Gros's battle scenes to the remote classical idealization of Canova's marble portraits.

Ingres's first portrait of Napoleon was commissioned on July 17, 1803, with characteristically propagandist intention. It was destined for the city of Liège, and was to commemorate an act of Napoleonic charity in which the First Consul offered a subvention of 300,000 francs for the reconstruction of the Liège suburb of Amercoeur, largely destroyed in 1794 by Austrian bombardments. Despite the abundance of public images he required, the feverishly active Napoleon had little time to pose. For this portrait, Ingres was granted less than a single posing session at the Palais de St. Cloud, and was obliged to share his hurried view of the new leader of France with the aged Greuze, who had also received a Napoleonic portrait commission, one that produced an unforgettably feeble result (fig. 75). By contrast, Ingres's painting, completed in An XII (that is, 1804, the twelfth year of the French Revolutionary calendar), is saturated with the strange and fresh intensity of a youthful experiment.

Appropriate to a painting executed for a Flemish city, Ingres's portrait seems to revive a curious archaism of style associated with the Flemish primitives, whose once-scorned art began to attract the admiring attention of many early nineteenth-century European artists and collectors who despised the virtuoso sketchiness and fluency of the Baroque pictorial tradition. Ingres's intense realism is, in fact, of a kind unfamiliar to art after the fifteenth century, though it can already be sensed in the work of his master, David. Here our eyes are constantly arrested by surface descriptions so meticulous that objects seem juxtaposed rather than fused. Thus, if we first feel compelled to examine the dazzling gilded red velvet of Napoleon's consular uniform, we soon realize that other textural passages are no less fascinating—the crisp white paper on which the decree of reconstruction is inscribed (*Faub[ourg] d'Amercoeur rebâti*); the pair of quill pens on the table; the sheen of silk stockings with their enumeration of the tiniest of wrinkles; the profusion of golden fringe, whose strands, we feel, could be counted; the sparkle of diamonds in the sword handle; the subtle con-

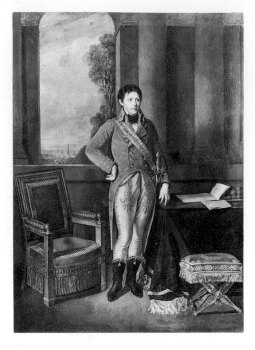

Figure 75. Jean-Baptiste Greuze.
NAPOLEON BONAPARTE AS FIRST CONSUL. Begun in 1804, completed after the artist's death in 1905.
Musée National, Versailles

trast between the velvet of the tablecloth and that of the chair; the flat, geometric pattern woven into the rug.

Consonant with this revival of an almost Eyckian realism, the painting's composition also smacks of an archaic style. Napoleon's characteristic official posture—a dignified frontal stance with hand concealed in jacket—is described here with a curious stiffness completely foreign to the gasps of full-blooded Baroque breath with which artists like David, Gros, Lefèvre managed to invigorate their own Napoleonic portraits. For, despite the painting's being well over seven feet high, Ingres's incredibly close-eyed observation of every last ripple and fold in the figure's contours reduces the scale to something magically small and doll-like. Even the space construction contributes to this: the floor plane tilts up at so steep an angle that, again as in the work of many Flemish primitives, the objects seem to hover weightlessly near the picture's surface. Indeed, the hyperrealism and archaic perspective of much Northern fifteenth-century painting were to become essential stimuli to Ingres's art.

Surprisingly contradictory in style is the window view disclosed by the parted green curtains. Here, the object of Napoleon's charity—the newly reconstructed suburb of Amercoeur with the Gothic spires of St. Lambert—is glimpsed in a suffused, pearly light quite unlike that of the foreground. Its cool, muted colors and intrinsic sense of geometric order presage not only Ingres's own Roman landscapes of this decade, but even those of Corot in the 1820's. Already here, in 1804, the polarity between Northern and Mediterranean pictorial styles can be seen in Ingres's work.

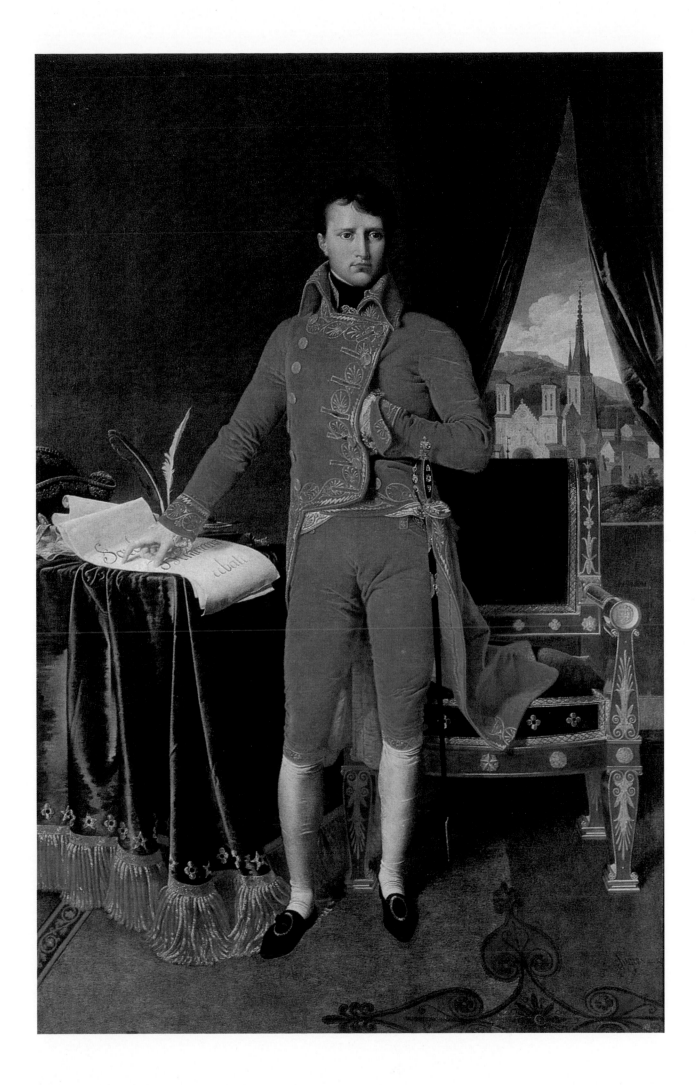

M. PHILIBERT RIVIÈRE

Signed and dated An XIII (1805)

Oil on canvas, 45⅝ × 35'. The Louvre, Paris

In 1805, M. Rivière, a court official under the Empire, wisely chose to have himself, his wife (née Marie-Françoise Beauregard), and his daughter commemorated in three portraits by the young Ingres, and was thus responsible for a group of masterpieces that in themselves could establish the greatness of the twenty-five-year-old artist. The portrait of the master of this wealthy family, which resided outside Paris at St. Germain-en-Laye, presented new problems to Ingres, for with the exception of the lavish *Bonaparte as First Consul* of the preceding year (colorplate 3), his male portraits were generally sober and unpretentious studies of the artist's intimate family and friends, in which details of clothing and setting were subordinated to a close scrutiny of the sitter's face. In the case of M. Rivière, however, a more elaborate kind of portrait was demanded, in which the genteel opulence of the sitter's impeccable person and environment would have to be taken into descriptive account.

For support in the creation of such an image of comfortable, worldly elegance, Ingres expectedly turned to cues in the more aristocratic portraiture of his master, David, in particular to works like *M. Meyer* of 1795 (fig. 76). Yet, characteristically, Ingres's portrait enriches and complicates the relative directness of its Davidian source. If, at first glance, the mat gray of the wall plane, the muted pink of the table covering, and the black, beige, and white of the costume strike an austere, even ascetic tone, this seeming reserve is soon countered by a quiet profusion of exquisite details that recall, in far more discreet and domestic terms, the overtly luxurious detail of the 1804 Bonaparte portrait.

Thus, the ostensible severity of M. Rivière's immaculate clothing is subtly challenged by the occasional gleam of precious metal provided by the circular variations of silver buttons, gold fob, and gold rings; and the geometric spareness of the highly polished mahogany chair is similarly transformed by the golden borders of the cushion, the volute just visible below the back, and the golden lion's head at the right, whose counterpart in the foreground is brilliantly concealed by the sitter's calmly poised hand in order to avoid, as elsewhere, any ostentatious or monotonous duplication of effect. Even the monochrome table covering, we realize, is enriched by a gold fringe just visible below the seat of the chair.

Ingres's preoccupations with a rich surface pattern in a restricted space continue to be pursued here, though less radically than in the portrait of Mme. Rivière. The prox-imity of the back and seat of the chair to the picture's framing edges; the continuity of the wall plane, whose flatness is asserted by the signature and date on the lower left baseboard; the vertical joining of the sitter's knees—such pictorial devices locate the objects in a space whose compression is mirrored in the delicate low-relief carving on the cameo ring as well as in the circular compactness of the print after Raphael's *Madonna of the Chair*, casually dropped among the handsomely bound and gilded books on the tabletop. It was, in fact, a copy of this Renaissance masterpiece, brought back from Italy by Ingres's first teacher, Joseph Roques, that first elicited the young artist's unshakable veneration of Raphael's art. In the next decade, Raphael's *Madonna* would be included by Ingres in his *Raphael and the Fornarina* (colorplate 18), and in *Henry IV Playing with His Children* (fig. 5).

Figure 76. Jacques-Louis David. M. MEYER. 1795. *The Louvre, Paris*

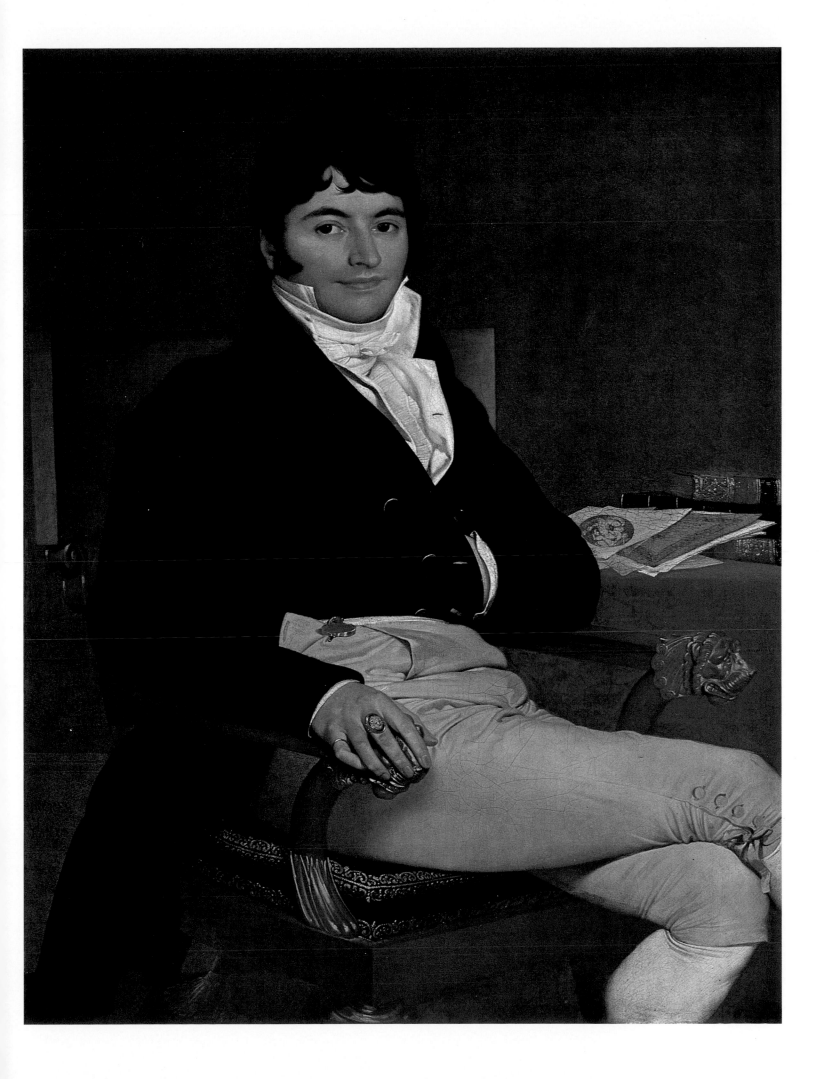

COLORPLATE 5

MME. PHILIBERT RIVIÈRE

c. 1805

Oil on canvas, oval, 45⅝ × 35½"

The Louvre, Paris

Of the abundant miracles in this portrait, it is perhaps the infinite linear invention to which one returns most often. Within the painting's broadest rhythms—the interlocking embrace of the body's sensual, upward arc in the sweeping countermovement of the Indian shawl that rises and falls almost the full height of the canvas—one discovers inexhaustible animation. Mme. Rivière's calmly poised expression, seemingly oblivious to the perpetual motion that surrounds it, is suddenly enlivened by a serpent's nest of black ringlets; and these springlike coils are, in turn, picked up by the spiraling foliate ornament on the couch frame at the lower right and then continued in the no less flat and stylized proliferation of embroidered leaf and flower patterns. Similarly, the rushing torrent of the pale ocher shawl has its quieter byways and echoes in the quivering fringe that nervously terminates its flow, or in the delicate trickles of the gauzy white dress and veil. The very hands partake of these rippling currents, so that the fingers seem to twist and curl like some invertebrate creature. Or one may look, too, at the intricate visual theme offered by the jewelry, whose linear variations on the thinnest of rings, bracelets, and necklaces all conform to the pervasive elliptical motif that extends even to the elegant oval format.

No less astoundingly, this fluttering activity seems frozen and static, a butterfly pressed under glass. Is it because the light is so cool, steady and shadowless, or is it because every detail of fold and stitch, wood and gold, wool and satin is fixed for all time with the patient, descriptive intensity of a Flemish primitive's brush? Or is it because the contours seem so perfectly predetermined in their circuitous swelling and contracting paths that they permit no change?

Critics at the Salon of 1806 were as perplexed by *Mme. Rivière* as by Ingres's other entries. To them, it looked oddly flat and white, naïvely or perversely ignorant of the luminary techniques of projecting a modeled form in space; and they complained, too, of such anatomical distortions as the extraordinarily attenuated right arm. Yet it was exactly this precocious abstraction that made the painting so compatible with early twentieth-century taste. Thus, the Cubist-oriented writer and painter, Bissière, remarked in *L'Esprit Nouveau* (IV, January, 1921, pp. 387–409) that *Mme. Rivière* prefigured Cézanne and certain Picassos in its rejection of traditional perspective devices and its affirmation of the flat picture plane. Indeed, only the *Venus Wounded by Diomedes* (fig. 12) prepares us for the insistent flatness of this work, though "flatness" hardly describes the continual, cameolike shifting of contours that expand and ebb in the shallowest of spaces. Even the couch cushions seem to be inflated in order to eliminate any spatial pockets, and also to provide a nearly comfortable padding that will accommodate the precariously hovering posture Mme. Rivière is obliged to assume in this network of surface arabesques.

The triumphs of *Mme. Rivière* were to be magnificently fertile in Ingres's future career. An ambiance of voluptuous, pampered femininity; an exquisitely cool yet sensual palette of whites, beiges, ochers, and chilly blues that congeals the blush of real flesh; a magical combination of a tour de force of quasi-photographic realism with a no less virtuoso elaboration of abstract line and surface pattern; an immaculate, brushless paint surface of enameled smoothness—such newly mastered sensibilities were to reverberate in a long succession of great female portraits.

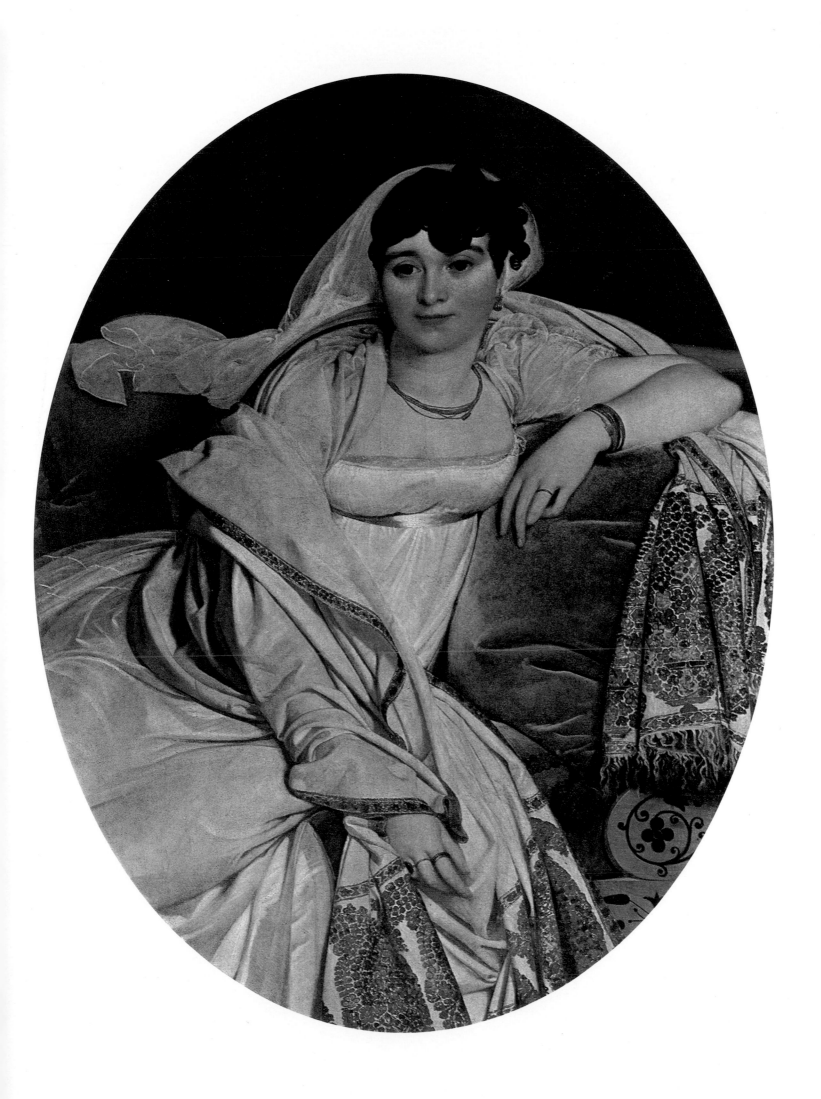

COLORPLATE 6

MLLE. RIVIÈRE

1805

Oil on canvas, 39³/₈ × 27¹/₂'

The Louvre, Paris

The third of the Rivière family portraits is that of the fifteen-year-old girl whom Ingres referred to as the "ravishing daughter." Unlike the portrait of her mother, this image of femininity seizes a quality of youthful candor just on the brink of a womanhood that Mlle. Rivière, who died that very year, was never to know. The sunlit openness of the spring landscape, the simplicity and slight stiffness of the stance, the natural ruddiness of cheeks and lips, the dazzling whiteness of the dress and swan's-down boa (which offended those 1806 Salon critics accustomed to a darker, more shadowed palette)—such elements create a purity and innocence foreign to the atmosphere of cultivated artifice and sensuality in Ingres's portraits of mature women. Appropriate to the age of the sitter, Mlle. Rivière's sensuality is nascent rather than overripe. Indeed, the chiseled clarity of the head, centered beneath the arcing upper frame, smacks of something strangely archaic. The staring, almond-shaped eyes; the fixed smile; the stylized geometries of hairline, eyebrows, earlocks—all recall an early moment in an artistic cycle, whether Egyptian, archaic Greek, or Italian *quattrocento*.

But if *Mlle. Rivière* conveys the first bloom of youth, it is nevertheless saturated with the same pictorial subtlety lavished upon the portrait of her mother. Thus, in its serpentine route, the boa echoes, in less extravagant terms, the mother's fabulous shawl; and the columnar stability of the figure is gently altered by the gradual curling of the multiple pleats that again reflect, at a youthful distance, the prodigious fluency of Mme. Rivière's dress. Such discreet embellishments are found throughout. The seams of the sleeves and boa join the laces of the gloves to form a rapid counter-current to the more ponderous rhythms, and the index fingers, just visible outside the chastely gloved hands and arms, similarly provide a minor undulation in the overall theme of slow sinuosity. Even the spray of fronds that frames the signature at the lower right contributes to this aura of quietly unfurling vitality.

The landscape background, as deliciously fresh as the adolescent subject, extends the view of Amercoeur in the Bonaparte portrait (colorplate 3) to a now breathtakingly limpid serenity. Its muted palette of pale greens and blues harmonizes perfectly with the costume's modulations of white and mustard yellow, and even combines these tones in the delicate sprinkling of blue and yellow spring flowers at the lower left. Typically, the landscape, rather than projecting into depth, rises in flattened horizontal tiers against which the figure seems crisply silhouetted as in a low relief. Thus, the swanlike neck seems to be modeled in front, but not behind; and the broad expanse of the distant river, with its unruffled, silvery reflections, almost merges with the glistening satin belt in the foreground.

Mlle. Rivière, in fact, introduces the emotional and visual dialogue between figure and landscape that Ingres was soon to explore more dramatically in his many Italian portraits. It is also a painting that he was always to remember with affection, perhaps because of the haunting charm of the tragically short-lived model. Some fifty years later, he tried to trace this portrait so that it might be included in his retrospective at the 1855 Exposition Universelle, but it was not until 1870, three years after his death, that the portraits of Mlle. Rivière and her parents were brought to light again and bequeathed to the State.

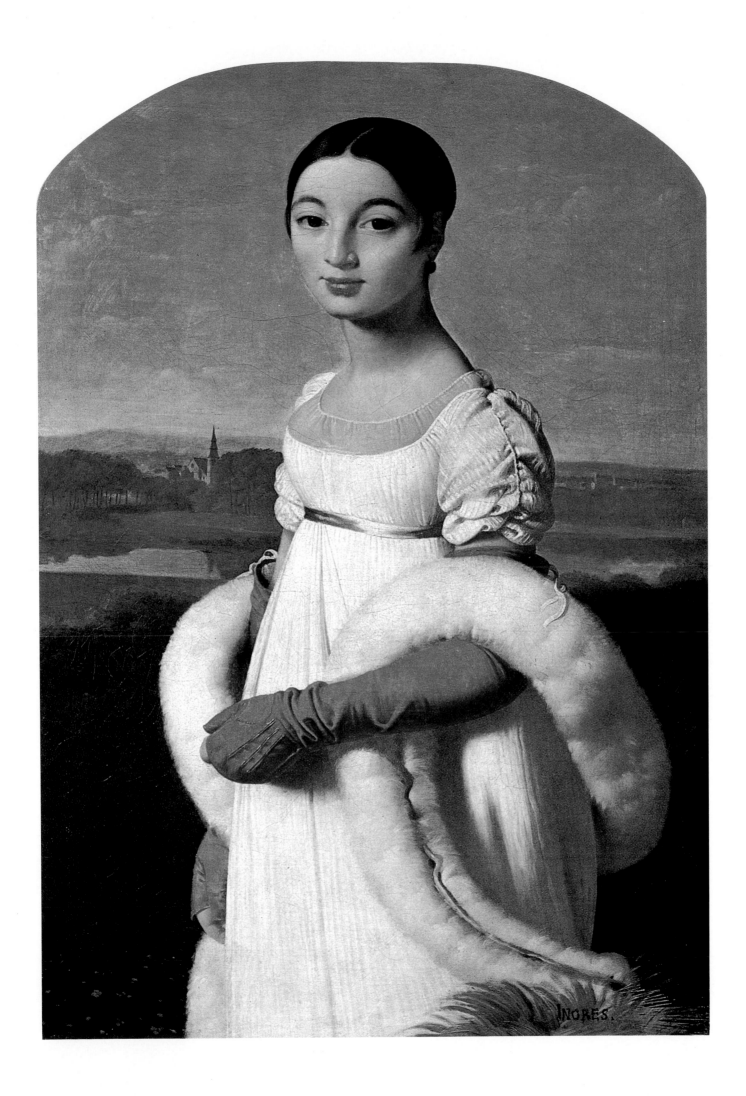

COLORPLATE 7

NAPOLEON I ON HIS
IMPERIAL THRONE

Signed and dated 1806

Oil on canvas, 104⅝ × 63"

Musée de l'Armée, Palais des Invalides, Paris

Figure 77. Jan and Hubert van Eyck. GOD THE FATHER (central panel from the top of the GHENT ALTARPIECE). Completed 1432. *St. Bavo, Ghent*

For unworldly, terrifying grandeur, no image of Napoleon, not even the marble classical giants of Canova and Bartolini, can approach Ingres's vision of the new Emperor on his throne. Executed in 1806 not as a public commission but as a personal invention, this enormous painting creates an impression of eternal, immutable authority that contrasts ironically with the breathtaking tempo of historical change, of rise and fall, at the dawn of modern French history. Separated from our earthly realm, first by a carpeted step covered with the imperial eagle and then by a velvet cushion for his feet, the Emperor seems to have reigned above us for all time on his lofty imperial throne. The rigid symmetry of his position lends him a hieratic quality associated with the divinities of classical and Christian civilization; and indeed, the trappings of Western history—the ancient Roman and Carolingian imperial eagles; the Frankish bees on the robe (revived by Napoleon as a symbol of industry); the marks of French monarchical power (the scepter of Charles V and the hand of justice of Charlemagne)—crowd this painting as though it were a museum case.

Ingres's art, too, was saturated with these multiple historical allusions, and if we feel here the presence of an implacable, almost supernatural ruler, it is because the painting combines two traditional representations of the supreme classical and Christian deities. For one, the pose restates the majestic imperturbability of Phidias' lost *Olympian Jupiter,* which Ingres was to re-create more literally in his 1811 *Jupiter and Thetis* (colorplate 13), and which Horatio Greenough, in America, was to use for his comparable idealization of a marble George Washington. And for another, it recreates the no less remote omnipotence of a great image of the Christian God, namely, Jan van Eyck's panel of *God the Father* (fig. 77) from the top of the *Ghent Altarpiece,* a panel that was exhibited at the Louvre from 1799 to 1816, after which time it was returned to its proper home.

Critics who saw this painting at the Salon of 1806 were as startled as we may still be today, and complained generally of its bizarre, retrograde character, which they felt carried art back to its medieval cradle, to a style they loosely referred to as "Gothic." For comparison, they pointed to the in-

discriminate surface realism of Van Eyck, which they claimed hid genuine knowledge of anatomy, or to the dry and stiff composition of a Gothic medallion. "Had Ingres attempted to paint Dagobert or another king of the earliest dynasty," wrote the critic of the *Mercure de France,* "he could not have chosen more Gothic ornaments or given the figure a more coldly symmetrical pose" (XXVI, 1806, p. 77). Another critic lamented the curiously hard and cold white light, which he likened to moonbeams, and hoped that Ingres's imminent journey to Rome, with a study of the portraits of Veronese, Titian, and Correggio, would soften his style and warm his colors (*Lettres Impartiales sur les Expositions de l'An 1806,* 1806, pp. 25–26). Such criticism, in fact, pinpointed the peculiar archaism of the young Ingres, who often did turn with fascination to the earliest phases of artistic cycles. Here, the revival of Flemish realism, already seen in the 1804 portrait of Bonaparte (colorplate 3), extends even to the window reflection on the ivory globe at the left and dazzles the eye in a dense array of bejeweled and gilded magenta velvet and white ermine that truly rivals Van Eyck's *God the Father* for sumptuous, heavenly splendor. And the oppressive frontality of a medieval icon contributes, too, in transforming a flesh-and-blood figure of modern history into a haunting and ageless image of unquestioned, unapproachable power.

Two decades later, under very different political conditions, Ingres once again attempted, but with less force and originality, to invest a French monarch's portrait, *Charles X in His Coronation Robes* (fig. 47), with that traditional faith in the divine right of kings which modern history had challenged and which it ultimately destroyed.

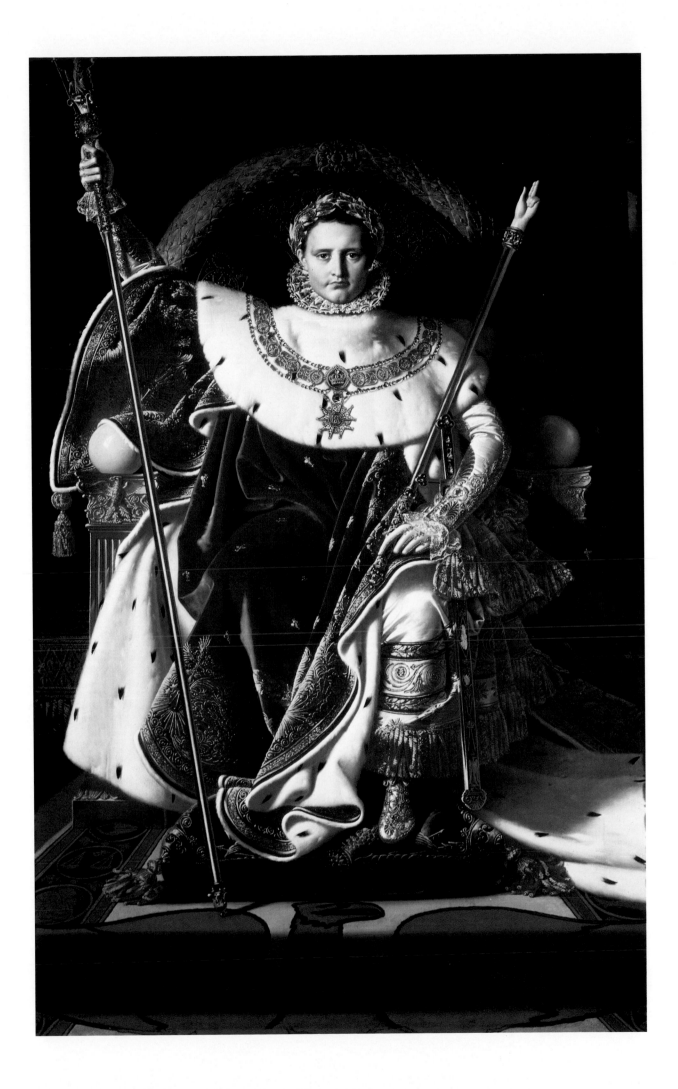

MME. ANTONIA DUVAUCEY DE NITTIS

Signed and dated 1807

Oil on canvas, 30 × 23¹/₄″

Musée Condé, Chantilly

The first known female portrait Ingres painted in Rome was that of Mme. Duvaucey, the Neapolitan mistress of Charles Alquier, a French statesman who had been sent from Naples to Rome to attempt to establish an alliance with the Pope. Like the portrait of Mme. Rivière (colorplate 5), it locates the sitter in a hermetic environment of feminine luxury that contrasts with the virile, outdoor settings Ingres often chose in Italy for his male sitters. Here, an ambiance of protective enclosure, appropriate to a beautiful young mistress, is literally afforded by the comforting inward sweep of the shawl and the stronger framing element of the curved chair back that delimits the sitter's shallow space both laterally and in depth.

Surprisingly, Mme. Duvaucey's display of adornments—the fan, the trio of partly visible rings, the embroidered, fringed silk shawl, the elegantly thin necklace and elephant-hair bracelets—can be held in temporary abeyance by the compelling clarity and directness of her frontal gaze, fixed against an austerely flat gray ground. But even here, the presumed simplicity of this almost Raphaelesque face gives way to a fabulous visual intricacy. Thus, the polished, abstract purity of the rounded head is subtly countered by such a minutely realistic observation as the single strand of hair that disturbs the immaculate geometric order of the sleek coiffure; or by the comb at the right that similarly alters this apparently simple symmetry. In fact, the head itself is placed slightly off center, a dislocation that is immediately answered by the rainbowlike arcs of the chair back that spring from the neck and absorb the elliptical rhythms of the necklace and shoulder line.

This wealth of pictorial invention is on Ingres's highest level. For instance, the intrusive sharpness of the fan's point among these caressing fluencies is concealed by a relaxed thumb and index finger, just as the most acute point of the

necklace's slowly unraveling loops is hidden beneath the curving contour of the low-cut bodice. And the gold brocade of the chair back subtly merges at the left with the decorative border of the shawl to spin out a long, meandering line whose ripples are brilliantly reiterated in the artist's very signature, which also seems to be part of the embroidery. The colors, too, contribute to this close harmony of forms. Thus, the dusty rose and gold of the velvet Louis XVI chair are inverted in the pale yellow and red of the shawl, and the quiet warmth of these hues resounds more deeply in the inky darkness of the hair and the velvet dress.

When *Mme. Duvaucey* was later exhibited at the Salon of 1833, critics complained of its dry, shadowless quality and of the defective anatomy evident in the length of the arms, the slippery juncture of head and neck, and the thin, abstract line that separates the pale pink lips. But here, as elsewhere, the insistent demands of Ingres's surface arabesques ultimately mold anatomy to their own needs. In the left arm, the protrusions of shoulder and elbow are carefully muffled and flattened by the flow of the shawl. In the right arm, however, these bold distortions are visible, so that, viewed realistically, this supple bridge between the plane of the shoulder and that of the hand becomes something strangely boneless and malleable, a prelude to the voluptuously unreal anatomies of Thetis and of the odalisques.

This portrait, for which Ingres was paid 500 francs, had a touching history. Forty years later, in 1847, the aged Mme. Duvaucey, desperately in need of money, visited the illustrious artist in Paris in the hopes of selling this memento of her prodigal youth. Finally recognizing her, Ingres considerately arranged to sell the portrait to Frédéric Reiset, whose collection was bought in 1879 by the Duc d'Aumale for his château at Chantilly, which is now the Musée Condé.

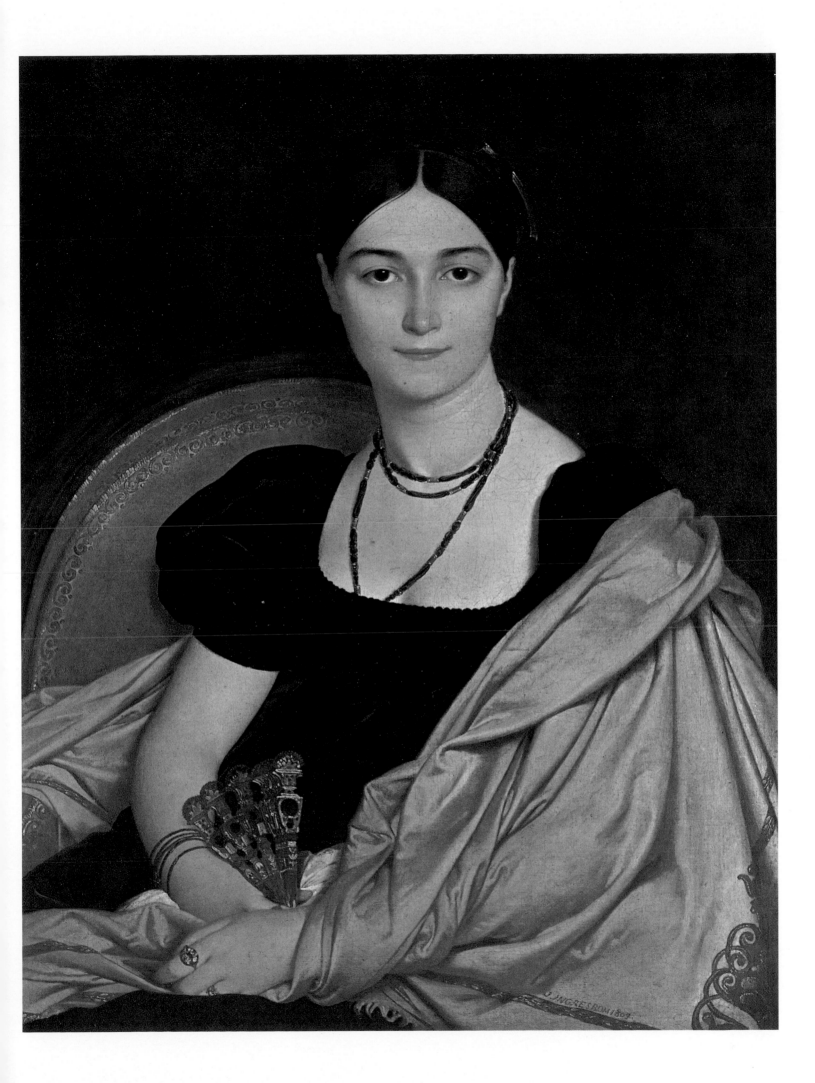

COLORPLATE 9

FRANÇOIS-MARIUS GRANET

c. 1807

Oil on canvas, 28³/₄ × 24"

Musée Granet, Aix-en-Provence

The first important male portrait Ingres painted in Rome was that of his close friend, the landscape painter Granet (1775–1849). With the appropriate exception of the portrait of another young artist, Ingres himself (fig. 1), the early portraits provide little preparation for the dramatic immediacy of this psychological confrontation. Perhaps reflecting a Romantic portrait type in which, as in Girodet's nearly contemporaneous record of Chateaubriand, the sitter broods heroically against a background of Roman ruins (fig. 78), Ingres has located Granet on the Pincio, overlooking a spectacular view of the Quirinale. The harmony of mood Ingres had achieved between figure and landscape in *Mlle. Rivière* (colorplate 6) is further explored here, but now in the more restless terms of a welling Romanticism. Thus, the gathering storm that darkens and fills the sky resounds directly in the Byronic cast of Granet's imposing stance and expression. The broad, dramatic sweep of the simple cloak, the vigorous turn of the high collar, the windswept, tousled

hair, the firm eyes and mouth, the dominating size of the half-length figure, whose handsome head, like the storm clouds, towers above the city below—such virile inventions are far removed from the cloistered elegance of Ingres's usual portrait settings.

This youthful breadth and force of feeling, however, are as tautly controlled as ever; even the swiftly spreading gray of the sky seems to be locked in a pictorial grid whose immutable order can rival Poussin's. Thus, as in the tiny landscapes Ingres painted at the same time, a deep vista is ordered by a pervasive geometric network that here extends from the clean, angular patterns of the artist's portfolio and the masonry divisions on the parapet through the cubic architectural harmonies of crisply defined wall planes, windows, arcades, and rooftops glistening under the blue-gray sky. And chromatically, too, the rich dark brown of the cloak, the intense black of the curling hair and tie, the starched whiteness of the collar and shirt, the yellow spine of the sketchbook are inseparable from their quieter tonal reverberations in the landscape.

Hardly less than in the indoor portraits, the space, for all its ostensible expansiveness, ultimately contracts into the most tightly knit surface pattern. Behind the meticulous modeling of Granet's face, as glossy and ruddy as a wax apple, the Roman panorama, like a painted backdrop, flattens into a web of thin planes as cardboardlike and papery as the sketchbook itself; and these rectilinear rhythms are, in turn, skillfully woven into the shallow space the artist occupies in front of the parapet. Thus, anticipating Cézanne, extremities of foreground and background seem to merge. For instance, the diminutive aqueduct at the left, crowned by an umbrella pine, not only marks the distant horizon but also springs forward to join the analogous horizontals of the moldings on the parapet and the line of the cloak that, interrupting the rounded sweep of collar and buttons, strictly parallels the lower framing edge.

This superb harnessing of both a compelling human presence and a magnificent landscape souvenir within the boundaries of a rigorous artistic order was often achieved more casually in the many portrait drawings Ingres executed in Italy and, on several occasions, as in the painted portraits of M. Cordier (colorplate 14) and of Count Nicolas de Gouriev, even more aristocratically.

Figure 78. Anne-Louis Girodet-Trioson.
FRANÇOIS-RENÉ DE CHATEAUBRIAND.
c. 1809. Musée d'Histoire, Saint-Malo

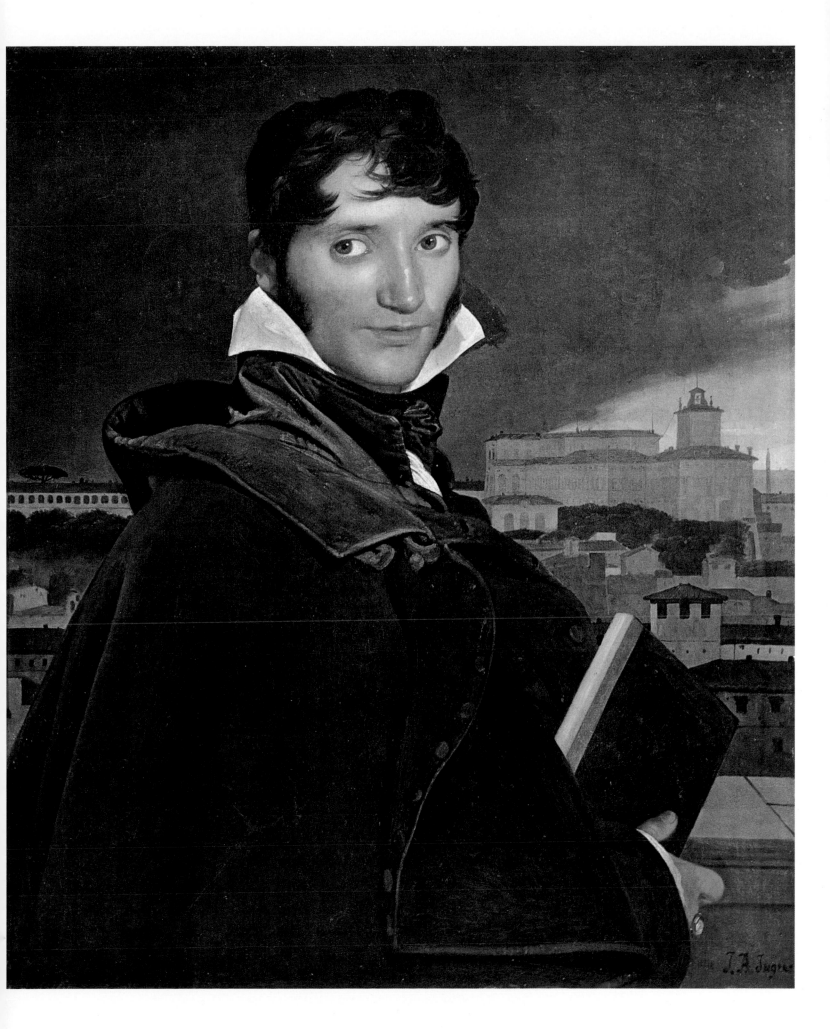

BATHER OF VALPINÇON

Signed and dated 1808

Oil on canvas, 56⁵/₈ × 38¹/₄". The Louvre, Paris

Figure 79.
Antonio Canova.
VENUS ITALICA. 1812.
Pitti Palace, Florence

Ingres's first great painting of the female nude creates a world of breathtaking stillness in which the elusive ideal of a timeless, classical perfection, which periodically haunts Western art, is miraculously reincarnated. Like the small *Bathing Woman* of 1807, the *Bather of Valpinçon* (named after the collector who bought it for 400 francs) is seen from behind, but without the equivocal sexuality of the earlier work. Instead, the nude is disclosed with a calm and measured tempo that carries us slowly downward from the exquisite turn of the head that just conceals the distant profile, through the marmoreal perfection of the arcing back and arms, to the quiet expiration of the crossed foot and leg. Perhaps inspired by one of the *Three Graces* in the Raphael School frescoes at the Farnesina, Ingres's nude nevertheless belongs more to the formal and erotic sensibilities of his own time, and, in particular, of Canova's Neoclassic marbles (fig. 79), whose tensions between extremes of coolness and sensuality, abstraction and realism have their pictorial counterparts here. Thus the flesh, for all its chilly, pumiced perfection, seems to conceal an underlying warmth and suppleness, like the metamorphosis of a Galatea; and the abstractness of the anatomy, which suppresses the angularities of joint and bone by the taut fluency of the arcing contours that define the curve of a shoulder, the length of an arm, or the juncture between thigh and waist, is similarly animated by such intensely realistic passages as the wisps of hair that cross the ear, and, above all, by the crystalline precision with which the ambient harmonies of draperies, sheets, and cloths are recorded.

This environment, as icy and elegant as the column of black-veined marble just visible at the left, accords perfectly with the paradoxical mood of frozen languor in which the luxurious indolence of the bath is pinpointed for all time in a tense pictorial order. Thus, the slow, sensual fall of the metallic green draperies at the left is echoed in the back plane by the gradual swell of the white curtain that, after crossing the astonishing variations of creamy white linen, merges in the foreground with the vertical folds of the sheets. Within the broad structural flow of these immaculate fabrics, smaller tributaries can be traced. The winding rhythms of the rose-striped turban are picked up in the bunching of cloth that softens the angle of the left elbow, and these, in turn, uncurl around the legs, like the draperies of a classical Venus. And, finally, in a brilliant conceit, the tiny jet of water from the lion's-head spout in the pool—the unique sound in an uncannily soundless ambiance—initiates another liquid current which fuses the contours of the white sheet and the embroidered drapery edge in a rippling surface pattern elaborated in the minute arabesque of the sandal's unknotted lace.

For all these restless undercurrents, the ultimate effect of the *Bather of Valpinçon* is of a magical suspension of time and movement—even of the laws of gravity. As in the female portraits, the figure seems to float weightlessly upon the enamel smoothness of the surface, exerting only the most delicate pressures, and the gravitational expectations of the heaviest earthbound forms are surprisingly controverted. Thus, the only visible leg of the couch that supports the bather rests on a tiny point as weightless as the analogous embroidery patterns above it, and the architectural mass of the marble column at the left is not only concealed by the drapery, but almost entirely vitiated by the flattening effect of Ingres's signature on its partly visible base. And even the uppermost points from which the draperies must be suspended are left unexplained, so that no gravity-bound post-and-lintel framework can disrupt the sensuous expanse of flesh and cloth across the entirety of the picture surface.

Ingres must have realized that with this nude he had achieved a kind of immutable perfection, for just as he might copy, with variations, the eternal harmonies invented by Raphael, so too was he to re-create his own *Bather of Valpinçon* in a series of more elaborate bathing compositions that culminated with *The Turkish Bath* (colorplate 40). And, not surprisingly, further homage was paid to this painting by Ingres's own students, like Armand Cambon, whose *Galel* of 1864 (fig. 62) respectfully paraphrases the lesson of the master.

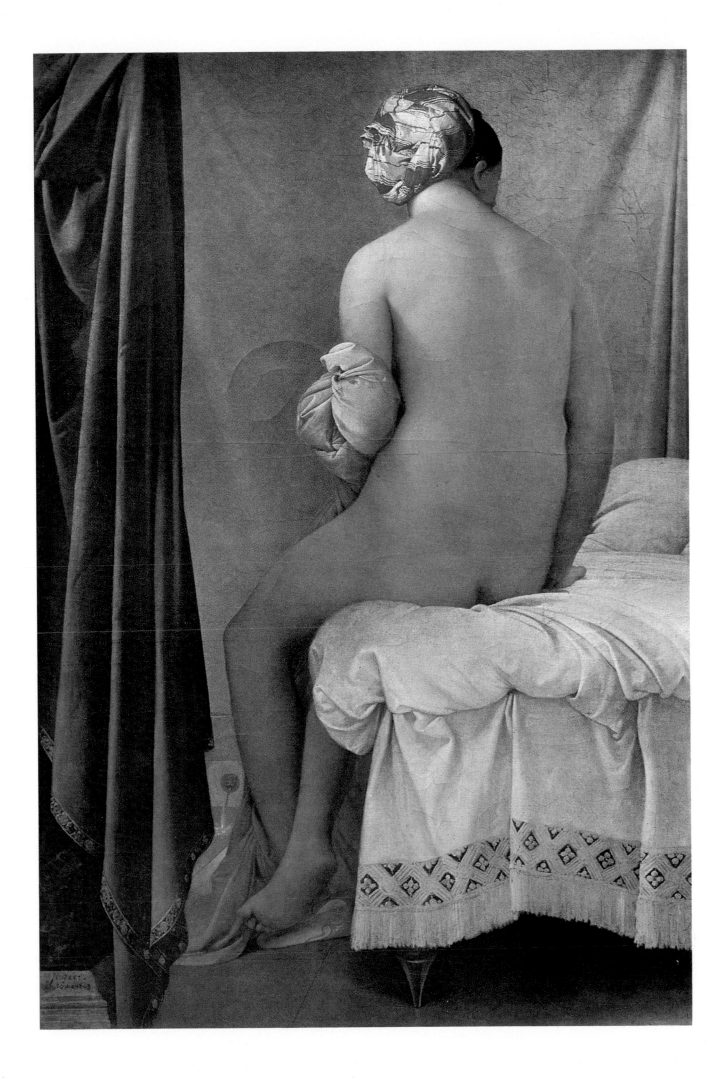

Figure 80. Gustave Moreau. OEDIPUS AND THE SPHINX.
1864. *The Metropolitan Museum of Art, New York.
Bequest of William H. Herriman, 1921*

OEDIPUS AND THE SPHINX

Signed and dated 1808; reworked c. 1827

Oil on canvas, $74^3/_8 \times 56^5/_8$". The Louvre, Paris

These horrifying details, however, are counterbalanced by the magnificent composure of the young hero, whose radiant wisdom and noble body assert the power of reason and beauty over unreason and ugliness. The penetrating intelligence of his Greek head, whose superbly idealized profile recalls that of Ingres's academic *Male Torso* (colorplate I), calmly but firmly confronts the monster. His athletic body takes a position that suggests, in the tautened muscles of the legs, a virile strength and determination, and, at the same time, a noble ease that can even permit the right hand to free its protective grip upon the pair of javelins. Indeed, the entire figure, reminiscent of a common classical prototype that Poussin himself had re-created in his *Shepherds in Arcadia*, conforms to a harmonious geometry. The triangular and perpendicular patterns of limbs, torso, and javelins are almost sufficient in themselves to conquer the irrational visual environment of craggy mountain passes, broken boulders, and the hideous anatomy of the sphinx.

The French Academy, which sent this painting to Paris on October 8, 1808, had reservations about its flat and shadowless quality, and when Ingres prepared the picture for exhibition at the Salon of 1827, he made several changes. Perhaps in partial conformity to the more dramatic style and subject conspicuous in French Romantic painting of the 1820's, Ingres widened the canvas to include both the landscape vista at the right and a more elaborate description of the sphinx at the left, and he may also have darkened the shadows and warmed the colors. Yet, despite the murkiness of the sphinx's lair, the distinctive surface arabesques of Ingres's early style are still apparent in such passages as the slow unraveling of Oedipus' cloak around the compressed profile of his body; the more rugged contours of the rocky crevice flatly silhouetted against a deep blue sky; or the abrupt jump in space that, as in many Mannerist paintings, locates Oedipus' diminutive companion in both foreground and background.

As was often the case with the inventions of his youth, Ingres repeated this painting, with variations, until the end of his life. The subject, rare in postclassical art until Ingres, also continued to fascinate nineteenth-century artists who, from Gustave Moreau (fig. 80) to lesser masters of the *fin-de-siècle*, found in this confrontation of horror and beauty an opportunity to dwell upon those morbid elements which Ingres, with classical rigor, had held in abeyance.

For Ingres, the Greek legend of Oedipus solving the enigma posed by the sphinx, who ravaged the Theban countryside, offered an opportunity to demonstrate the triumph of the highest human intelligence and nobility over a monstrous adversary. Conforming to the growing Romantic taste for the grotesque and the sublime that, in France, was to reach its climax in the works of Géricault and Delacroix, the painting offers a multitude of terrifying elements. Thus, access to the sphinx's lair is achieved through a precipitous gorge whose terrors are accentuated by Oedipus' companion, who shrinks back, his draperies swept by the wind, in a rhetorical, Poussinesque gesture of fear. At the upper left, within the mysteriously darkened grotto, the sphinx herself presides —part eagle, part lion, part human. And below, half concealed in her rocky domain, the spine-chilling evidence of her long reign of savagery can be seen—the crumbling bones of an old victim's skeleton and the cadaverous green flesh of a new victim's foot.

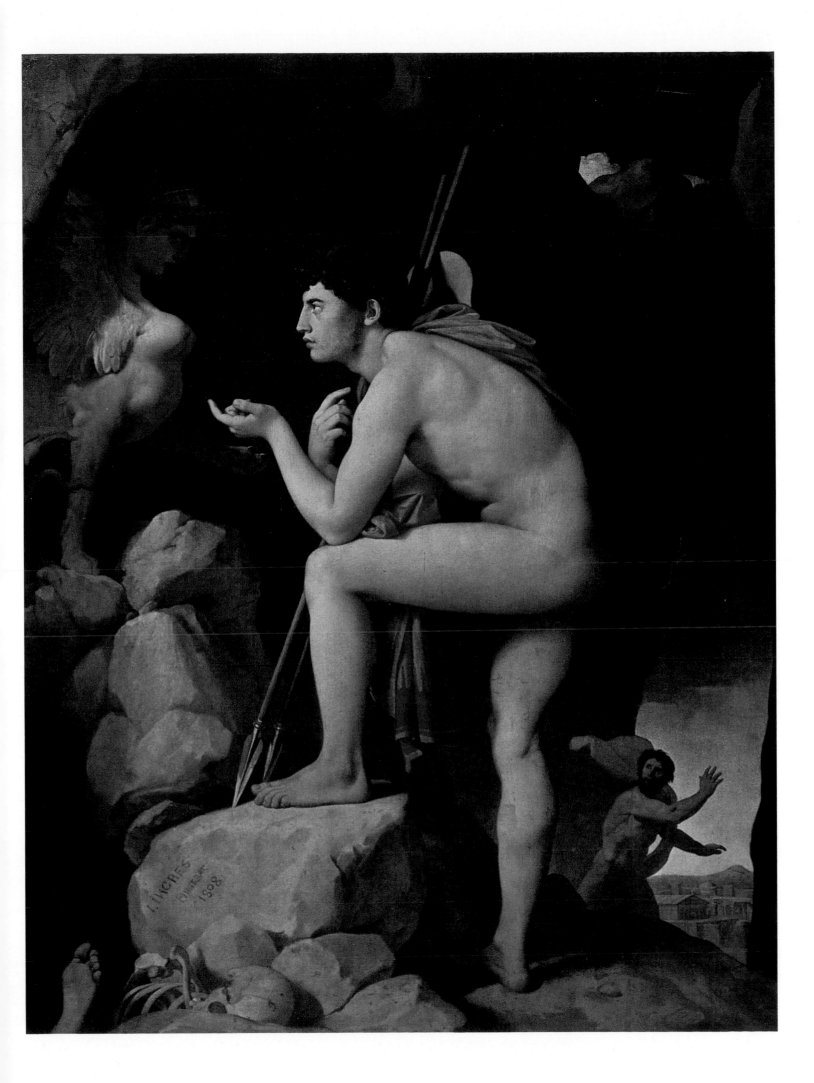

COLORPLATE 12

M. MARCOTTE

Signed and dated 1810

Oil on canvas, 36³/₄ × 27¹/₄"

The National Gallery of Art, Washington, D.C.
Samuel H. Kress Collection

Wishing to have his portrait painted, the twenty-three-year-old Director of Waters and Forests in Napoleonic Rome, Charles-Marie-Jean-Baptiste-François Marcotte d'Argenteuil (1787–1864), was wisely advised by a Prix de Rome medalist, Édouard Gatteaux, to choose the young Ingres. The result was this pervasively dour portrait, in which the sternness of the sitter's head, tensely fixed in a high and restrictive collar, is matched by the severity of his clothing, whose dry, leathery textures seem as rigid as the firm gaze and tightly pursed lips. Even the hand participates in this tautness; paralleling the clawlike cluster of the gold tassel that protrudes from the black cocked hat on the table, its seemingly relaxed fingers become no less stiff and immobile.

Yet this veneer of chilly, almost Spanish solemnity conceals a vibrant pictorial richness. Thus, the coolness of the gray ground, of the starchy white collar and cuff, and of the black tie and hat creates a foil to the glowing resonance of dark browns, blues, and reds that are further animated by the small Legion of Honor rosette on the lapel and the pale yellow of the vest. And the light-absorbent textures of the clothing are given a comparable warmth by the discreet golden glimmer of the fob, the ring, and the tassel in the foreground. The linear patterns, too, slowly disclose an unexpected complication in rhythms which, appropriate to the rigorous mood, are often more angular than curved. The M-shaped contour between the left lapels, the straight lines of seams, buttonholes, and drapery folds all act as subtle checks to the looser sweep of the cloak and the somewhat unruly hair. The tensions between surface and depth, so familiar in Ingres's work, are also surprisingly intricate here, as in the complex shuffling of the thin, multilayered planes of the lapels, collars, and tie. Moreover, the flat signature at the lower right counters the effect of the shadow cast by the hat above it; and, as in a portrait by Holbein, even the sculptural density of the sharply incised head can barely penetrate the shadowless expanse of gray behind it.

Like Gatteaux, who introduced him to Ingres, M. Marcotte d'Argenteuil was to remain one of the artist's most loyal friends and patrons, responsible not only for commissioning other portraits of himself and of his family, but such subject paintings as *Pope Pius VII in the Sistine Chapel* and *Odalisque with Slave* (colorplates 19, 30).

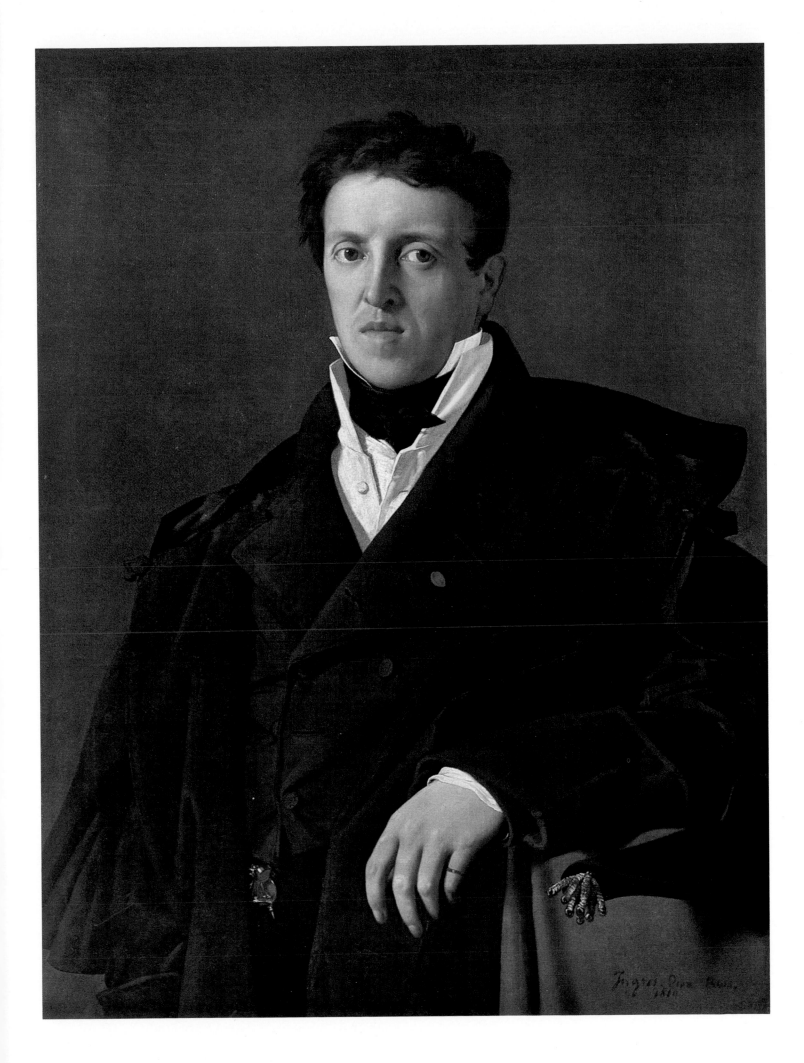

COLORPLATE 13

JUPITER AND THETIS

Signed and dated 1811

Oil on canvas, 136⅝ × 101¼"

Musée Granet, Aix-en-Provence

The two most extravagant extremes of Ingres's youthful imagination—the terrifying grandeur of a supreme male deity and the seductive power of the female nude—are combined in this re-creation of that scene from the *Iliad* in which Thetis pleads with Jupiter for divine aid to her son Achilles, fighting in the earthbound wars below. Like the enthroned Napoleon of 1806 (colorplate 7), Ingres's Jupiter is an omnipotent deity, who here reigns in remote and majestic symmetry from his cloud-borne, Olympian realm. By contrast, the nymph Thetis, viewed in profile against the god's awesome frontality, is a creature of prodigal fluidity appropriate to her watery origins. In the despair of her supplication she slithers like an eel around the immobile giant, her limbs extending toward him with the delicate pressures of an erotic caress. Her left arm, of invertebrate malleability, rises upward with five vermicular fingers that dare to tweak the bearded chin of Jupiter's ferociously leonine head; her right breast and arm establish an equally provocative contact with his broad and godly lap; and her right leg presses so far forward in entreaty that, beneath the cascades of drapery, as if surreptitiously, her large toe just touches that

of Jupiter. In this sensual beseeching of Olympian favor, Thetis' head plays an unforgettable role. Staring upward in humble, wide-eyed servitude, it is no less supple than her attenuated limbs and torso or the fish upon her diadem. The Greek profile molds nose and forehead to a continuity as fluent as the line of her hair and necklace; and the neck swells erotically, like that of an animal in courtship. Small wonder that Jupiter's wife, Juno, dimly visible at the upper left, gazes at Thetis no less sternly than does his torch-bearing eagle.

In keeping with its Homeric subject, this huge and ambitious painting is steeped in an erudite study of both classic and Neoclassic art. From antiquity, Ingres probably used Greek vases, reconstructions of Phidias' *Olympian Jupiter*, a cameo representing the battles of gods and giants (on the throne); and from his Neoclassic contemporaries, illustrations of this scene in Flaxman's outline engravings to Homer (fig. 81) as well as, possibly, a lost drawing of the same subject by his friend, the sculptor Bartolini. Such abundant borrowings, however, are thoroughly transmuted by Ingres's own genius. Thus, the schematic outlines of archaeological engravings are brought to sensuous life by the meticulously recorded textures of flesh, hair, cloth, marble, feather, cloud; and these, in turn, are woven into a dense surface pattern as luxurious as in the portraits. Even Jupiter's enormous bulk seems to hover on the picture plane, the air-borne clouds supporting his throne as easily as his relaxed left arm; and Thetis herself merges with the widening proliferation of draperies that, concealing the legs and throne, create a sumptuous pyramid of palpable flesh and fabric in a relief space whose shallowness echoes the cameo-like carvings in the foreground.

Ingres highly esteemed this painting, which he kept in his studio until 1834, when it was purchased by the State, and which he was later, in 1848, to copy in a drawing. Indeed, *Jupiter and Thetis* offers a unique fusion of the two great themes, voluptuous and austere, that would continue to inspire his art—the molding of the female nude into a rarefied creature of exclusively erotic use, and the high-minded re-creation of the immutable and authoritative grandeur of classical art and literature.

Figure 81. John Flaxman. JUPITER AND THETIS.
Illustration for *The Iliad of Homer*, engraved by
Thomas Piroli from the compositions of John Flaxman.
First edition, Rome, 1793

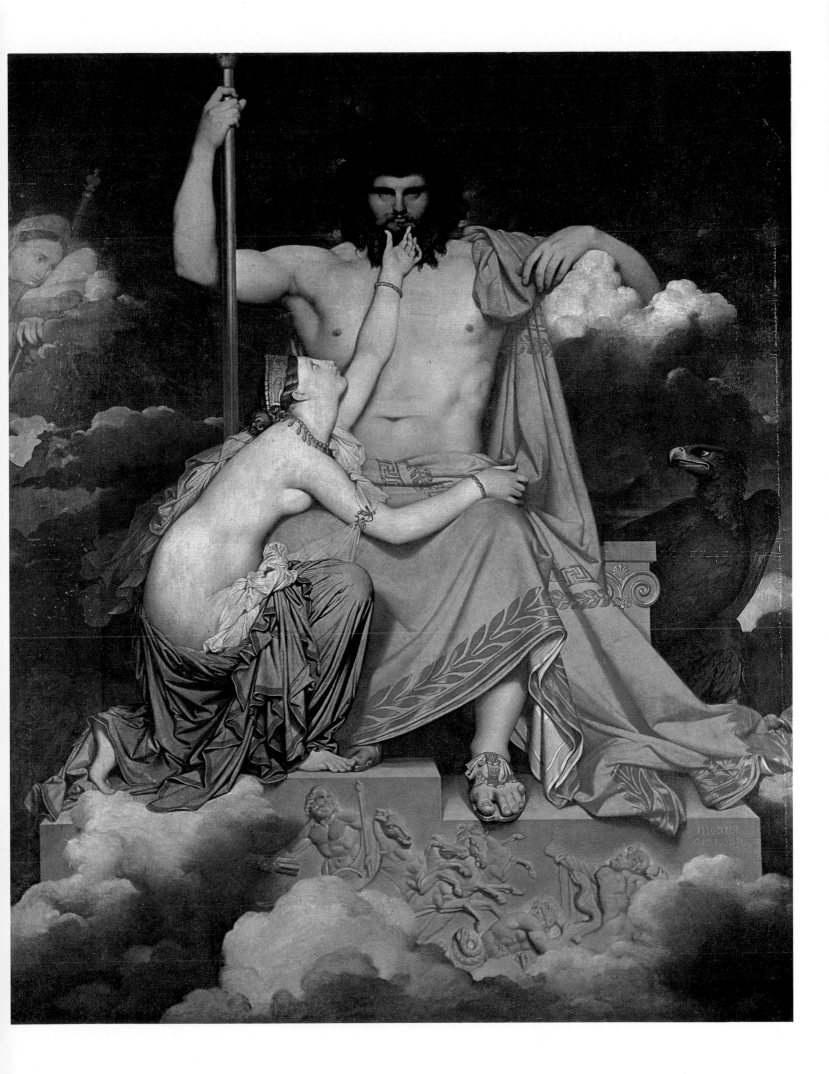

M. CHARLES-JOSEPH-LAURENT CORDIER

Signed and dated 1811

Oil on canvas, $35^1/_2 \times 27^1/_2''$

The Louvre, Paris

Although this portrait of M. Cordier against a stormy sky at Tivoli recalls the spectacular weather conditions of Ingres's 1807 portrait of Granet (colorplate 9), the psychological rapport between sitter and setting is of a different order here. Rather than sharing the vibrant drama of nature, M. Cordier, like many British aristocratic sitters at the turn of the century, remains coolly impervious to the landscape background. Indeed, his impeccable attire, his decorous composure, his elegant bearing (one hand in a pocket, the other casually holding a hat) would be more appropriate to the security of a wealthy drawing room than to the menace of a summer storm. This subtle disjunction between figure

and background tends to corroborate the recollection of M. Cordier's daughter, the Comtesse Mortier, that Ingres's friend, Granet, who painted many views of Rome (fig. 82), assisted him in the painting of the Tivoli landscape. Moreover, the brushwork of the diminutive Temple of the Sibyl and adjacent buildings is somewhat broader and patchier than is usual for Ingres.

Nevertheless, in pictorial more than in emotive terms, it is difficult to extract M. Cordier from the ominous setting. The deep gray intensity of the threatening sky merges closely with the blue-blackness of the suit and finds a chromatic echo in the cool blue-gray of the eyes; and even the distant architecture is closely fused with the foreground in the form of the gray rock upon which M. Cordier rests his right arm, or in the bit of stone just visible in the small aperture created by the bend of the left elbow.

The somber blues, grays, and blacks that saturate both figure and landscape are, as usual in Ingres, vivified by contrasting touches, in this case the starchy whiteness of collar and cuff, the gold sheen of the elaborate fob and simple buttons, and the single accent of red in the Legion of Honor ribbon that warms the already ruddy flesh of the face and hand. Similarly, the figure's darkened silhouette is animated by long, undulant rhythms that begin at the black curls and sideburns, then join the sinuous complexity of three layers of curving collars, and are finally dispersed in two directions—that of the pocket and that of the hat's rounded brim—by the subtly shifting planes of the paired buttons and the fob. And even in psychological terms, this circuitous complexity is reflected. For all the ostensible directness and frontality of M. Cordier's aristocratic head, his masklike reserve and slightly wall-eyed gaze keep eluding us and, as in the Mannerist portraits of Bronzino (fig. 49), permit us to penetrate no further than the richness of exterior artifice.

Figure 82. François-Marius Granet. OGNISSANTI, ROME. c. 1807. *Musée Granet, Aix-en-Provence*

JACQUES MARQUET, BARON DE MONTBRETON DE NORVINS

c. 1811

Oil on canvas, remounted on panel, 38¹/₄ × 31'

The National Gallery, London

Like the portrait of another French official working in Napoleonic Rome, *M. Marcotte* (colorplate 12), that of the Baron de Norvins (1769–1854) conveys a mood of caution and restraint. In this case, the portrait psychology is of singular relevance, for the Baron was Director of the Police in Rome between 1810 and 1814, during which time he sat for Ingres. The Baron was also a historian, whose most famous work was to be a four-volume *Histoire de Napoléon* (1827–28), and whose writings were to earn him a membership in the French Academy.

With a gift that, at times, could almost verge on caricature, Ingres has seized the Director of Police in what would appear to be a typical pose. The face seems strained and alert, the eyes sharp and inquisitive, the mouth tight and humorless, and the stance rigid and withdrawn. Indeed, the right arm, presumably resting on the chair, seems considerably stiffer than the curtain-covered chair arm itself; and the left arm, in Napoleonic fashion, is protectively concealed within the jacket. The vertical edge of the curtain that joins the line of the right arm, and the cubic statue base that would prevent the left elbow from moving too freely, similarly underline the sense of restriction. So, too, does the continuity of the damask floral pattern of the wall in the chair fabric, a device that compresses still further the narrow confines of the sitter's space.

By contrast with the tightly enclosed figure, the setting has a surprising warmth. That in 1868 the worn condition of the canvas necessitated the addition of a panel backing for security may, in part, explain the softer, less glossy quality of the paint surface, but the chromatic harmonies are nevertheless of an almost Venetian cast. Thus, against the stark black suit and crisp white collar and cuffs, the curtain, the wall plane, the chair covering, and the Legion of Honor ribbon are saturated in a deep wine-red that becomes all the more vibrant in the context of the bilious green of the antique bronze (which, despite the inscription, is not an image of Rome, but of the goddess of wisdom, Minerva). Together with the ornamental complications of the wall pattern (introduced here for the first time in Ingres's portraiture), the frontal stare of this bust sets up strong secondary points of pictorial interest that vie for attention with the sitter himself.

Appropriately, this portrait was later owned by another great nineteenth-century painter whose portraiture created comparable tensions between an aloof sitter and his inanimate surroundings—Edgar Degas.

In 1811, all of Rome expected Napoleon to arrive in the following year. Because of the disastrous Russian campaigns he never, in fact, got there, but elaborate preparations had nevertheless been made for a triumphal sojourn in the Eternal City. For one, the Emperor was to replace the Pope in the Palazzo del Quirinale, and this change from a sacred to a secular occupant demanded commissions for new decorations. Among these were two large paintings by Ingres —*Romulus* and *The Dream of Ossian* (colorplate 17)—whose subjects were culled from two of Napoleon's favorite books, Plutarch's *Lives* and the epic poems of the legendary bard, Ossian. This pairing offered not only a dramatic contrast between a theme of virile, military victory and one of eerie, cloud-borne visions, but also a polarity between two archaic worlds, one Roman, the other Nordic.

The scene of *Romulus*, which was to be placed in one of the Empress' salons, provided precisely the image of classical heroism with which Napoleon liked to surround himself, for, like the Roman-inspired architecture with which the Emperor had aggrandized Paris, such an allusion to the triumph of Romulus, the founder of ancient Rome's military and political institutions, created a pedigree of past glory that might legitimize and ennoble the events of modern history. Ingres, however, had conceived the work as early

as 1808, and the commission merely provided the occasion for him to transform it into a mural whose large size demanded a special studio in the tribune of S. Trinità dei Monti.

Ingres followed Plutarch's text closely. Acron, king of the Caeninensians, has been killed in hand-to-hand combat with Romulus and stripped of his weapons, which the Roman leader has promised to return to Jupiter. These trophies, the so-called *spolia opima*, are placed on a staff carved from an oak and carried back in triumph to Rome by the purple-cloaked, laurel-wreathed Romulus and his soldiers, thereby establishing the pattern that later Roman military processions were to follow.

Like David in his *Sabines* of 1799 (fig. 13), Ingres here attempts to reconstruct an epic subject from the dawn of Roman history in a heroic style of appropriate austerity and power. Yet, almost as if improving upon his master, Ingres carries this classical ideal to an even more archaic extreme, which recalls the Flaxman Homeric outlines that so often inspired him. Thus, the space has been further compressed, so that we no longer see fully modeled flesh-and-blood actors strongly illumined on a shallow stage, but rather, forms that seem dehydrated to a chiseled firmness on a flat plane that unrolls before our eyes like the processional movements of a classical bas-relief and cramps the major protagonists into frontal and profile positions. Indeed, both the Parthenon frieze and Roman reliefs have been suggested as partial influences, and such early Ingres drawings as a copy of a *Wounded Amazon* relief (fig. 83) bear out this general affinity.

The painting technique, too, contributes to this archaic mood, for Ingres used tempera here, a medium that, in contrast to oil, tends to produce flat and clearly outlined forms which, around 1800, evoked the lucid and vigorous compositions of the Italian primitives and the speculative world of ancient painting. The results are startling. The paint surface is dry and chalky, the pastel colors astringent and chilly; the whole conjures up a wall painting of a distant epoch. Yet this lapidary and metallic stiffness, which Charles Blanc likened to Mantegna's frescoed reconstructions of Roman triumphs (*Ingres*, Paris, 1870, p. 32), is constantly countered by passages of subtle, realistic observation. The frozen gray flank of what at first seems a carrousel horse reveals veins, wrinkles, and dapples; the dead Acron, blood still trickling from his wound, and the warrior who stoops to lift him, are made up of surprisingly supple flesh and muscle. And even the shadows cast on the ground and the glint of light on the shields and helmets complicate the would-be austerity and abstractness of the style with a pervasive naturalism that can soften the stony hair and draperies and breathe life into this monumental dream of remote classical grandeur.

Figure 83. Ingres. WOUNDED AMAZON. c. 1806–12. Pencil and watercolor, 10 × 10″. *Musée Bonnat, Bayonne*

COLORPLATE 16

ROMULUS, CONQUEROR OF ACRON

Signed and dated 1812

Tempera on canvas, $108^5/_8 \times 208^5/_8''$

École des Beaux-Arts, Paris

THE DREAM OF OSSIAN

Signed and dated 1813

Oil on canvas, 137 × 108¹/₄″

Musée Ingres, Montauban

Befitting its intended location on the ceiling of Napoleon's bedroom at the Palazzo del Quirinale, *The Dream of Ossian* explores a nocturnal world of phantom reveries inspired by the legendary Nordic heroes of the Ossianic poems that had been "discovered" and published by James Macpherson in 1760–63, and then quickly translated on the Continent. Although the authenticity of this literary hoax had been contested soon after its publication, Ossian was nevertheless responsible for exciting the imagination of most of the Western world. For Jefferson and Napoleon, for Goethe and Mme. de Staël, the poems of the Homer of the North, as Ossian was called, became the Nordic parallel to an equally distant Mediterranean past of primitive power, in which heroic deeds and battles were chanted in a hauntingly vigorous poetic style. Even musicians and travelers dreamed of this mythical, fogbound realm: witness the discovery and naming of Fingal's Cave in the Hebrides in 1772, and the overture with which Mendelssohn commemorated his own visit to this Romantic site in 1829.

Although British artists had begun to illustrate Ossian as early as 1770, it was not until the turn of the century that French artists in the Davidian circle began to seek inspiration in what was one of Napoleon's favorite books. Not only are there examples by Gros, Duqueylar, Mme. Harvey, but, more prophetic of the Quirinale decoration, Ossianic paintings by Girodet and Gérard (fig. 84) had been commissioned in 1800 for Malmaison, Napoleon's residence near Paris.

Ingres's painting, in fact, follows closely the apparitional mood of Gérard's, in which the ghosts of warriors and lovers are conjured up through song and a primitive harp by the bard Ossian. But Ingres's version is still more hallucinatory. Accompanied only by two baying dogs in a bleak and craggy Nordic landscape at the edge of the sea, aged Ossian, blind like Homer, has stopped his song and, resting upon a rock and his harp, has fallen into a deep sleep. From the cold white locks that crown his poet's head emerges an even chillier vision of Nordic specters, distinguished from palpable reality not only by their cloud-borne hovering above the earthbound Ossian, but also by the chromatic contrast of their ectoplasmic grisaille to the cool greens, pinks, and blues that tint the poet's robes and the night sky. As a transition to this eerie realm of the dead, Malvina—widow of his slain son, Oscar—extends a comforting arm that carries us into a vision of strange, blind creatures, both as icily firm as the Snow King, Starno, who reigns in the center, and as voluptuously pliant as the chorus of harpists, the pink-tinged heroines who embrace their warrior-lovers. In this weird, moonlit mixture of the erotic and the heroic, of ghostly sirens and the Nordic counterpart of Romulus' militant troops, the extremes of Ingres's imagination are fused and the arbitrary boundaries between Neoclassicism and Romanticism are effaced.

The bizarre quality of *The Dream of Ossian* has been further underlined by the painting's subsequent history. Originally oval, it was altered to its present form sometime after 1835 by one of Ingres's students, Raymond Balze, and several new figures (e.g., the dark, spear-bearing warrior at the right) were added but never quite completed. As an accidental but hardly inappropriate result, this congested vision now appears all the more macabre and impalpable, thanks to the shadowy films of limbs and armor that overlay the original paint surface.

Figure 84. After François Gérard. OSSIAN EVOKING SPIRITS. Engraving by Jean Godefroy exhibited at the Salon of 1804

RAPHAEL AND THE FORNARINA

c. 1814. Oil on canvas, 26 × 21¹/₂'

The Fogg Art Museum, Cambridge, Massachusetts
Grenville L. Winthrop Bequest

Figure 85. Giulio Romano (formerly
attributed to Raphael). LA FORNARINA.
c. 1516. *Galleria Borghese, Rome*

Ingres's veneration of Raphael extended not only to artistic reinterpretations of the master's works, but also to an intense interest in his biography. In 1812, Ingres planned a series of pictures illustrating the life of Raphael, from birth to death, as culled from Italian biographies that ranged from Vasari (1550) to Comolli (1790). The only scenes he actually painted, however, concerned Raphael's public and private relationships with women—his betrothal to Cardinal Bibiena's niece (1813) and his love for the so-called Fornarina, the baker's daughter, first painted in a lost version of 1813 and then repeated in later variants. Was it the circumstance of Ingres's own marriage, on December 4, 1813, to Madeleine Chapelle that allowed him to identify most closely with the love stories from Raphael's life?

In painting such romanticized chapters from the history of art, Ingres followed a tradition begun in the late eighteenth century, when subjects taken from the lives of great artists, as if they were modern saints, first appeared at the Salon. Such serious scenes as the death of Leonardo in the arms of Francis I (by Ménageot, Salon of 1781) or the death of Raphael himself (by Monsiau and Bergeret, Salons of 1804 and 1806) were often complemented by more charming and anecdotal episodes. Ingres's painting is one of these; it shows us Raphael's studio at the time he was painting the Fornarina, who, with typically Ingresque seductiveness, seems to be both embracing and withdrawing from the artist, just as she appears to be seated both on the arm of the chair and on his knee. As in all of Ingres's historical and mythological paintings, a scrupulously truthful reconstruction is attempted. The window offers a view of the Vatican and old St. Peter's before the advent of Michelangelo; the *Madonna of the Chair* is seen against the wall; the portrait of Raphael depends on his self-portrait in the Uffizi, which Ingres had copied.

This studious enumeration of High Renaissance fact is enlivened by complex visual and psychological undercurrents. For one, there is the fascination of the Fornarina herself, dependent on a portrait which Ingres thought to be by Raphael but which modern scholarship has generally attributed to his pupil, Giulio Romano (fig. 85), whose clandestine eroticism and cool, firm contours were surely more congenial to Ingres than the simpler psychology and warmth of Raphael's portraiture. For the spectator as, it would seem, for Raphael himself, attention is tensely divided between the palpable presence and the painted re-creation of the Fornarina, whose turbaned head, like that of the 1807 *Bathing Woman* and the 1814 *Grande Odalisque* (colorplate 20), returns our gaze with a provocative sensuality in both the real image and the ideal one drawn on the canvas and just cut off by the framing edge. And this interplay between various levels of art and reality is further enriched by the sacred re-creation of the same facial type in the similarly turbaned and segmented Madonna in the background.

Fascinating, too, is the meticulous pictorial architecture; the entire Renaissance environment, from the columns of the distant and near loggias to the footstool, bench, maulstick, and easel in the foreground, is ordered by a tidy grid marked out in geometric patterns on a steeply tilted floor plane that recalls the diminutive perspective-box effects of painting before Raphael. In contrast to this precise rectilinear network, the figures of Raphael and his beloved are defined by an exquisitely thin and fluent contour that evokes the gilded drapery edges in Sienese primitive painting; and this linear flourish is, in turn, echoed subtly in the sweep of curtain across the window and the tiny curl of cloth on the frame of the easel.

Such subjects, if not such artistry, were hardly uncommon in the early nineteenth century. Indeed, the same scene of Raphael and the Fornarina was repeated in works by Picot and by Coupin de la Couperie at the Salons of 1822 and 1824; and other, more imaginative musings upon the nature of Raphael's working methods appeared at the same time. There are, for instance, pictures by Alexandre-Evariste Fragonard and by the German brothers Franz and Johannes Riepenhausen which offer delightful pictorial legends about the diverse procedures—both empirical and visionary—through which Raphael arrived at the harmonious image of the *Sistine Madonna*, a painting Ingres himself was soon to re-create in his *Vow of Louis XIII* (colorplate 26).

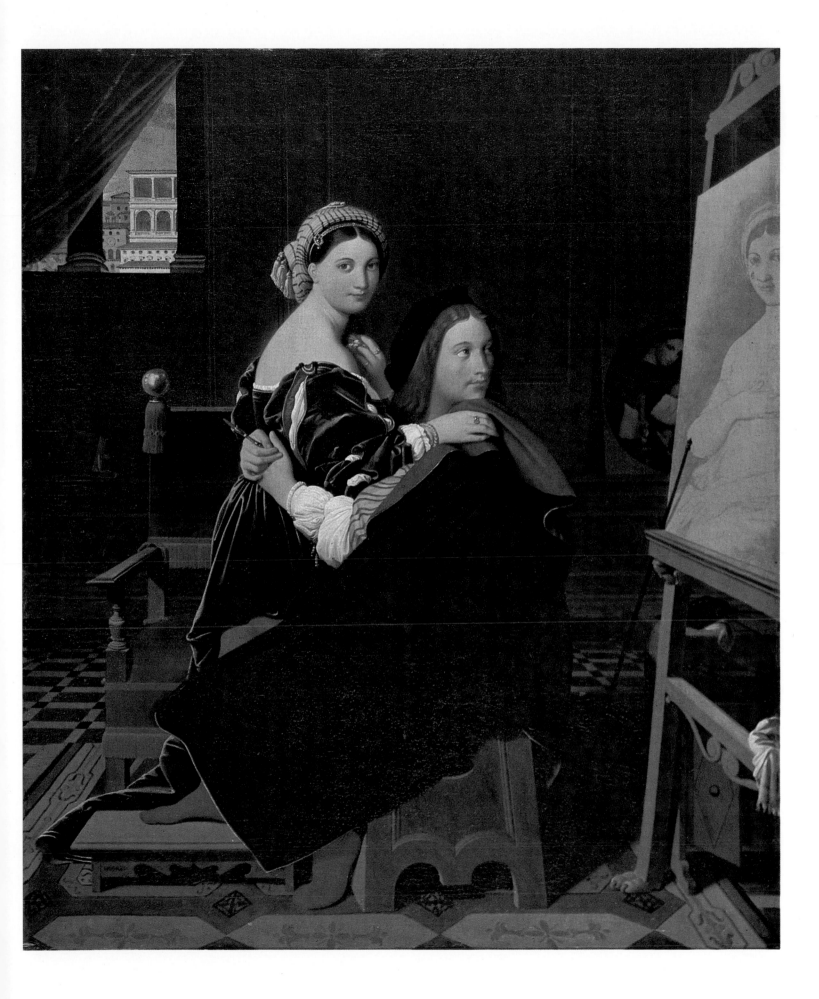

POPE PIUS VII IN
THE SISTINE CHAPEL

Signed and dated 1814

Oil on canvas, 29¹/₄ × 36¹/₂'

The National Gallery of Art, Washington, D.C.

Samuel H. Kress Collection

The weakening of Christian faith in a modern, secularized society had profound effects on religious art. Although official commissions tended to cling to moribund formulas inherited from the old masters, a new kind of religious iconography also developed in which the artist, often as a spectator rather than a believer, represented scenes of Christian ritual or objects of Christian devotion. Cathedrals, religious processions, pious peasants—such observable realities began to replace the supernatural images of traditional Christian art. Thus, instead of painting the Crucifixion, many nineteenth-century artists, from Friedrich to Gauguin, painted pictures of crucifixes.

Like Chateaubriand in his *Génie du Christianisme* (1802), the young Ingres could be intoxicated by the splendor of Catholic art and ceremony. Already in a letter of April 7, 1807, he had written excitedly of his visit to the Vatican during Holy Week. There, surrounded by the sublimities of Michelangelo's frescoes, he had also heard a Miserere chanted from the Sistine Chapel tribune, and was overwhelmed by this joint artistic evocation of Christian

grandeur. In 1812, M. Marcotte, whose portrait Ingres had printed in 1810 (colorplate 12), was impressed by one of Ingres's drawings of the Chapel and commissioned this painting. Begun in 1813 and completed the following year, it represents Pope Pius VII holding chapel the morning of Holy Thursday. If Ingres had earlier represented the Pope's nemesis, Napoleon, in terms of an unworldly, authoritative frontality (colorplate 7), here he represents the Pope and his splendid entourage of cardinals and trainbearers (among whom Ingres includes a self-portrait) in terms of a casual obliqueness that is almost Impressionist in effect. Thus, our attention is constantly demanded by many separate and fragmentary points of interest—the turning heads and informal movements of the foreground figures cut off by the lower frame; the central but miniature splendor of the white-clad Pope himself; the harrowing power of one-quarter of Michelangelo's *Last Judgment*; and the equally partial views of those frescoes by—reading from left to right—Rosselli, Botticelli, and Perugino and Pinturicchio, whose late *quattrocento* style would find echoes in Ingres's

Figure 86. François-Marius Granet. CRYPT OF S. MARTINO
DEI MONTI, ROME. Salon of 1806. *Musée Fabre, Montpellier*

Figure 87. Léon Bonnat.
THE SISTINE CHAPEL. *The Louvre, Paris*

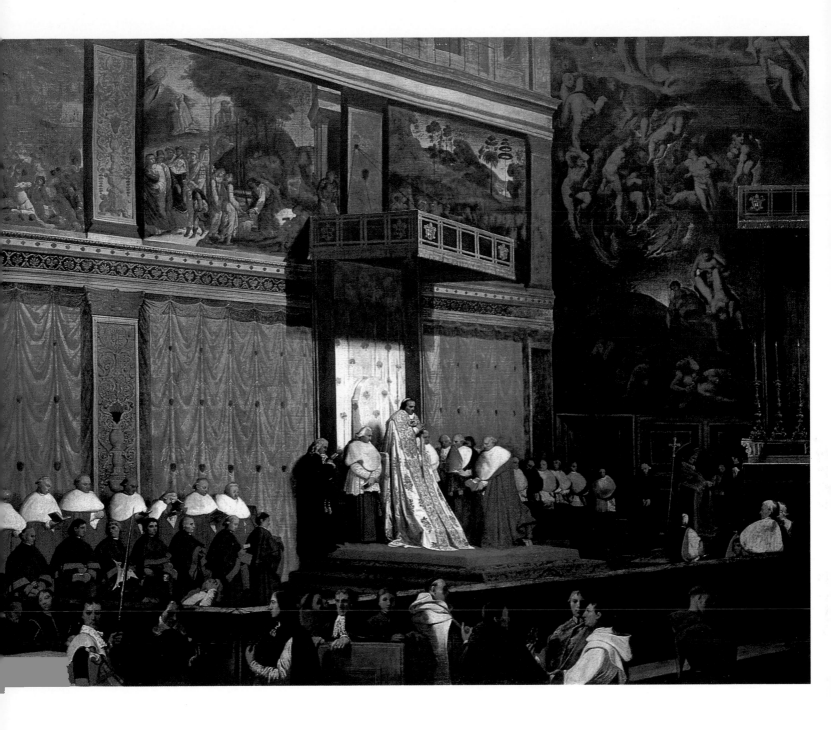

own work. Yet, thanks to the overall shimmer of warm light and shadow and to the pervasive tonality of sumptuous golds, reds, and browns, the spectacle becomes a unified vision that recalls the splendid religious processions of a Venetian Renaissance master. Moreover, the curiously diminished scale, as if the scene were viewed through a reducing glass, fuses the extraordinarily rich details of portraiture, clerical robes, and wall decoration into a coherent, glistening moment of perception.

Throughout his later career, Ingres painted variations on this secularized vision of Christian pageantry (including historical reconstructions of ceremonial events in the life of a seventeenth-century pope, Urban VIII); but his strong vein of conservatism meant that he also persisted in his efforts to revitalize the past glories of Christian art itself, particularly in his close imitations of Raphaelesque models. Some early nineteenth-century artists, like Horace Vernet, aggrandized Ingres's spectacle of papal splendor in works like *Pope Leo XII Carried into St. Peter's, 1829.* Others contented themselves with quiet, humble records of ritual activity in minor shrines of Christendom, such as Ingres's friend Granet's view of the *Crypt of S. Martino dei Monti, Rome* at the Salon of 1806 (fig. 86). In the later nineteenth century this tourist approach to religious monuments became completely secularized, so that Léon Bonnat could produce a representation of the Sistine Chapel not in Ingres's terms of Christian magnificence, but rather as a genre setting for an elegant lady sightseer (fig. 87).

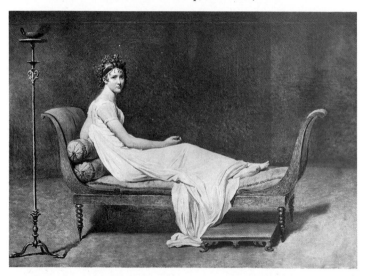

Figure 88. Michelangelo. TOMB OF GIULIANO DE' MEDICI. 1524–34. *New Sacristy, S. Lorenzo, Florence*

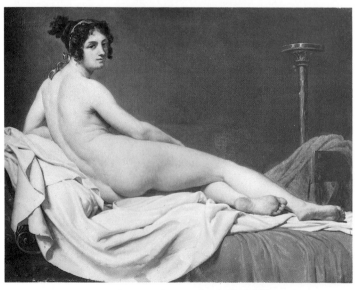

Figure 89. Jacques-Louis David. MME. JULIETTE RÉCAMIER. 1800. *The Louvre, Paris*

Figure 90. Jacques-Louis David (?).
FEMALE NUDE (study for MME. RÉCAMIER?). C. 1800.
Musée des Beaux-Arts, Boulogne-sur-Mer

COLORPLATE 20

GRANDE ODALISQUE

Signed and dated 1814

Oil on canvas, $35^7/_8 \times 63^3/_4$'

The Louvre, Paris

The most obsessively fascinating of Ingres's nudes, this indolent yet alert creature was commissioned by Napoleon's sister, Queen Caroline of Naples, as a pendant to another Ingres nude, also in that royal collection but now lost, which represented the sensual abandon of a sleeping woman (1808). As early as 1819, when the *Grande Odalisque*—as it has come to be known—was first exhibited at the Salon, critics associated it with the great traditions of the Western nude, and, in particular, with Titian's *Venus of Urbino*, which, in fact, Ingres was later to copy (1822). Yet the complexity of the odalisque's posture and psychology has less to do with the overt eroticism of the Venetian nude than with the intricate, unstable contortions of mind and body found in Mannerist art, and, especially, in the figure type established by Michelangelo's Tomb of Giuliano de' Medici (fig. 88), where the monumental opposition of *Night* and *Day* offers a not inappropriate reference for Ingres's pair of sleeping and wakeful nudes. Moreover, Ingres knew this Michelangelesque prototype through its reinterpretation by David, who used it not only in *Mme. Juliette Récamier* (1800, fig. 89), with which Ingres is said to have assisted his master, but in a closely related study of the female nude (fig. 90).

But Ingres's transformation of such sources effaces questions of influence, for the *Grande Odalisque* creates a world uniquely his, and one in which the multiple paradoxes of his art are set into the most vital tensions. There is, for one, its erotic complexity, which as in the *Bathing Woman* of 1807 discomfits but allures the spectator. An idle creature of the harem, whose feet have never been wrinkled or sullied by use, the odalisque is presumably displayed passively for our delectation; yet at the same time, she partly recoils from our scrutiny, half concealing all but her back. And her head, prefiguring Picasso physiognomy in the contrast of a strongly illuminated near-profile view against an almost frontal and darkly shadowed eye and cheek, returns our gaze with an equally disquieting combination of directness and obliquity. Her posture is no less intricate. She reclines in padded luxury, fondled by satins, silks, furs, and feathers, yet her Oriental languor is countered by points of extreme tension. The head is held erect by the unyielding vertical of the neckline; the weight of the upper torso is borne by the

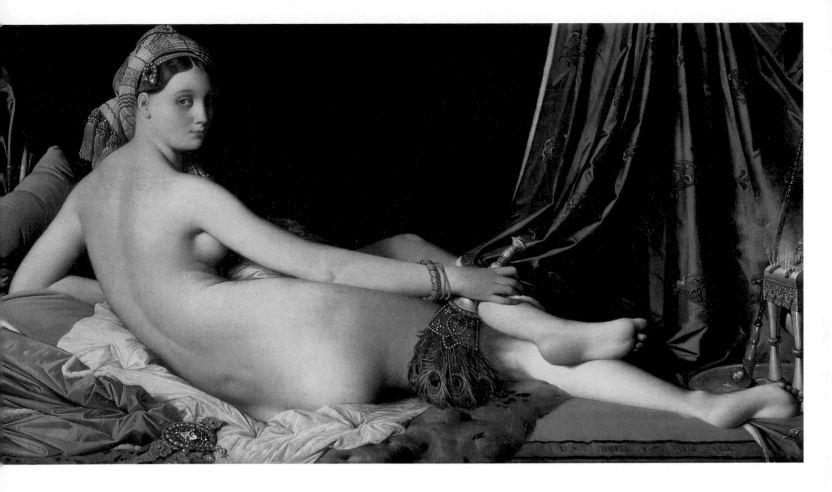

taut triangle of the flexed left arm, subtly echoed in the shape of the pillow; the left leg crosses the right in a precarious torsion. The whole figure is tightly compressed in a narrow enclosure not only by the four framing edges that impinge upon elbow, toe, and head, but by the shallow, rectilinear confines of the paneled and cushioned wall plane behind and the edge of the bed in front, with the artist's signature seemingly embroidered upon it. Furthermore, the body's contours and textures produce as oddly paradoxical effects as the chromatic contrast between the silvery chill of the accessories and the pinkish warmth of the skin. The prodigious ductility of the line, whose elongated trajectories were prepared in many drawings, suggests a flesh of voluptuous malleability, yet this pliant stuff is polished to a marmoreal firmness, so that it seems alternately warm-blooded and cold, slack and taut, a fusion of opposites.

Critics at the Salon of 1819 were baffled by the ostensibly arbitrary anatomy. They complained that the odalisque had three extra vertebrae, not seeing that this permitted the sensual attenuation of the spine to rhyme with the arcing lower contour of the back; and they complained that she lacked bones and muscles, apparently disapproving the extension of an elbowless arm to a point where it could join, with four caressing fingers, the rising arc of the silk curtain. Typically for Ingres, this abstract anatomy, whose contractions and expansions revive the erotic and formal preciosity of much Mannerist art (fig. 54), is rendered with a photographic clarity and precision of detail. And the pipe and smoking censer, the peacock feathers, the pearl buckle of the discarded belt, the floral patterns on the blue curtains, the wrinkles of the sheets, the gold tassels on the turban—all these trappings of the harem are recorded with a glassy objectivity that, almost as in a Surrealist painting, demands credence of an incredible image.

COLORPLATE 21

MME. DE SENONNES

1814

Oil on canvas, 41³/₄ × 33¹/₈″

Musée des Beaux-Arts, Nantes

Even more than the earlier portraits of Mme. Rivière and Mme. Duvaucey (colorplates 5, 8), that of Marie Marcoz, who married the Vicomte Alexandre de Senonnes in 1815, creates a hothouse ambiance of dense and indolent luxury. Although its date has also been given as 1816, it was most certainly painted in 1814, the same year as the *Grande Odalisque* (colorplate 20), to which it offers, as it were, the Occidental feminine counterpart–a seductive, lavishly dressed and bejeweled woman in the sheltered comfort of a nineteenth-century domestic interior. The analogies with the *Odalisque* go even further, for we know from preparatory drawings that Ingres first planned to represent Mme. de Senonnes reclining on a chaise longue, with a mirror above, a footstool below—in a portrait situation that would have closely resembled David's *Mme. Récamier* (fig. 89), and, still more, Canova's marble *Pauline Bonaparte*. But, characteristically, Ingres changed this languorous posture to one of far greater compression and tautness, although he preserved the idea of a mirrored background.

Indeed, in the painting, Mme. de Senonnes, for all the seeming limpness of her elbowless arms and jointless fingers, seems inscribed in a tense, spiraling rhythm that gains further energy through its oblique position against the picture plane. The almost egg-shaped smoothness of the head, seen from a slightly distorting angle, is first multiplied in the triple ellipses of the blonde-lace collar, and then, in turn, echoed in the fluent, springlike arc that carries us up the right sleeve and across the diaphanously veiled breast, neck, and shoulders. Only in the fabulous expanse of an ocher Indian shawl that rivals Mme. Rivière's does this coiled linear network begin to unwind more freely.

Within these nearly Venetian harmonies of a deep wine-red velvet and of a golden silk that covers the couch and even the wall, there is almost, but not quite, a surfeit of embellishments. The hands, caressing a pillow and a handkerchief, are heavy with no fewer than thirteen rings, whose pale red and green jewels reverberate in the shawl's floral embroidery; and the velvet dress is elaborated by a profusion of satin, tulle, and lace that are further enriched by a cluster of golden pendants hanging below the white satin belt. Yet, strangely, the effect is not one of vulgar ostentation but of a curious reserve and aloofness; to this, the mirror contributes in large part.

From a tiny preparatory drawing for a lost portrait of a certain Mme. Bérenger, it is possible to speculate that Ingres may have earlier experimented with a mirror image; but *Mme. de Senonnes* is, in any case, the first extant Ingres portrait to explore the additional spatial and psychological dimensions offered by a reflection. Here, the upper half of the painting becomes distant and unreal, evoking a filmy, intangible space that contradicts the glossy and palpable luxury below. And the hazy reflection of the back of Mme. de Senonnes' head, as magically elusive as a mirror image in a Vermeer, likewise conveys, in terms of personality as well as optics, an aura of something concealed and mysterious that counters the sitter's overtly sensual allure. And as a final touch in this world of double realities, Ingres has added his signature in a small calling card that is slipped into the mirror's vertical frame and just reflected in the glass. Such brilliant interplays between the glassy precision of reality, as observed by Ingres, and its softer, secondary reflection in yet another glass look forward to the haunting mirror images in the later portraits of the Comtesse d'Haussonville and Mme. Moitessier (colorplates 32, 38).

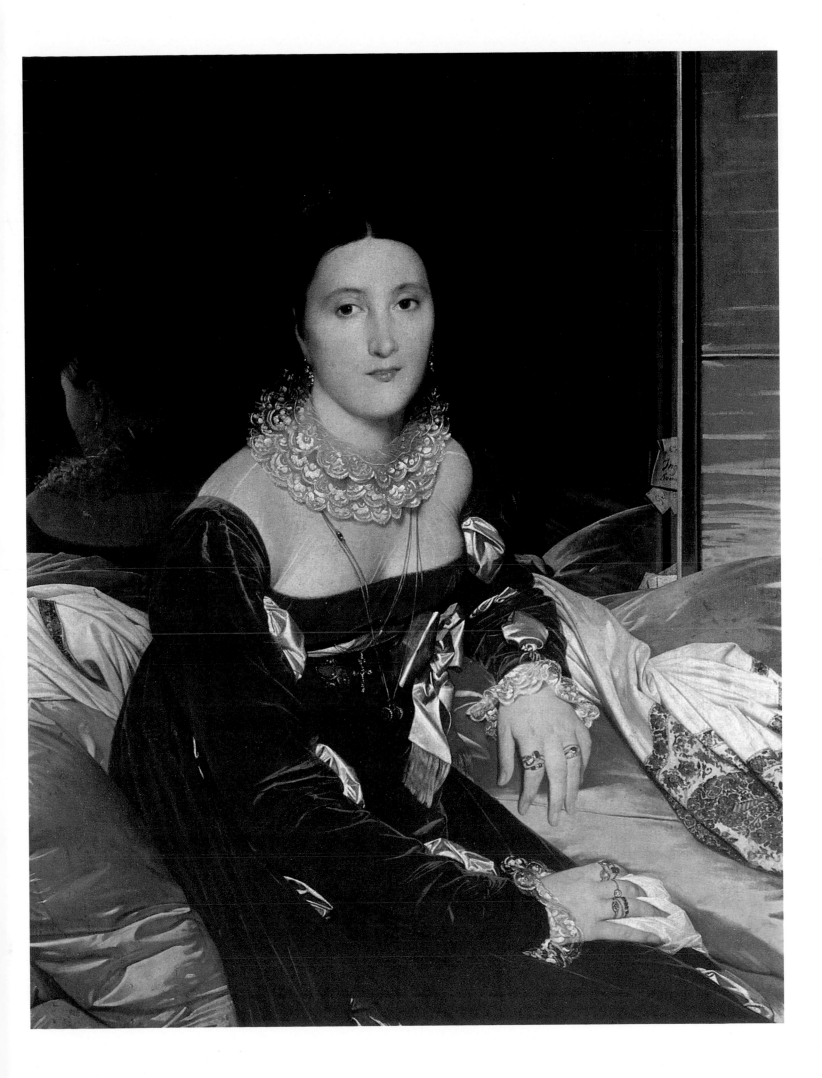

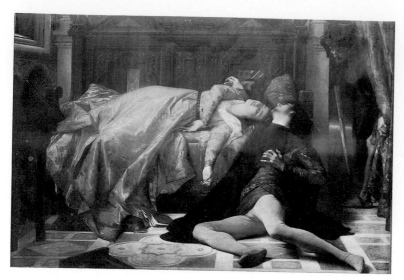

Figure 91. Alexandre Cabanel. PAOLO AND FRANCESCA.
1870. *Formerly Musée du Luxembourg, Paris*

PAOLO AND FRANCESCA

Signed and dated 1819

Oil on canvas, $18^7/_8 \times 15^3/_8$"

Musée des Beaux-Arts, Angers

Like the complex erotic narrative of Antiochus and Stratonice (colorplate 31), the pathos-ridden story of the star-crossed lovers, Paolo Malatesta and Francesca da Rimini, must have fascinated Ingres. He had read closely Dante's description of the encounter with the spirits of these thirteenth-century Italian lovers in the Second Circle of Hell (*Inferno*, Canto V), and he often painted and drew the poignant circumstances of their death. The beautiful Francesca had been forced, for reasons of state, to marry the lame and ugly Giovanni Malatesta, whose handsome brother Paolo served as proxy at the wedding. One day Paolo and Francesca were reading together an account of the illicit love of Sir Lancelot, Knight of the Round Table, for Queen Guinevere, an amorous narrative that kindled Paolo and Francesca's own adulterous love. The two were then surprised by Francesca's husband, who killed them both with one stroke of his sword.

In the version illustrated here, painted in Rome in 1819, Ingres contracts the narrative to a split-second situation that dramatically combines the critical moments of love's wakening and death's imminence. So sudden is the welling of passion in the reading lovers that we actually see the book dropping from Francesca's hand to the floor while Paolo impulsively seeks her mouth to kiss. And at the same crucial instant, Francesca's grotesquely crabbed husband emerges from behind the arras and draws his sword to kill his own wife and brother.

Yet despite this pinpointed tension, Ingres's painting is curiously frozen and static—the book of Arthurian legend will never reach the ground, the sword will never be drawn. For here, appropriate to the thirteenth-century Italian theme, Ingres has consciously adapted the archaisms of early pictorial styles, seeking inspiration not only in the linear purism of Flaxman's illustration of the same scene (fig. 17), but in such elements of Italian primitive painting as the centralized box space, the precision of contour, the brilliant local colors. The effects, however, are anything but simple in either psychological or formal terms. Paolo's importunate desire may be considered the male counterpart to Thetis' seductive entreaty to Jupiter (colorplate 13), a fluent surge that rushes from the tips of his flexed toes to his swollen neck and wriggling fingers; and if Francesca may seem more innocent than, for example, Mme. de Senonnes (colorplate 21), her averted eyes, blushing cheeks, and sudden limpness suggest the complex sexuality of the nineteenth rather than the thirteenth century. Moreover, the almost Florentine clarity of abstract color, drawing, and one-point perspective construction is complicated by elaborate undercurrents of ornamental line and descriptive realism that recall the styles of other primitive schools and produce the diminutive, dollhouse scale so common in Ingres's medievalizing paintings. Thus, the lower hem of Francesca's dress might rival that of a Van Eyck or a Duccio Madonna in its exquisitely restless and thinly looping rhythms; and the intense naturalism of the Flemish primitives is evoked not only in the luminous, shadow-filled space and warm resonance of color, but in the multitude of miniaturist details that includes the tiny curls in the falling strands of Francesca's soft hair, the glistening window reflection on the flower-filled cruet at the left, the gleam of gilding on the lectern, book, stool, and sword hilts.

The consciously pre-Raphaelesque quality of Ingres's painting was probably reflected directly in another version of the subject, by the Scottish master William Dyce (1837, fig. 9), who was almost as precocious as Ingres in admiring and assimilating the styles of the Italian and Northern primitives. But, later in the nineteenth century, pictorial interpretations of the theme descended to the waxworks bathos of Cabanel's Salon picture of 1870 (fig. 91). Nevertheless, in late Romantic music and literature the tragedy of Paolo and Francesca, like that of Romeo and Juliet, continued to provide a vital source of inspiration—witness Tchaikovsky's stormy symphonic poem of 1876 or D'Annunzio's morbid drama of 1902.

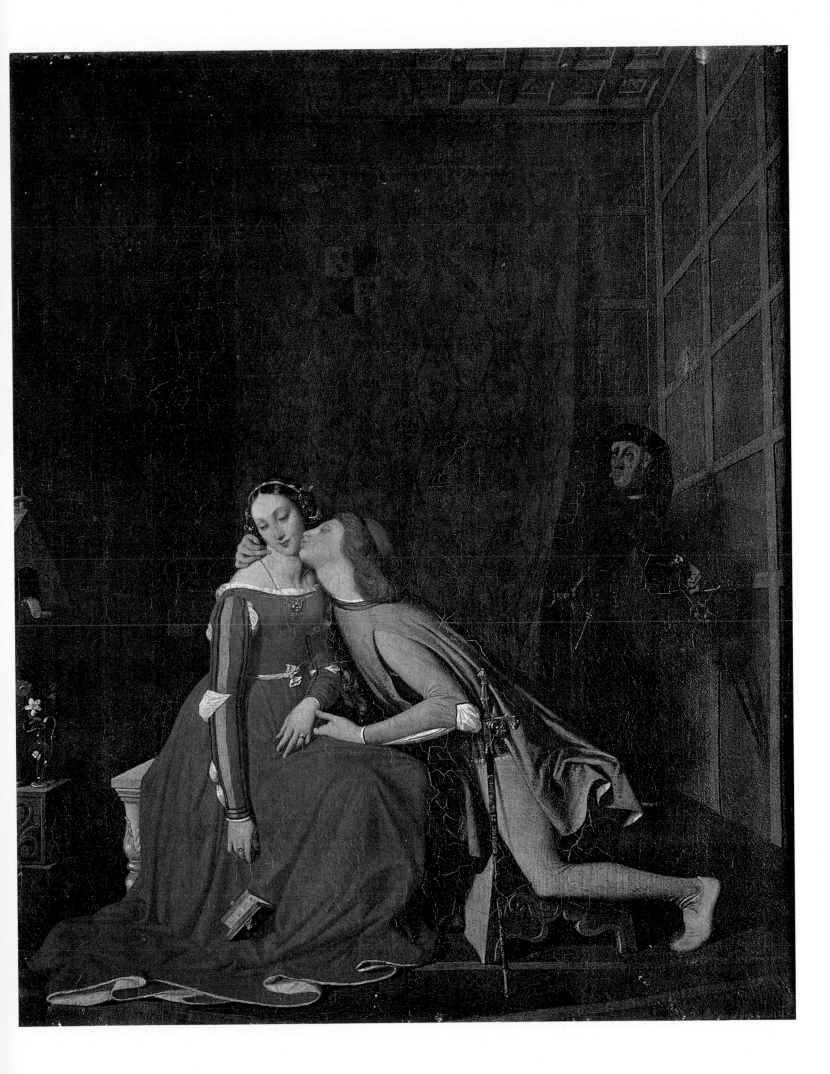

LORENZO BARTOLINI

Signed and dated 1820

Oil on canvas, 41³/₄ × 33¹/₂

The Louvre, Paris

In June, 1819, Ingres visited his close friend Bartolini (1777–1850) in Florence, and decided to return there soon to live. When he did so, in 1820, he again stayed with his friend, whose portrait he then painted. Unlike the earlier 1806 portrait of this Neoclassic sculptor (fig. 29), which shows a youthful artist of casual, smiling demeanor, the 1820 portrait presents an ideal of sober, middle-aged respectability that reflects, too, the change in Ingres's own personal status. Indeed, in symbolic terms, the portrait could almost be considered a double portrait of the two artist-friends, for the literary, musical, and artistic still life at the left itemizes the enthusiasms that Ingres and Bartolini shared. There one finds a tiny classical vase and a tragic mask; a violin bow, which evokes both Bartolini's and Ingres's mastery of that

instrument; a marble bust of a composer they both admired, Cherubini, which was carved by Bartolini himself and inscribed with a dedication to his friend Ingres; a group of scores by composers whom the two artists venerated—Mozart, Haydn, Gluck; and another trio of volumes by equally beloved authors—Dante, Machiavelli, and, lying flat on the table, the first volume of an Italian edition of the *Iliad*.

In accord with this erudite arrangement of library objects, Bartolini himself strikes a note of intense seriousness and decorum that closely revives the form and mood of much Mannerist portraiture, and, in particular, that of Bronzino, a Florentine like Bartolini (fig. 49). Like the work of this sixteenth-century master, Ingres's painting immobilizes the sitter in an elegant stance whose clean, abstract silhouette is filled in with a punctilious description of elaborate surface details. Even the expensive sobriety of the costume recalls Bronzino's portraits, for it is only careful scrutiny that discloses the richness of the black velvet collar on the brown frock coat, the deep green silk vest, the quiet touches of gold in the pencil holder, fob, and rings. As in Bronzino, too, the sitter's personality seems more of a public mask than a private revelation, and the accessories also contribute to rebuffing any effort to probe further into his true psychology. Here, as in Ingres's earlier portrait of M. de Norvins (colorplate 15), or in another portrait by a French Neoclassic painter of an Italian Neoclassic sculptor—Fabre's 1812 portrait of Canova (fig. 92)—the intrusion of other works of art, especially when they vary sharply in color, texture, and scale, prevents us from concentrating upon the sitter's face alone. In this case the profile view of Bartolini's chilly white marble bust of Cherubini vies for attention with the frontal view of Bartolini's own ruddy but almost as tightly modeled head; and even the studied poses of the swarthy but elegant hands, or the crisp white curls of paper at the lower right, set up points of visual interest that rival the sculptor's frozen gaze.

Such affinities to the devious formal and psychological intricacies of Mannerist art recur constantly in Ingres's work. Six years later, Ingres completed the portrait of the Comte de Pastoret (fig. 48), whose brittle sophistication of posture, expression, and ambiance pays even closer respects to Bronzino.

Figure 92. François-Xavier Fabre. ANTONIO CANOVA.
1812. *Musée Fabre, Montpellier*

COLORPLATE 24

THE DAUPHIN ENTERING PARIS

Signed and dated 1821

Oil on panel, 18¹/₂ × 22'

The Wadsworth Atheneum, Hartford, Connecticut

In the late eighteenth century, French artists began to incorporate scenes from the history of France into their iconographic repertory, but with the advent of the French Revolution and Napoleon, such pictorial reminiscences of a glorious monarchical past were largely suppressed. With the Bourbon Restoration, however, these themes reappeared in growing abundance, and from 1814 on, Ingres himself began to paint domestic and official moments in the lives of such monarchs as Francis I and Henry IV (fig. 5), and even illustrated, in the case of a Spanish patron, events in the history of Spain (fig. 21). In 1821, the Comte (later Marquis) Amédée-David de Pastoret, whose portrait Ingres was soon to paint (fig. 48), commissioned a scene from fourteenth-century French history. The episode, described in Froissart's *Chroniques*, concerns the triumphant return of the Dauphin (the future Charles V) to Paris on August 2, 1358, after a long period of war and internal chaos in which an opposing faction led by Etienne Marcel forced the Dauphin to flee from Paris, attempted to replace him with Charles II, King of Navarre, and fomented bloody peasant revolts.

The Dauphin's return, symbolizing the beginning of a new reign of stability and order in France, is reconstructed by Ingres with the same efforts at historical accuracy he had exerted for such a classical triumphal entry as that of Romulus (colorplate 16). Thus, the Dauphin, whose portrayal here may well depend on that of Charles V in the Louvre's *Parement de Narbonne*, is seen arriving at the Porte St. Antoine, visible at the left, and is halted by Jehan de Pastoret, the first president of Parliament, who, with the other two regents, welcomes him back to Paris with head bared and hands outstretched in loyalty. In the right foreground a widow and child, together with a nun, kneel and pray before the monarch, alluding possibly to the family of Marcel, to whom the Dauphin, in a benevolent gesture worthy of a Trajan or a Scipio, restored part of their lost possessions. At the left a vicious dog gnaws on a hat, perhaps a reference to the violence and misery of the interregnum. Throughout, the luxurious accessories of a medieval procession are lovingly recorded, from the red-and-gold gleam of the Dauphin's cloak and of the dais that awaits him to the gilded fleurs-de-lis that decorate the horse's harness in the foreground and the royal blue sword and pennant upheld by the heralds in front of the dais.

In keeping with his acute sense of historical correctness, Ingres must have searched for an appropriate pictorial style with which to record this glittering event, and, as in his earlier painting of the Duke of Alba (c. 1815–19), he was surely inspired by late medieval painting. In this case, the very subject had already been illustrated by Jean Fouquet and his school in the *Grandes Chroniques de France* (c. 1460–70), and Ingres may well have used such fifteenth-century manuscript pages as sources not only for the hilly, fairy tale landscape behind, and for details of costume and portraiture, but also for the jewel-like effect of brilliant colors and gilding, for the exquisite textural variety that ranges from ermine to armor to brocade, and for that curiously minia-

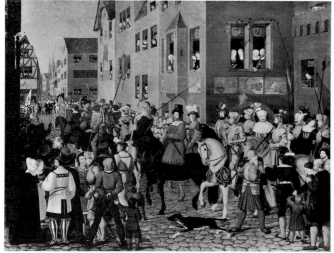

Figure 93. Franz Pforr.
ENTRY OF RUDOLF I INTO BASEL IN 1273. 1809.
Staedelsches Kunstinstitut, Frankfort

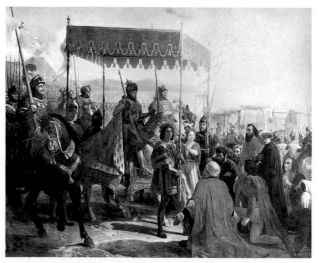

Figure 94. Eloi-Firmin Féron.
ENTRY OF CHARLES VIII INTO NAPLES ON MAY 12, 1495.
Salon of 1837. *Musée National, Versailles*

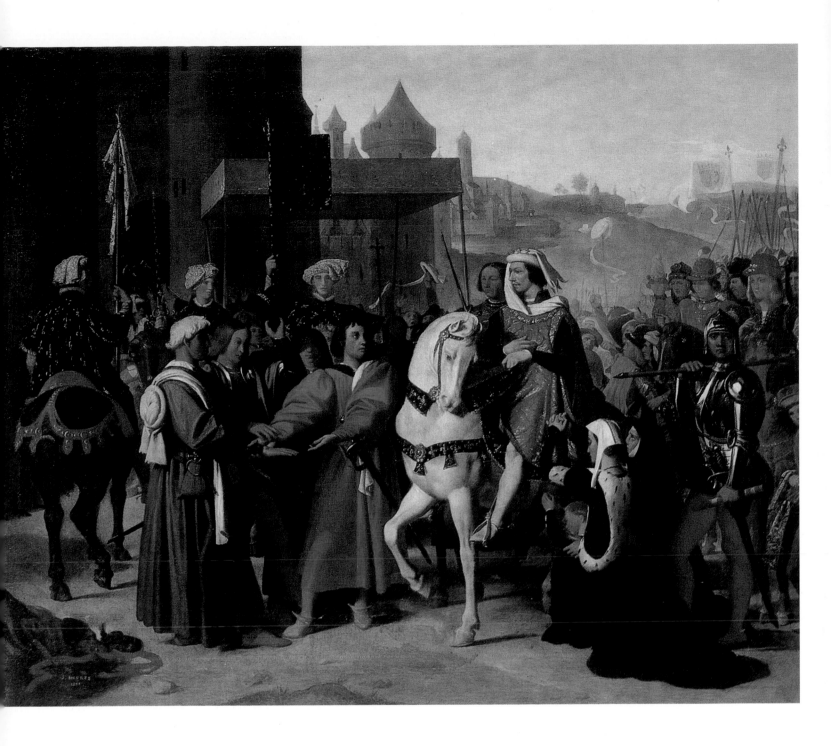

turist scale which, as in the best of Ingres's medieval history paintings, unifies the profuse visual riches in a tiny, shimmering microcosm of light, color, and uncannily sharp descriptive detail.

In its nostalgic yet archaeological celebration of the lost splendors of a Gothic past, Ingres's little panel painting participates modestly in the early nineteenth century's frequent efforts to recapture the pageantry of the Middle Ages, whether in novels like Scott's *Ivanhoe* (1820) or the actual coronation of Charles X at Reims Cathedral (1825), which Ingres was to attend. In more specifically pictorial terms, it continues as well the direction marked out by the Nazarenes, a group of German artists of Ingres's generation, who also worked in Italy in the first decades of the

century and who attempted to re-create the simple purity of form and feeling that they perceived in art, both Northern and Italian, before Raphael. In fact, a painting like Franz Pforr's *Entry of Rudolf I into Basel in 1273* (1809, fig. 93), with its archaic perspective, its vivid and clear colors and outlines, and its wealth of historical detail, may have stimulated Ingres's own impulses toward such reincarnations of late medieval style and subject matter. Quite soon, however, these noble triumphal processions, like so many of Ingres's favorite themes, became common coin in nineteenth-century art—witness Féron's *Entry of Charles VIII into Naples on May 12, 1495* at the Salon of 1837 (fig. 94), which vulgarizes Ingres's and Pforr's medieval dreams into a public panorama of cinematic exactitude and impersonality.

Figure 95.
Jacques-Louis David. MME. DE VERNINAC.
1799. *The Louvre, Paris*

MME. FRANÇOISE LEBLANC

Signed and dated 1823

Oil on canvas, 46 × 36¹/₂'

The Metropolitan Museum of Art, New York
Wolfe Fund, 1918

During a financially difficult four-year sojourn in Florence (1820–24), Ingres was assisted by a small group of friends who commissioned portraits from him. Conspicuous among the French patrons was Jacques-Louis Leblanc (1774–1846), a wealthy government official who remained in Florence after Napoleon's demise. In 1822–23, Ingres drew carefully finished standing portraits of both M. Leblanc and his wife, née Françoise Poncelle (1788–1839), and, as in the case of the Rivière family, he also painted portraits not only of the father and the mother, but one, now lost, of their daughter, Isaure.

The portrait of Mme. Leblanc, dated 1823, fully conveys the new mood of bourgeois respectability that began to permeate Ingres's female portraiture from the 1820's on, a mood that mirrors the changes in society and costume that followed the more libertine manners and fashions of the Empire. But it is also a portrait that maintains earlier traditions. Thus, her posture, carefully defined in a multitude of detailed preparatory drawings, recalls such Davidian prototypes as *Mme. de Verninac* of 1799 (fig. 95), which in turn looks back to such a famous Roman portrait as that of Agrippina, so often reincarnated in Neoclassic painting and sculpture. It is perhaps this classicizing pedigree that creates the particularly cool and imperious cast of Ingres's portrait. The head, like that in the David, seems purified to an almost perfect, frontal geometry, and the timeless relaxation and poise of the body establish an equally unprosaic calm. But this said, the Davidian and classical comparisons also reveal Ingres's predilection for a far more mannered and sensuous style. For one, the figure proportions, from the swanlike neck to the tapered fingers, have been even further attenuated to a state of weightless elegance that can rival Parmigianino; and the accessories have become so elaborate

that the David appears all the more Spartan by contrast. Moreover, the spatial milieu has been compressed and flattened: Mme. Leblanc's elbow and finger merge with the frame's lateral edges, and there is no ground plane left to provide a clear definition of the distance between the wall of the background and the chair arm of the foreground. And in the same way, the modeling is drastically minimized, so that the barely shadowed expanse of neck and shoulders, defined by an exquisitely sharp contour, seems reduced to a papery flatness.

The virtuoso variations that Ingres could play on the portrait theme reach coloratura extremes here. If Mme. Leblanc is less bejeweled than most of her predecessors, the fabulous circuit of her golden watch chain, which first remains obedient to the slow descent of shoulder and breast and then loops up at the right in an unexpected linear counterpoint, can compensate for this relative sobriety. And if her black dress initially strikes an austere note, this is soon contered not only by the tour de force of diaphanous black tulle that veils the indolent arms, but by the patterned intricacies of the Indian shawl in the foreground that reappears behind in a continuation of the puffed sleeve's welling contours and then joins the knot of black silk at the wrist, which in turn leads to the denser blackness of the purse. And for the first time in his painted portraiture Ingres introduces a fragment of a flower still life, which crowns the table's rich textural sequence of marble, mahogany, and gilt, and offers in its pastel bloom a visual complement to the pink softness and delicacy of Mme. Leblanc's complexion.

When this portrait was exhibited at the Salon of 1834, critics voiced their familiar complaints. One found the textures coldly alike, the flesh bloodless; another was horrified by the anatomy, and considered the sitter "a monster, whose head was cut short, whose eyes popped, whose fingers were shaped like sausages," distortions he likened to the perspectival warpings created by curved mirrors (A.D. Vergnaud, *Examen du Salon de 1834*, Paris, 1834, p. 18). Negative in intention, such comments nevertheless defined with surprising precision the astonishing liberties that resulted from Ingres's precarious balance between a glassy image of reality and a taut surface pattern of insistently abstract calligraphy.

COLORPLATE 26

THE VOW OF LOUIS XIII

Signed and dated 1824

Oil on canvas, 165³/₄ × 103¹/₈″

Cathedral, Montauban

In 1820, the Ministry of the Interior honored Montauban's native son with a commission for a painting whose subject was to disturb the artist for the full four years of his Florentine sojourn—Louis XIII placing France under the protection of the Virgin of the Assumption. Although this historical event of 1636, which was ritualized on February 10, 1638, had in fact been represented in earlier French art, as in the painting by Philippe de Champaigne (fig. 96), Ingres initially found the subject impossible. By his classical standards it violated the Aristotelian unities of time, place, and action in its collision of two separate events—one, a scene from seventeenth-century French history, the other, a great moment from the life of the Virgin. The result bears out the subject's curious duality and also demonstrates most clearly Ingres's eclectic approach to historical styles.

Thus, in the heavenly vision above and the inscription-bearing angels below, Ingres once more restates motifs borrowed from Raphael. In this case, the *Sistine Madonna* and the *Madonna da Foligno* (which Ingres had partially copied as a student) provide the timeless beauty that he felt could be revitalized in his own art. Indeed, these High Renaissance quotations, as painted by Ingres, still evoke much of their original breadth and spacious harmony. By contrast, the figure of Louis XIII belongs to a different visual mode allied to the sharply focused realism of Ingres's historical subjects. Unlike the generalized textures of the Virgin and Child,

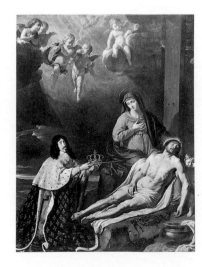

Figure 96.
Philippe de Champaigne.
VOW OF LOUIS XIII. 1638.
*Musée des Beaux-Arts,
Caen*

those of the monarch insist upon the distinctions between lace, velvet, and ermine, between the gilding of the fleurs-de-lis and the golden gleam of the proffered crown and scepter. The drapery patterns, too, alternate between a rounded, Raphaelesque fullness and a stiff and crabbed angularity that one critic found as displeasing as the harsh light that similarly separates the King from the soft, supernatural glow above. And even the colors shift accordingly, from the warmer radiance of the basic hues of the Virgin and attendant angels to the brittle iciness of the King's robes and of the sharp marble geometries on the floor tiles and tomb.

As Raphaelesque as the upper zone may at first appear, especially vis-à-vis the King, closer scrutiny reveals Ingres's characteristic transformation of his sources. Much as a Raphael pupil like Giulio Romano altered his master's inventions in the direction of a more chilly and devious style and expression, so too does Ingres add new dimensions to his High Renaissance prototypes. As compared to Raphael, the contours and surfaces have hardened and seem inscribed in a shallower space. And the psychology has changed too. The Virgin and Child have lost their candor; their heavenly reign now seems almost imperious. Indeed, the Virgin's downward, heavy-lidded gaze and full, rouged lips are saturated with Ingres's boudoir sensuality, announcing that strange amalgam of would-be innocence and an innate voluptuousness which was vulgarized in so much official religious art of the nineteenth century. Already at the Salon of 1824, a critic complained of the painting's willful and hence hypocritical sweetness, likening it to popular Madonnas carried by blind beggars and Christmas carolers (*Revue Critique des Productions...Exposées au Salon de 1824*, Paris, 1825, p. 152).

Nevertheless, *The Vow of Louis XIII* was widely acclaimed at the Salon, and established Ingres's position as an artist who could maintain traditional values against such younger heretics as Delacroix, whose *Massacres at Chios* was also exhibited. Afterwards, the *Vow* was returned to Montauban and, to the sound of a Cherubini mass, was finally installed in the Cathedral on November 20, 1826—first behind the main altar, and later in the left transept. The loss of genuine innocence implicit in Ingres's painting was made explicit by the provincial clergy's and congregation's embarrassment at the exposed sex of the Christ Child and of the two angels, which the artist was obliged to cover with gilded vine leaves that were later removed. In fact, on less trivial levels the equivocal character of this painting continues to discomfit many who find it flawed by its plagiarisms, its dual mode of vision, its courtesanlike Virgin. Yet it might also be asked whether Ingres's cool and incisive draftsmanship has not thoroughly reinvented Raphael, whether the opposing styles do not brilliantly convey the contrast of heavenly and earthly realms, and whether the Virgin and Child are not of an unforgettably arrogant and sensual majesty.

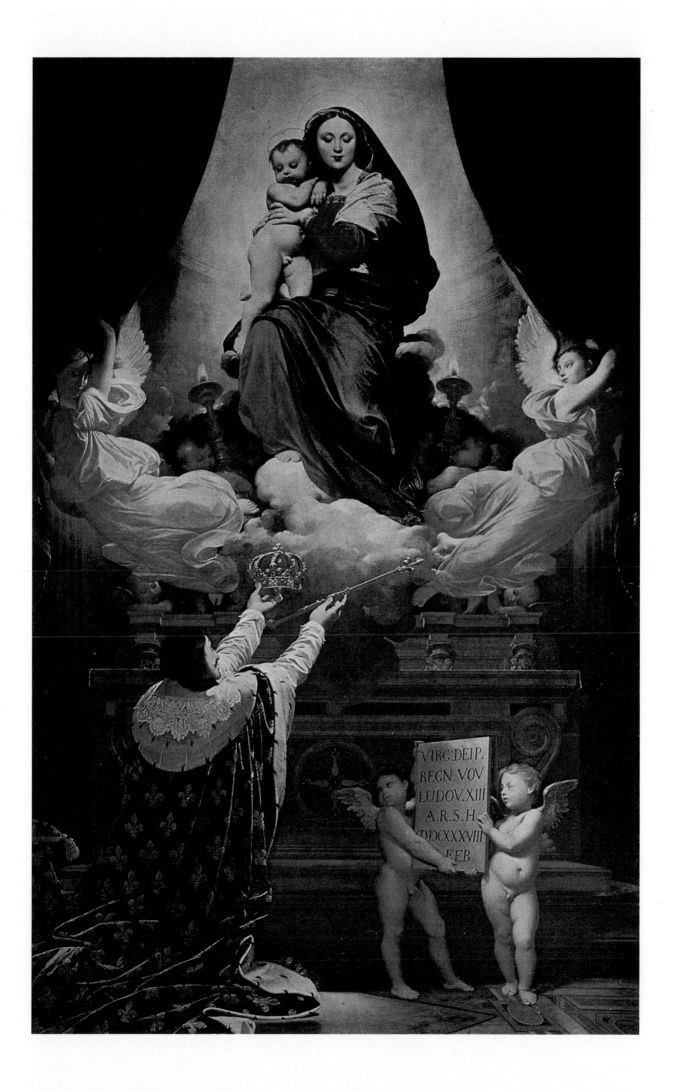

COLORPLATE 27

THE APOTHEOSIS OF
HOMER

Signed and dated 1827

Oil on canvas, 152 × 203"

The Louvre, Paris

Always respected but seldom loved, *The Apotheosis of Homer* has come to symbolize Ingres's most doctrinaire statement of his belief in a hierarchy of timeless values that are based on classical precedent. Commissioned in 1826 as a ceiling decoration in the Louvre, it was completed and exhibited in the following year. In 1855 it was removed from the ceiling and shown vertically, first at the Exposition Universelle and then at the Musée du Luxembourg. Finally, in 1874, it was returned to the walls of the Louvre, with a copy, still visible today, replacing it on the ceiling.

It is, in fact, a work that is better seen on a wall than from below, for its tiered, rectilinear structure makes no concession to the aerial illusions of traditional ceiling painting. Rather, its strict symmetry of figures and architecture attempts to revive the harmonies of Raphael's wall frescoes, the *School of Athens* and *Parnassus*. Ingres's choice of this most lucid of compositional schemes is in close consonance with the nature of his subject, which would deify a single genius to whom all subsequent generations are indebted. Like Zeus on Mount Olympus, Homer is located in splendid isolation at the apex of a slowly ascending pyramid of historical figures, both ancient and modern, who have come to venerate him. As in a Hellenistic bas-relief that Ingres knew, the blind poet is accompanied below by personifications of the *Iliad* and the *Odyssey*, represented here by a pair of Michelangelesque women who bear the attributes of a sword and an oar. Above, a hovering winged Victory crowns him with a laurel wreath. The architectural setting also contributes to this apotheosis, for the poet is seated like a cult statue before an Ionic hexastyle temple (derived from the Erectheum) that bears his name. At left and right, both above and below, this sacred precinct is enclosed by walls that isolate it like a proscenium.

Ingres's hierarchic pantheon of great men is not only characteristic of his century's love of encyclopedic Halls of Fame (witness, for example, the Walhalla, a Parthenon-inspired temple near Regensburg completed in 1842 as a shrine for great Germans of all historical periods), but is also steeped in those French academic traditions that, in the nineteenth century, grew more and more inflexible as they were challenged by modern dissenters. As if remoteness in time lent an aura of supernatural grandeur, the classical figures in this artistic genealogical table are placed in the higher middle stratum, where they are seen mainly in full length. As in a mirror, their greatness is paired—Aeschylus, with his scroll on the left, is reflected on the right by Pindar with his lyre; Apelles, with his brushes and palette, by Phidias with his mallet. Amid these classical semi-divinities, only two moderns are admitted: Raphael, who is led by Apelles, and Dante, who accompanies Vergil but stands in an intermediate position between the classical and postclassical worlds. Below, seen in half-length and cut off by the frame, another compendium of *homérides*, as Ingres called them, is presented. Two trios of great seventeenth-century Frenchmen echo each other—Poussin, Corneille, and La Fontaine at the left, Boileau, Molière, and Racine at the right. And at the lower corners, partly fragmented by the framing edge, three non-French writers may be seen, recently admitted, as it were, to this empyrean realm by the more progressive literary taste of the French Romantics of the 1820's—at the left Shakespeare and Tasso, at the right the one-eyed Camoëns.

When he saw the finished painting, Ingres's archaeologist friend, Désiré Raoul-Rochette, who had assisted with the Greek and Latin inscriptions on the steps, claimed that "it seemed like a fresco that had just been discovered under antique ruins" (*Journal des Débats*, November, 1827). Modern spectators, however, have tended to support the later judgment of Huysmans that the *Apotheosis* is a "glacial transposition in paint of an already mediocre bas-relief" (*Certains*, Paris, 1889, p. 211). Indeed, Ingres's reconstruction of the historic and aesthetic glories of a lost past has a synthetic quality that speaks of a willful determination to preserve moribund traditions in the face of the radically new experiences of the modern world. As in many other grandiosely symmetrical compositions of the nineteenth century, the clarity seems contrived rather than natural, an artificial attempt to resurrect the harmonies of Raphael and the antique. Moreover, the pervasive realism of Ingres's perception creates oddly photographic passages that produce an oil-and-water sensation in the context of these ideal forms. One recognizes, for example, the pigeon feathers that Ingres used as models for the wings of the Victory; and the portrait gallery of great men—scrupulously copied from such historical sources as Poussin's self-portrait in the Louvre (fig. 31) or Greco-Roman portrait busts—yields a pastiche effect of juxtaposed forms, like a composite illustration from the pages of the Larousse encyclopedia.

Still, Ingres's painting bears marks of its master's greatness, not only in the intensely personal seriousness of the conception, but in many formal inventions that compel close scrutiny. Thus, despite the strong recessive illusion that might be expected from the grave and measured ascent of the tiered steps and the enclosing side walls (inspired by the Poecile of the Agora at Athens), the painting is fascinatingly adjusted to those flattened surface patterns that obsessed Ingres, so that ultimately the figures appear to

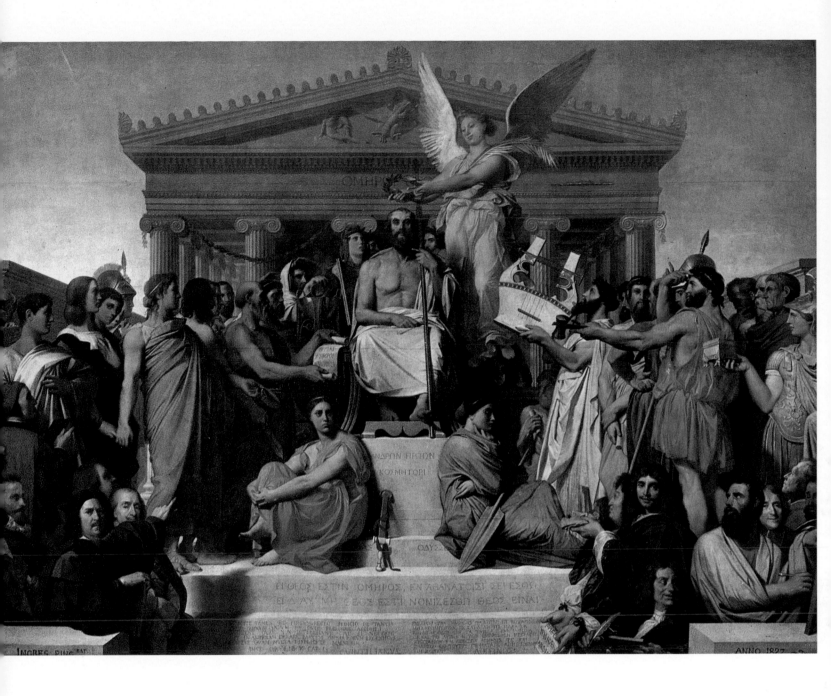

hover in a rising, shallow space rather than to obey the pull of gravity, which is so feeble here that the moderns below seem to float above an invisible ground plane. Shadowed and shadowless areas are adjusted to negate rather than to create depth: the temple façade (with its acroterium just touching the upper edge of the frame), the high steps below, the abundance of cameolike profiles all mark strong accents of two-dimensionality that constantly contradict such fully modeled passages as Homer's protruding left foot or the dark spatial pocket between Phidias and the sinuously flattened figure of Alexander the Great, who bears the casket containing Homeric manuscripts. As a result, the assembly of moderns appears to be absorbed into the same plane as the middle ground, and is merged with it by such beautiful continuities as the outstretched finger of Poussin that flows into the swiftly rising fold of Apelles' limpid blue draperies. The colors, too, contribute to this dialectic between surface and depth. The brilliant whites of Homer's draperies and the Victory's wings protrude from the back plane in contrast to the recessive qualities of the sober brown and black costumes of the moderns below; and the clarity of the local colors, whether of the blue sky or of the monochrome draperies, vie for foreground attention against the neutral tones of the architectural setting.

Ingres himself esteemed this painting as highly as any other, and from the 1840's to the year of his death, he projected a new version of it that would enlarge the roster of *homérides*. It might even be said that Courbet's most ambitious and consciously allegorical painting, his enormous *Studio* of 1855, reflects the authority of Ingres's *Apotheosis of Homer* by translating its classical deity and his attendant worshipers into the explicitly modern language of a no less centralized self-portrait of the contemporary artist-genius amid a vast assembly of respectful admirers.

COLORPLATE 28

LOUIS-FRANÇOIS BERTIN

Signed and dated 1832

Oil on canvas, 45³/₄ × 37³/₈"

The Louvre, Paris

Manet called this, the most famous of Ingres's male portraits, "the Buddha of the bourgeoisie," and it has indeed come to symbolize, in its sober and aggressive realism, the reign of Louis-Philippe. The sitter himself, Louis-François Bertin (1766–1841), was one of the great leaders of the French upper middle class, a businessman and journalist who, from 1799 on, directed the *Journal des Débats*, a newspaper that in 1830 actively supported the July Monarchy.

Ingres had particular difficulties in finding a suitable pose for the portrait of this burly, active sixty-six-year-old man, and first planned to show him standing. But one day, at an outdoor café, he suddenly observed a striking pose that his seated friend and student, Amaury-Duval, had taken, and immediately decided on this for the portrait, which was then rapidly finished. The result has the disarming reality of an intense confrontation with an actual person, described in microscopic detail. We may even feel at first that this is nothing more or less than an objective, almost photographic transcription of what Ingres saw, an effect underlined by the strong modeling in gray-brown tonalities that are relieved by only one tiny patch of color, the sharp red of the just visible chair seat.

Figure 97. Balthasar Denner. PORTRAIT OF AN OLD WOMAN. *Early 18th century. The Louvre, Paris*

It is soon apparent, however, that Ingres has constantly altered this scrupulous record of minute visual data to underline both psychological and aesthetic points. Thus, the sitter's nearly ferocious presence is achieved, for one thing, by the constriction of the space he occupies. At the right the chair back, like a huge clamp, tries unsuccessfully to contain his ample bulk, which is even more compressed at the left by the proximity of the Greek fret decoration on the wall. And the sense of vigorous force momentarily trapped, like an animal in a cage, is further accentuated by the vitality of the arms, whose springlike rhythms seem about to snap. The hands, too, participate in this coiled energy. Only the stubby fingers emerge from the arcing sleeves, and press or dangle impatiently upon the squarely set thighs. Still, the focus of this monolithic but restless figure is the head, which caps the swiftly rising and superbly animate black silhouette of the sleeves and shoulder line. Squeezed into a narrow starched collar, and crowned like an eagle by sharp curls of white hair, the tremendous density of M. Bertin's head almost assaults the spectator. The directness of the stare and position, however, is altered by the most subtle shifts of axis. Almost as if to balance the twist of the collar, the eyes, eyebrows, and mouth break the seeming symmetry and tilt upward to the more warmly shadowed half of the ruddy face. The resulting sense of an elusive, interior life makes the frontality of the gaze all the more hypnotic.

The descriptive realism of *M. Bertin* is as magically compelling as the psychology, and again recalls Ingres's fascination with the obsessive detail of much Northern painting. When the portrait was shown at the Salon of 1833, one critic claimed it resembled some curious portraits (which, in the 1830's, entered the Louvre from Louis-Philippe's collection) by the German Balthasar Denner (1685–1749), who, as a late survivor or early reviver of Eyckian realism, specialized in recording every last line on the faces of aged men and women, and even reflections of windows in their eyes (fig. 97). In fact, Ingres has done almost exactly this. Not only is the replication of wrinkles, hair, and folds of clothing astonishing, but, as in *Napoleon I on His Imperial Throne* (colorplate 7), even the mullioned window of the room is sharply reflected in the edge of the chair back. Once again, Ingres has harmonized the polarities of abstraction and realism, and has created as well one of the most vivid personalities in the history of Western portraiture.

M. Bertin, like most of Ingres's portraits, both reflects and establishes a period style in nineteenth-century French art, in this case creating an image that has long been associated with the bourgeois reign of Louis-Philippe. But if its businesslike directness can be found in other portraits of these years, its visual and psychological power is nevertheless unique, even in Ingres's own male portraiture, and was to be remembered by later portraitists. And it might even be said that the ghost of *M. Bertin* is revived also in the overwhelming presence of Picasso's portrait of Gertrude Stein.

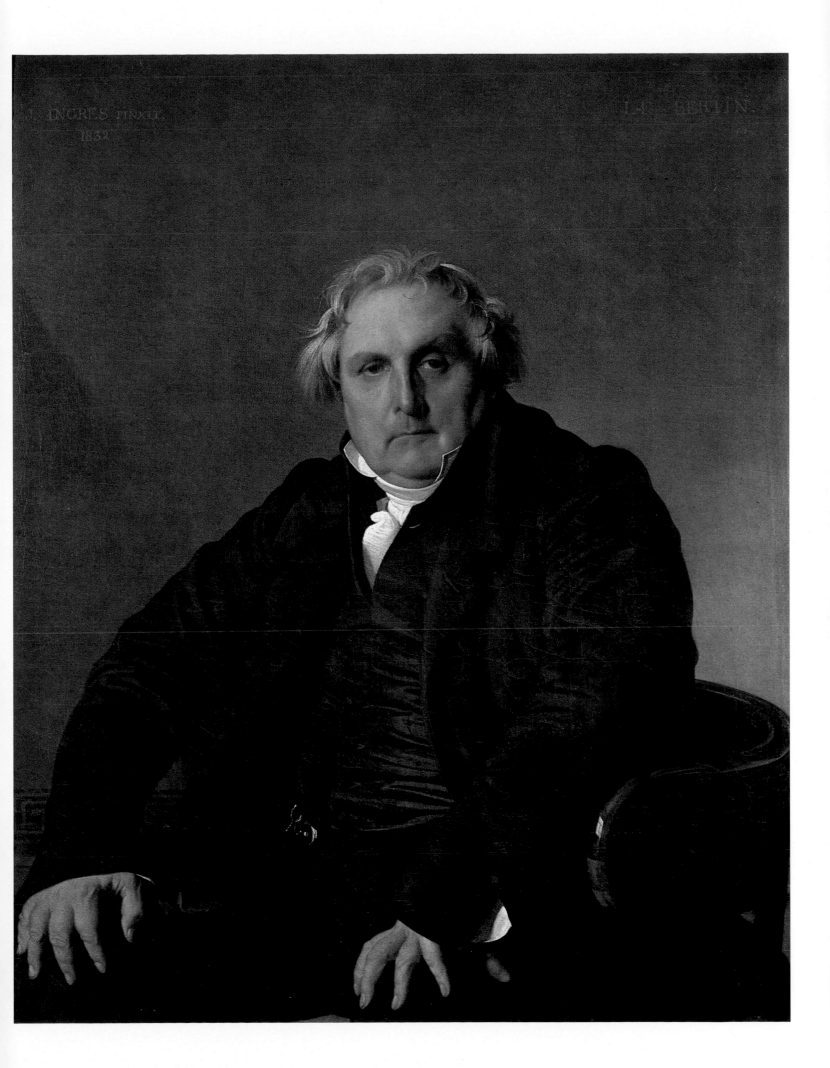

ROGER AND ANGELICA (ANGELICA SAVED BY RUGGIERO)

c. 1839
Oil on canvas, 18³/₄ × 15¹/₂'
The National Gallery, London

The theme of a voluptuous woman shown at a moment of extreme desperation inspired some of Ingres's most personal inventions. Like his Venus wounded in battle or his Thetis entreating Jupiter, the heroine of this curious scene is clearly in distress, in this case menaced by a monster. The subject, closely allied to such traditional classical and Christian legends as Perseus and Andromeda (which Ingres first had in mind), Hercules and Hesione, and St. George and the Dragon, is culled from a sixteenth-century source, Ariosto's epic poem, *Orlando Furioso* (Canto X, stanzas xcii ff.). Utterly naked and chained to a rock on the "Isle of Tears" (Isola del Pianto), Angelica has been left the victim of the Orc, a slimy sea monster. We see her at the moment of her imminent rescue by Ruggiero (or Roger, in English), who has arrived on his hippogriff, a hybrid creature that is half horse and half eagle and can both gallop and fly. Although, as Martin Davies has pointed out in the 1957 National Gallery catalogue (*French School*, London, p. 118), Ariosto

Figure 98. Ingres. STUDY FOR ROGER AND ANGELICA.
c. 1819. Black chalk heightened with white chalk on gray paper,
16½ × 12⅝″. *Musée Bonnat, Bayonne*

indicates that the Orc's mouth was poisonous and thus to be avoided, Ingres has nevertheless shown Roger striking the mouth with his long sword rather than dazzling the monster with the magic shield he carries under his arm, as he will, in fact, do in Ingres's last version of the subject (1859).

The London version reproduced here follows closely Ingres's first full statement of the theme for the Salon of 1819, although it contracts the original wide format to an even greater concentration of horrors. As in his odalisques, Ingres here steps fully into the ostensibly alien territory of Romanticism, creating a setting as fantastic as the players. The scene is a desolate coast line of savage rocks and foaming sea, weirdly illuminated above by a tiny beacon and below by abrupt alternations of dark shadows and milky, lunar light. The protagonists shift startlingly, too, from a knight in shining armor to a naked damsel, from a loathsome monster of the deep to a noble but equally fabulous beast.

Unlike Delacroix's later interpretation of a comparable theme, *St. George and the Dragon* (1847), in which details are swallowed by a murky, dramatic swirl of light and color, Ingres's painting freezes the action with a diminutive precision that singles out each figure for individual scrutiny. On the left, Ruggiero and his hippogriff are described, as in a preparatory drawing (fig. 98), with such miniaturist accuracy of detail that we can count the eagle feathers, or feel the textural contrast between outstretched claws, golden armor, and flying silk cloak. At the right, Angelica is equally isolated, an icily carved statue whose sleek but pliable flesh strikes a particularly erotic note when juxtaposed with silken hair, jagged rock, slimy scales, savage teeth, bristling feathers, and gleaming metal. Angelica, in fact, is one of the most astonishing of Ingres's nudes, a helpless creature whose body seems to have been artfully manipulated for both formal and expressive reasons. Against the tense, incisive contour of her back, her head falls in pitiful anxiety, the goitrous throat puffing like a dove's, the large eyes rolling tearfully in the direction of the hero. Her arms, like those of the wounded Venus, are of an uncanny elasticity, first extended to the imprisoning chain, and then released in a limp cluster of fingers. The feminine frailty of head, arms, fingers, and breasts is then further underlined by the slender waist and thighs, whose converging contours finally join at the knee and taper off to a weightless point at the ankle. Indeed, despite the apparent palpability of objects as heavy as rocks and armor, the whole painting produces a curiously unreal, diminutive effect, as if we were watching a puppet show in which a tale of medieval chivalry is enacted. Even the head and hands of the hero are delicately shrunken to these tiny proportions that give the painting a bizarre but pervasive coherence. It is not surprising that critics who saw the first version at the Salon of 1819 were bewildered by this archaic style, and accused Ingres of willfully regressing to the fifteenth-century infancy of painting.

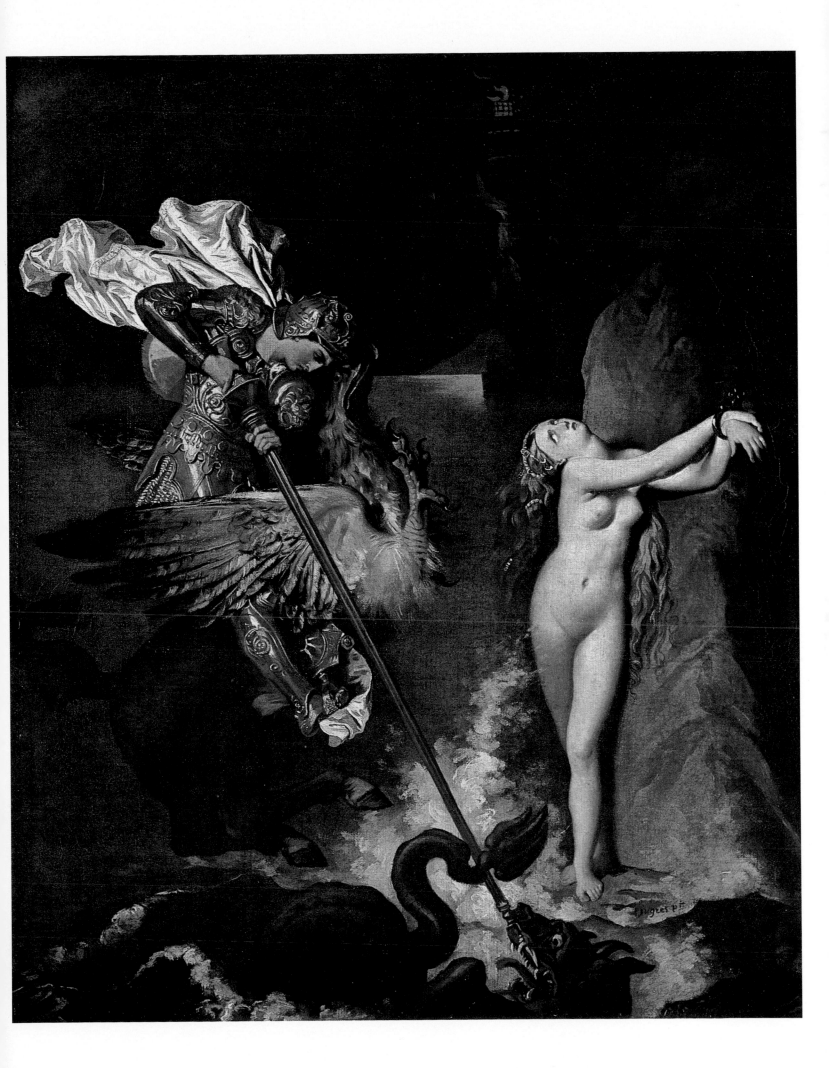

COLORPLATE 30

ODALISQUE WITH SLAVE

Signed and dated 1839; completed 1840

Oil on panel, 28¹/₂ × 39¹/₂ʼ

The Fogg Art Museum, Cambridge, Massachusetts
Grenville L. Winthrop Bequest

As early as the *Grande Odalisque* of 1814 (colorplate 20), Ingres had been fascinated by the cloistered sensuality and exoticism of a Near Eastern harem. In the late 1830's he once again took up this theme, in a painting commissioned by his faithful friend M. Marcotte, whose portrait he had painted in 1810 (colorplate 12). Typically for Ingres's later style,

Figure 99. Ingres. SLEEPING WOMAN. C. 1808.
Pencil, 6 × 10¾". *Musée Ingres, Montauban*

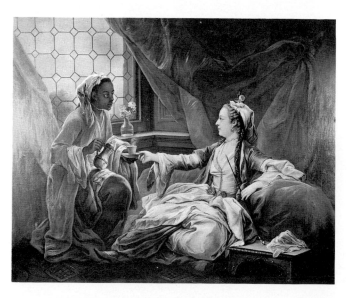

Figure 100. Carl Van Loo. THE SULTANA. 1755.
Musée des Arts Décoratifs, Paris

this new odalisque both borrows from and expands upon earlier motifs. In this case, the nude is a variation on the lost *Sleeper of Naples* of 1808, whose pose—ultimately based upon the classical statue of Ariadne and prefigured in countless Renaissance sleeping nymphs and Venuses—was restated by Ingres in many minor paintings and drawings (fig. 99). But now the engrossing voluptuousness of the single nude must compete for attention not only with two other figures —a music-making slave and a Negro eunuch—but also with a visual environment whose obsessive insistence on a multitude of exotic decorative motifs recalls the patterned surfaces of a Persian miniature. Whether in terms of the abstract geometries of the upper walls, fountain, balusters, and floor tiles, or the stylized floral designs of the lower walls, the slave's and eunuch's costumes, and the rear pillows, the entire picture surface is crowded with this luxurious proliferation of ornamental detail. The colors and textures are no less profuse in their variety, constantly assaulting our eye with such harsh juxtapositions as those afforded by the collision of the astringent reds of the columns with the warmth of the curtain at the right or with the resonant red-and-gold brocade of the slave's hat at the left.

Yet, astonishingly, the ultimate effect is one of a serene yet rigorous harmony, the product of a taut structural network that, like a sequence of Chinese boxes, reduces the large rectangular and cubic zones into ever smaller and more compact rectilinear units. And against these intricate mosaic geometries of surface and depth, the undulant abandon of the odalisque herself seems all the more wanton. Half swathed in white draperies like an Oriental Venus, her body swells and contracts, rises and falls with fluent, caressing rhythms that run an unbroken course from the tips of her toes to the prodigiously supple and fleshy juncture of tiny ear, bent elbows, and curled hand and fingers amid a slow and widening stream of golden hair. Her skin, so much paler than that of the slave or eunuch, elaborates the icy eroticism of the *Grande Odalisque* in its titillating fusion of rounded breasts and belly with contours almost as cold and metallic as those of the columns in the background. And upon this flawless surface of unwrinkled, boneless flesh, the jewels of the necklace and earring become as exquisitely sensual as the

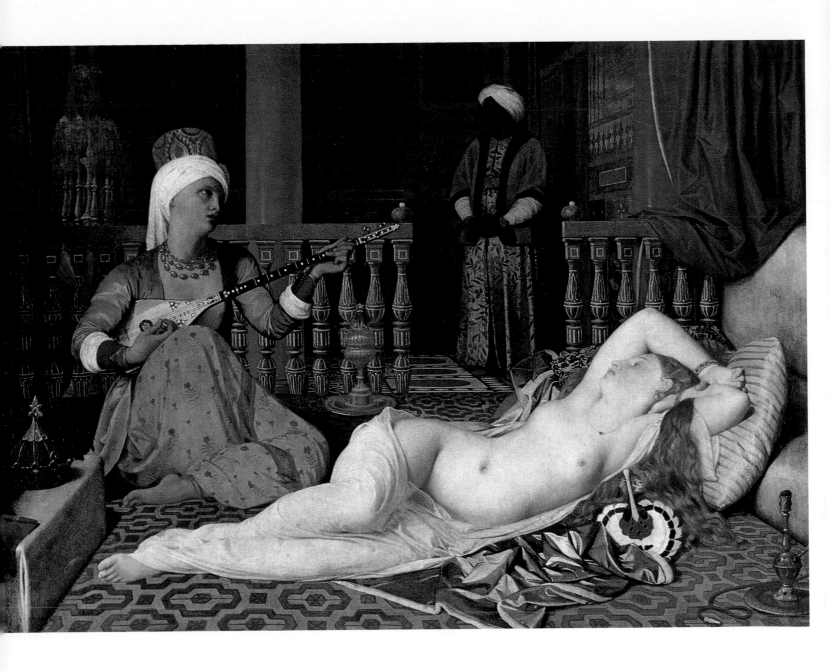

pink mouth, nipples, and navel. Yet even this libertine creature is subjected to the disciplines of Ingres's pictorial order —the sinuous circuits of her body and jewelry are reflected in the cobra curls of the hookah in the right foreground, the relaxed extension of her leg rhymes exactly with that of the slave behind, the cushioned slope of her head and torso rises in unison with the thin fingerboard of the tar, an Oriental lute. By such artful means the bewildering abundance of separate, jigsaw puzzle components is suddenly crystallized into an immutable whole.

Ingres's attraction to the feminine languor of the harem and his scrupulous reconstruction of its exotic contents, both animate and inanimate, were hardly unique to the mid-nineteenth century and mark yet another point of contact with the art of Delacroix, whose *Algerian Women* Ingres had seen at the Salon of 1834. Already in French eighteenth-century art, scenes of sultanas and odalisques by masters like Carl Van Loo (fig. 100) were introduced into an increasingly exotic repertory, and by Ingres's time such subjects flourished in France and abroad: witness only Léon Bénouville's own variation of 1844 on Ingres's theme (fig. 10), or the more chaste and Victorian interpretation of a light-flooded harem and its occupants by the British painter John Frederick Lewis (fig. 11). And even after Manet's *Olympia* of 1863, which so irrevocably translated the odalisque and slave into the modern language of a prostitute and maid, this vision of an erotic Arcadia, still surviving in the Oriental world, continued to inspire modern painters from Renoir to Matisse.

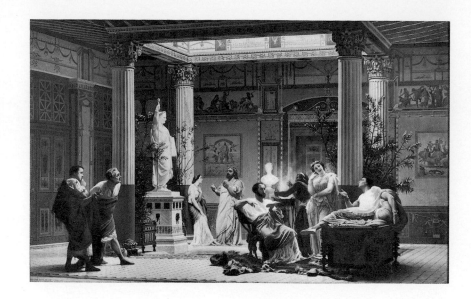

Figure 101. Gustave Boulanger.
REHEARSAL OF "LE JOUEUR DE FLÛTE" IN THE
PRINCE NAPOLEON'S POMPEIAN HOUSE.
1861. *Musée National, Versailles*

Throughout his life, Ingres was intrigued and touched by the strange, quasi-incestuous story of Antiochus and Stratonice, recounted in Plutarch's *Lives* and re-created in many operas and paintings. The narrative concerns Antiochus, whose secret love for his stepmother Stratonice made him suffer from what seemed an incurable illness. However, a doctor, Erisistratus, who was called in to cure the youth, finally diagnosed this clandestine passion as the cause of Antiochus' waning health. In order to save his son's life the father, Seleucus, with extraordinary charity, gave him his own wife. Already in a drawing of 1807, Ingres had illustrated this erotically complex drama, as his master David and another David student, Girodet, had done before him; and he was later to paint many other variants on the theme, of which this version, commissioned by the Duc d'Orléans in 1834, is the first fully elaborated interpretation.

Especially by contrast with the 1807 drawing, which adapts the lean and stiff stylizations of early Greek art, this painting of 1840 reveals the growing intricacy of Ingres's later style. Like the *Odalisque with Slave* of the previous year (colorplate 30), it creates upon a stagelike space a hermetic environment that is recorded with lacquered perfection. In this case the milieu has changed from the Near East to ancient Rome, but the sense of an exquisitely wrought profusion of decorative patterns remains the same. Appropriate to the subject, Ingres—with the assistance of his students Paul and Raymond Balze and the architect Victor Baltard—attempted to reconstruct the polychrome luxury of a Roman home replete with such classical details as the wall paintings that illustrate the deeds of Hercules, the glistening bronze statue of Alexander the Great, the columns whose lower shafts are painted Pompeian red, a Medusa-headed shield, and an elaborately canopied bed for which a small model, still visible in the Musée Ingres, had been made. Indeed, in some ways the painting resembles a dollhouse crammed with so much archaeological information that it might serve as a museum display or as a classical handbook for students at the École des Beaux-Arts.

Yet for all its insistent erudition, Ingres's account of a Roman domestic drama is instilled with a rare poetry of form and feeling. The narrative structure produces a mood of hushed revelation, in which the totally despairing figures of the prostrate father, the grief-stricken servant who leans against the column at the right, and the pale and feeble son whose heart palpitates so tellingly at the presence of his stepmother are set off as sorrowful dramatic foils to the wise doctor, about to disclose the truth, and above all, to the mysteriously solitary Stratonice, who reincarnates the classical statue of Polyhymnia (fig. 44). Her eyes averted from her family, her arms contained within the slender sheath of her torso and draperies, she stands as isolated as a column, a *femme fatale* whose disturbing beauty has caused this scene of distress.

No less refined than the unraveling of this subtle drama is the Epicurean ambiance of wealth, with its thin, elegantly tapered columns and rich array of classical ornamental moldings and painted borders. Within these more stable, architectonic members, the drapery patterns weave about with a nervous, quivering fluidity which ranges from the seductive flutter of Stratonice's tunic to the broader rhythms that describe the passionate desperation of her husband. The colors are equally supple, offering, as in a collection of rare gems, the most fragile tints of lilac, salmon pink, icy orange. And, as always in Ingres's finest work, there is a constant interplay between patterns of flatness and depth, which here even extends to such visual conceits as the close juxtaposition of column and pilaster, statue and painting.

For Ingres and for other mid-century artists, writers, and patrons, these visions of the effete and extravagant beauty of late classical antiquity could at times even be realized in living fact. Thus, in the 1850's, the Prince Jerome Napoleon had built for himself a Pompeian home in Paris, where he and famous friends like Gautier and the actress Rachel might dress in antique clothing and enact classical dramas. As recorded by the painter Gustave Boulanger in 1861 (fig. 101), such events translate the imaginative world of Ingres's painting or Gautier's own Parnassian poetry into the materialistic prose of aristocratic life under the Second Empire.

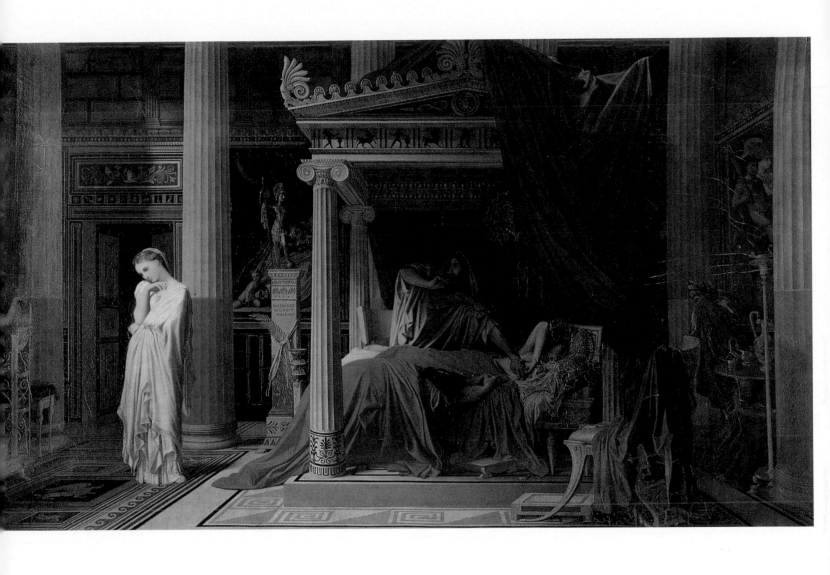

COLORPLATE 31

ANTIOCHUS AND STRATONICE

Signed and dated 1840
Oil on canvas, $22^1/_2 \times 38^5/_8''$
Musée Condé, Chantilly

THE COMTESSE
D'HAUSSONVILLE

Signed and dated 1845. Oil on canvas, 53¹/₄ × 36¹/₄"
Copyright The Frick Collection, New York

In his later years portrait painting, especially of wealthy and aristocratic women, became for Ingres an increasingly laborious task that demanded the lengthy and meticulous preparations which he felt would be better expended on history painting. Yet, happily for posterity, some of his patrons coerced him into exerting his maximum pictorial efforts on a sequence of great female portraits of the 1840's and 1850's, which is auspiciously announced by that of the Comtesse d'Haussonville (1818–1882), the beautiful sister-in-law of the Princesse de Broglie (colorplate 36). A woman of learning, the Comtesse in her later years was to publish historical romances based on the dramatic lives of Lord Byron, Marguerite de Valois, and the Irish revolutionary, Robert Emmet. Twenty-four years old when her portrait was projected in a painted sketch of 1842, she had not only aged three years by the time of its completion, but had also become a mother. Writing to Marcotte on June 18, 1845, Ingres expressed his tremendous relief at finishing the work, but also his regrets that he had not quite caught all the charms of the model.

For us, at least, the portrait is of an uncanny perfection, fully encompassing its creator's genius. In psychological terms, its mood continues and expands the feminine mysteries of Stratonice (colorplate 31), whose reference to such classical prototypes as the muse Polyhymnia (fig. 44) is further elaborated in the Comtesse's meditative stance. These learned allusions, however, are thoroughly transformed into a modern expression that is at once serene and disquieting. Alone within her luxurious environment, the Comtesse is further isolated by, for one, the sense of enclosure created by the oblique corner view, and, for another, by the pairing of chair arms and vases at her left and right. But, above all, it is the mirrored background, first introduced in the portrait of Mme. de Senonnes (colorplate 21), which evokes a hypnotic aura of private reverie, an unexpected reflection that complicates, rather than answers, the questions posed by the pensive tilt of the head or the elusive gaze of the eyes.

The magic of this nineteenth-century sphinx lies as well in the painting's perfect reconciliation of the two ostensibly contradictory styles that Ingres had always kept in precarious balance—a glassy transcription of reality that seems almost photographically indiscriminate, and a no less acute sense of abstract order. Thus, the sheer description of luminous surfaces is as dazzlingly intense as in a Van Eyck or a seventeenth-century Dutch still life, whether we choose to concentrate on the intricate pleats of the satin dress, whose chilly gray-blue echoes the Comtesse's eyes; the gleam of the tortoise-shell comb only visible in the mirror; the delicate profusion of half-real, half-illusory flowers in the two Sèvres jardinieres; or the tiny window reflected in the sheen of the black binoculars as it had been, earlier, in Napoleon's throne or M. Bertin's chair (colorplates 7, 28). But this visual surfeit is at the same time chastened by a severe pictorial discipline. The head, crowned though it is by soft strands of hair, is of a geometric clarity worthy of Raphael, who might have admired, too, the perfect crescents of the eyelids. The contours of the figure as a whole, with their supple rhythms that connect the shifting axes of head, arms, and waist, sharply silhouette the Comtesse against a shallow background that seems to flatten almost entirely the oblique juncture of the wall planes in the corner. Indeed, so inevitable is this abstract order that we can even accept such familiarly Ingresque violations of reality as the extraordinary length of the right arm or the optically incredible reflection of the shoulders.

Typically, these larger patterns are embellished by a multitude of minor inventions. For instance, the tautly twisted threads of the bellpull, which at first seem to be part of the straight mirror edge at the left, subtly break away from this parallelism, disappear behind the vase, and finally relax in the fluffy blue tassel; and the delicate curl of the Comtesse's coyly poised index finger reverberates not only in the fingers of her right hand, which join the folds of her dress at a surprising variety of angles, but in such accessories as the looping ormolu handles of the Oriental vases and the rococo twist of the sconce and its reflection. And the colors are no less controlled. Within a range of unusually light tones, as icy as a mirrored surface, Ingres has restricted his palette to pale blues, grays, golds, browns, and whites that seem all the cooler by contrast to the prodigious detail of the red hair-ribbon and red rose and their filmy pair of reflected images.

If Ingres was never to surpass this portrait in its mysterious dialogue between multiple levels of visual and psychological realities, he was later at least to challenge it on equal terms in another mirror portrait, *Mme. Moitessier Seated* (colorplate 38).

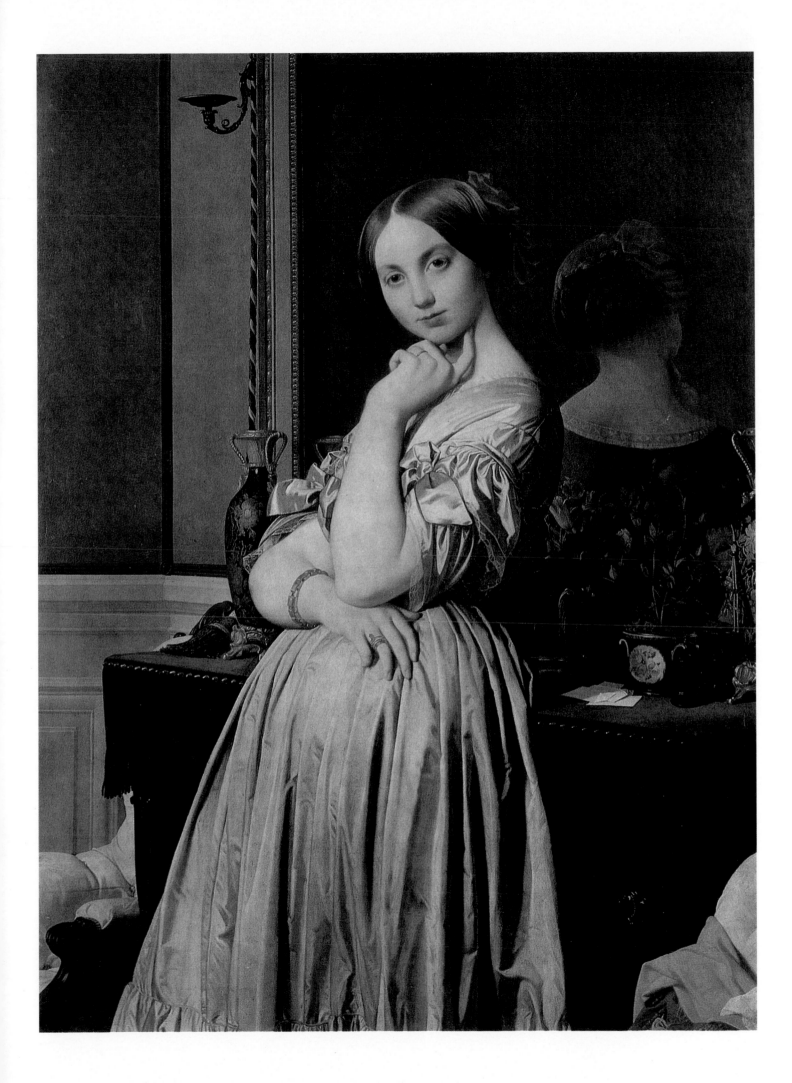

COLORPLATE 33

VENUS ANADYOMENE

Signed and dated 1808 and 1848

Oil on canvas, 64¹/₈ × 36¹/₄″

Musée Condé, Chantilly

Figure 102.
Ingres. STUDY FOR VENUS
ANADYOMENE. C. 1807.
Ink and pencil, 7½ × 3¾″.
Musée Ingres, Montauban

With its rounded corners, polished surfaces, and sinuous frontality, this painted Venus resembles an antique cameo suddenly invested with warm, pulsating life. Its origins, in fact, date back to 1807, when Ingres was especially attracted to the exquisite linear sensuality of Greek vases and reliefs, and to the comparable forms that could be found in the paintings of the Italian primitives. Not surprisingly, then, Ingres's first drawings for *Venus Anadyomene* (fig. 102)—that is, the newborn Venus emerging from the sea—take close inspiration from Botticelli's famous reinterpretation of classical Greek beauty in terms of a sharp outline of fabulously supple grace. One foot on a sea shell, and, as the penned inscriptions indicate, surrounded by zephyrs who would adorn her with a necklace and with roses at her head and feet, Ingres's early Venus was to have expressed her first awareness of modesty by assuming the classical pose of the Venus Pudica.

However, completion of the painting was constantly postponed, and although Ingres first intended to finish it for Florentine patrons in the early 1820's, it was not until June 1848 that his Venus was finally born, bearing the inscription J. INGRES FACIEBAT 1808 ET 1848. This delay of forty years produced inevitable changes of conception and style. For one, Venus is now shown at an earlier, more innocent moment when, not yet having looked at the proffered mirror, she is still unaware of her nudity. Yet Ingres's rendering of the flesh is, if anything, more overtly palpable and sensuous than we might imagine it to have been in the original painting. For if a Botticellesque flavor still clings to the incisive contours, whose compactness obliges even arms and fingers to conform to an enclosing linear shell and to the curving patterns of the framing edge, other passages strike a different note. The strongly shadowed modeling of Venus' right leg and of the attendant Cupids produces a rounded, sculptural effect that partly contradicts the flatness of Ingres's early work and conforms more to the stronger naturalism of Ingres's late style, particularly as seen in *La Source* (fig. 58). Could this transformation to a new, more corporeal ideal of classical nudity have been effected by an equally famous Renaissance painting of a marine goddess—Raphael's *Galatea* (1514)—which, in fact, seems to have inspired such details as the red-eyed, wriggling dolphin or the Cupid who has just shot his arrow?

If close scrutiny may reveal a visual disparity that reflects the double date of the inscription, the overall effect is nonetheless of a fresh and radiant reincarnation of Greek beauty. Unlike Chassériau's somber and mysterious interpretation of the theme of 1838 (fig. 66) or such later academic paraphrases of both Ingres and Raphael as Bouguereau's *Birth of Venus* of 1879, Ingres's *Venus* is of a Mediterranean limpidity that extends from the deep blue expanse of sea, sky, and sunlit horizon to the immaculate smoothness of the flesh. Slowly, the statuesque body comes to life through an abundance of caressing details. Above, the languorous fingers braid a cascade of auburn hair and loosen a trickle of glistening pearls. Below, a quartet of dove-winged Cupids fondle the goddess of love with pudgy hands and cheeks that cushion her as tenderly as the foamy sea upon which she floats. At the left and right, the undulant arabesques of a golden mirror and Cupid's bow announce the erotic domain over which she will preside. And in the background the calm, flat extension of opaque blue water, against which the goddess is silhouetted, is delicately broken by the rippling movements of tiny nereids.

Such a precious, enameled vision of antiquity heralds the equally chiseled verbal perfection of the Parnassian poets' classicizing verse, which also sought to describe the Greco-Roman world in terms of a cool but sensual imagery of ivory flesh, rare gems, and erudite detail. Not surprisingly, Gautier, who was to be one of the leaders of the Parnassians, found in Ingres's painting the re-creation of his own dream of antiquity. When he wrote about Ingres's picture in 1848, he claimed that no work could give a better idea of the lost masterpieces of classical Greek painting. "The Venus Anadyomene of Apelles has been rediscovered," he announced. "May the arts no longer mourn its loss!"

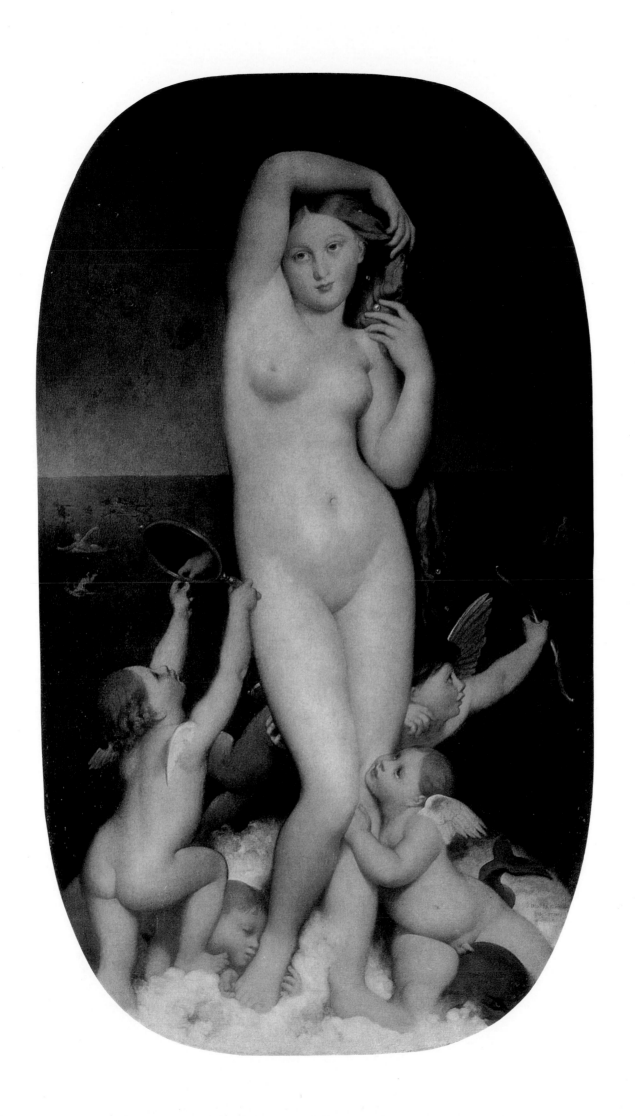

Figure 103. Ingres. STUDY FOR
THE BARONNE DE ROTHSCHILD'S DRESS. C. 1848.
Black chalk heightened with white chalk
on brown paper, 13 × 10¼″.
Musée Ingres, Montauban

BARONNE JAMES
DE ROTHSCHILD

Signed and dated 1848

Oil on canvas, $55^7/_8 \times 39^3/_4''$

Private collection, Paris

Of the sequence of female portraits Ingres painted in the 1840's and 1850's, none is so beguiling as that of the Baronne James de Rothschild, née Betty de Rothschild (1805–1886), a woman whose beauty inspired Heine's poem *The Angel*. Yet for all its seductive ease, the portrait was the product of particularly arduous labors. Returning from Rome in 1841 to a triumphant reception by Parisian academic officialdom, Ingres felt all the more strongly dedicated to the superiority of history painting over portraiture. "Damned portraits," he was to complain in 1847. "They are so difficult to do that they prevent me from getting on with greater things that I could do more quickly." However, his fame as a portraitist recommended him to the wealthiest Parisian patrons, and upon his arrival in 1841 the Baronne requested to sit for him. After refusing this commission for two years, Ingres finally met the lady at a ball, and, finding her irresistible, agreed to paint her. But it was only in 1848, after a false start and many detailed studies of the accessories (fig. 103), that Ingres completed the work.

The Baronne's seven-year wait was magnificently rewarded in a portrait that remains perhaps the most sumptuous yet approachable image of mid-nineteenth-century opulence. First disarmed by a confrontation almost as direct as in the portrait of M. Bertin (colorplate 28), the spectator is then caught in a delicious rivalry between the dense and shimmering luxury of the Baronne's costume and the relaxed and enticing poise of the Baronne herself. Her arms and legs crossed, her tilted head delicately supported by a supple curl of wrist and fingers, she presides from the cushioned comfort of a velvet sofa; and, as Gautier observed when he saw the portrait in Ingres's studio in 1848, she ap-

pears to be caught in the midst of an elegant soirée, enjoying a vivacious and witty conversation.

Were it not for two brilliant pictorial inventions, the sheer optical dazzle of the Baronne's beribboned satin robe might overwhelm the more fragile charm of her personality. But the potential surfeit of an elusive cerise tone that is alternately cold and warm, sweet and sour, is countered by the surprising sobriety of the upper half of the painting, a flat expanse of quiet, gray-green flowered damask that muffles the glistening stuffs below. Moreover, the upward extension of this wall plane is unusually high, so that the head appears lower and more isolated than is customary in a seated portrait, and hence all the more compelling.

The weaving together of the disparate luxuries that adorn the Baronne achieves one of the highest moments in Ingres's art. For instance, the deep wine-red velvet of the cushions not only provides an exquisite chromatic and textural transition between the silvery pink of the dress and the muted, neutral tones of the wall, but also extends more gently the swiftly arcing contours of the shoulders and collar line. The prodigal jewelry, too, contributes to these rich minor harmonies; the gleaming accents of pearl, turquoise, and pink mirror the broader contrast of blue-white lace and cerise satin, and even reverberate in the tones of the flesh. Above all, the head is the object of the subtlest embellishments. The nearly perfect oval of the face is first sharply crowned by a jewel-encrusted pin on a black velvet toque, and then softened by the more undulant paired crescents of the hair and ostrich plumes. Below the chin, these rhythms appear inverted in the double necklace of pearls that joins the sinuous contours of the fingers and finally converges on the lace collar in a tight cluster of pearl strands that echo more nervously the velvet tassel of the cushion at the right, which, in turn, is varied in the glimpse of fringe below the damask.

So saturated is the Baronne's portrait with a sense of innate and easy splendor that we feel it could take its place most comfortably in any gallery of Renaissance and Baroque royal portraiture. Indeed, the flattening, heraldic effect of the inscribed name and the Rothschild coat-of-arms at the upper right adds a final, decisive touch in Ingres's transformation of the mid-nineteenth century's material wealth into a timeless icon of aristocratic grace and beauty.

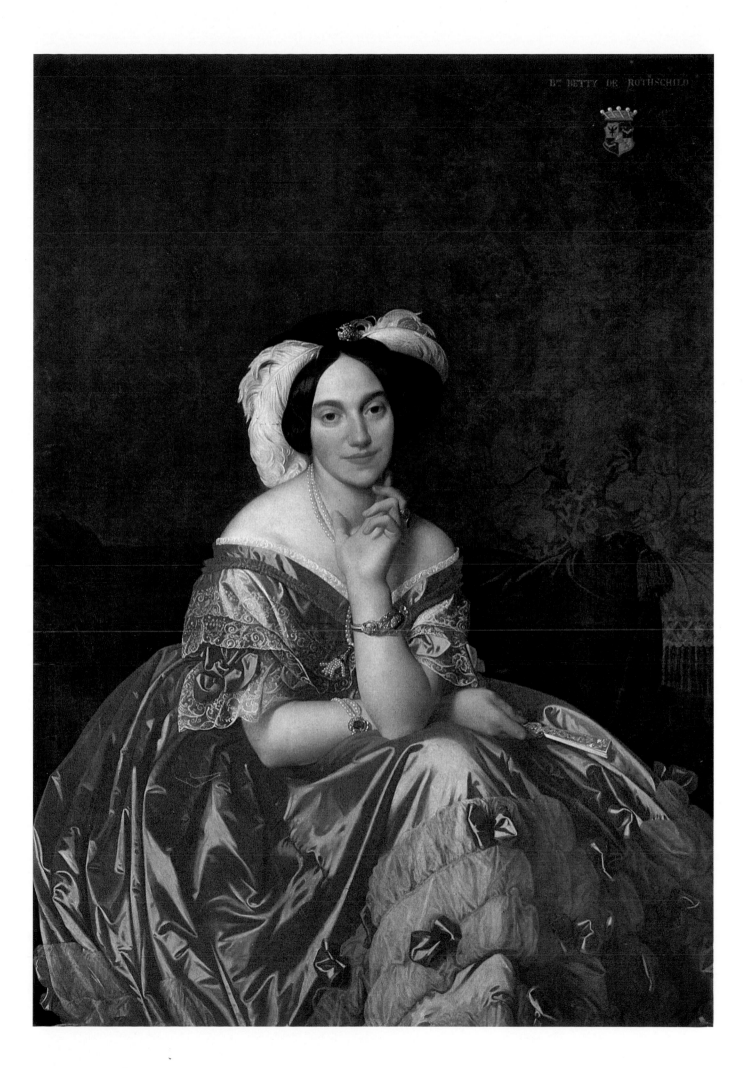

Figure 104.
Ary Scheffer. MME. CAILLARD.
1842. *Petit Palais, Paris*

MME. INÈS MOITESSIER

Signed and dated 1851

Oil on canvas, 58¹/₄ × 40'

The National Gallery of Art, Washington, D.C.
Samuel H. Kress Collection

As was often the case in his later years, Ingres first resisted a commission to paint yet another portrait, this time that of Mme. Inès Moitessier, née de Foucauld. But again, after meeting the lady one evening in 1844, he finally accepted what was to become a particularly difficult chore. His labors were to produce not one but two portraits, worked on over an unusually long period, from 1844 to 1856. Ingres's first idea was to paint Mme. Moitessier seated with her daughter, Catherine, at her side; but the child, whom the artist first found "*charmante,*" soon became "*insupportable,*" and was finally omitted. In the summer of 1851, however, Ingres—whose conscience may have been pricked by Mme. Moitessier's polite reminder that she had already been waiting seven years for her portrait—temporarily abandoned the seated version (colorplate 38) and painted relatively quickly the standing version reproduced here.

The result of these endeavors is the most imperial and commanding of Ingres's female portraits. Placed against a flat magenta damask that provides the secular equivalent of a medieval gold background, Mme. Moitessier stands high above the spectator with the superb aloofness and imperturbability of a classical goddess or a Byzantine Madonna. Indeed, the stark directness of Mme. Moitessier's head, surrounded by a halo of roses and closely aligned upon a central axis of symmetry, transforms her into the kind of female deity, Greco-Roman or Christian, that Ingres attempted to re-create in such works as *The Vow of Louis XIII* (colorplate 26) or *The Virgin with the Crown* (fig. 3). Yet characteristically for Ingres, the hieratic frontality of Mme. Moitessier's gaze and posture, which might have turned into an inert formula, is intriguingly complicated in psychological and visual terms. The haughty serenity of her expression, for example, becomes more and more disquiet-

ing, thanks to the wall-eyed stare that prevents a static confrontation; and in the same way, the line of symmetry that bisects the sleek black hair and runs down the nose and mouth is suddenly broken by the most devious circuits. Thus, if the magnificently smooth and boneless shoulders at first appear forced into a symmetrical pattern, they soon reveal subtle imbalances that are enlarged upon by the tense opposition of the strands of the pearl necklace, which swiftly turn to the right, and the comparably arcing rhythms of the neckline, which, momentarily fixed by the brooch, then turn quite as abruptly to the left. Moreover, the simple clarity of the head is constantly countered by the abundance of material adornments—the diaphanous layers of black tulle and lace that flutter about her dress, the multiplication of rings and bracelets, the casual array of evening accessories on the gilded chair—objects that appear like lavish votive offerings to a sacred image.

For finally Mme. Moitessier transcends this luxurious world of tangible embellishments through a strange impalpability that is in part the product of her goddesslike features and in part the result of the contracted space that half denies her corporeal presence. Thus, her black dress and shawl become inky silhouettes against the insistent flatness of the paneled dado and damask wall, and even the marmoreal modeling of her shoulders is ultimately compressed to a heraldic two-dimensionality. And as a final contradiction in this both natural and supernatural creature, the pudgy, beringed fingers look almost too weightless and frozen to grasp securely either the curl of pearls or the gilded fan which hovers on the picture plane, strangely suspended in a sea of immaterial black.

Such icons of elegant portraiture were familiar in mid-nineteenth-century art: witness Ary Scheffer's *Mme. Caillard* of 1842 (fig. 104), in which the décolletage and smooth, polished hairline and shoulders belong to the same mode of beauty as Mme. Moitessier's. But in Ingres's interpretation of this ideal, the nineteenth-century world of material grace and wealth is transformed into a haunting, timeless image of feminine grandeur and mystery that far transcends the prosaic vagaries of fashion.

COLORPLATE 36

THE PRINCESSE
DE BROGLIE

Signed and dated 1853

Oil on canvas, 41³/₄ × 34⁵/₈″

The Metropolitan Museum of Art, New York.
Robert Lehman Collection, 1975

Figure 105. Ingres. STUDY FOR
THE PRINCESSE DE BROGLIE.
1853. Pencil, 11¾ × 6¼″.
Musée Bonnat, Bayonne

The short-lived Princesse de Broglie (1825–1860), née Pauline Eléonore de Galard de Brassac de Béarn, was the sister-in-law of the Comtesse d'Haussonville, whom Ingres had already painted in the 1840's (colorplate 32). Begun in 1851 and completed in 1853, this portrait of the young wife of Jacques-Victor-Albert, Prince and later Duc de Broglie, evoked Ingres's familiar complaints about the difficulty of painting portraits, which for him even involved preparatory studies of the underlying anatomical structure (fig. 105) that would ultimately be concealed by the elaborate accessories of costume and furniture obligatory in his society portraits of the 1840's and 1850's. In June, 1852, he wrote to his friend Marcotte that this portrait would be his last, except for that of his new wife, Delphine.

He was right. Although he was later to paint a few portraits of his wife and himself, that of the Princesse de Broglie was in fact the last to be begun, if not the last to be completed, of Ingres's great series of aristocratic portraits. As such, it tends to offer masterful variations on themes already explored, while casting its own unique spell, particularly in the unexpectedly melancholy, even troubled expression of the small, tightly pursed lips and the unfocused gaze of the almond-shaped eyes. But most striking is the overall tonality of breathtaking coolness, in which the glassy chill of the *Comtesse d'Haussonville* descends to an even more extreme temperature that excludes all but the most glacial modulations of gray, white, blue, and gold.

As in the portrait of the Baronne de Rothschild (colorplate 34), Ingres has set into tension a flat and evenly textured background with an active foreground in which the feminine appurtenances of Second Empire splendor are densely crammed. In this case the wall plane, with its taut rectilinear structure of fine moldings, is of a spareness that harks back to the ascetic elegance of Ingres's earliest portrait backgrounds. However, these lean geometries, reflected in the thin gold necklace, are suddenly countered by the fluttering pyramid of crystalline textures that begins with the marabou plumes and blue hair ribbons, swells into the shimmering mull collar and sleeves, and expands broadly in the glistening juxtaposition of the frosty blue satin hoopskirt, the pale gold damask chair, and the white-and-gold shawl which leads, as in the 1851 portrait of Mme. Moitessier (colorplate 35), into a still life of glove, fan, and evening wrap.

As always, the compositional clarity of the broader patterns is complicated by a multitude of minor intricacies and visual conceits. Thus, Ingres's familiar dialogue between flatness and depth reaches an exquisite counterpoint here in the compression of the burgeoning volumes of the figure and the furniture against a bare plane whose two-dimensionality is affirmed by the coat-of-arms in the upper right. For one, the ovoid form of the head is contracted by the incisiveness of the far contours of cheek and hair, just as the sinuous rhythms of the collar and shoulders appear to join the flat line of the molding behind them. Even the overall posture, which would conform to the gracious and easy bearing of a princess, participates in these spatial tensions: witness the position of the right arm, which, by rhyming with and disappearing into the oblique angle of the shoulders, tautly encloses the volume of the torso. And, as further embellishments to this supple interplay between two and three dimensions, there are such inventions as the slow, irregular curves of the upper edge of the sofa and the cord of the bellpull that challenge the rectilinear severity of the adjacent moldings; or the flattened echo of the modeled volume of the left hand, which emerges from a multiple looping of pearls, in the equally relaxed fall of the glove's white fingers on the chair arm.

Yet, for all the elaborate animation in these minor adornments, the portrait's ultimate effect is one of utter silence and calm.

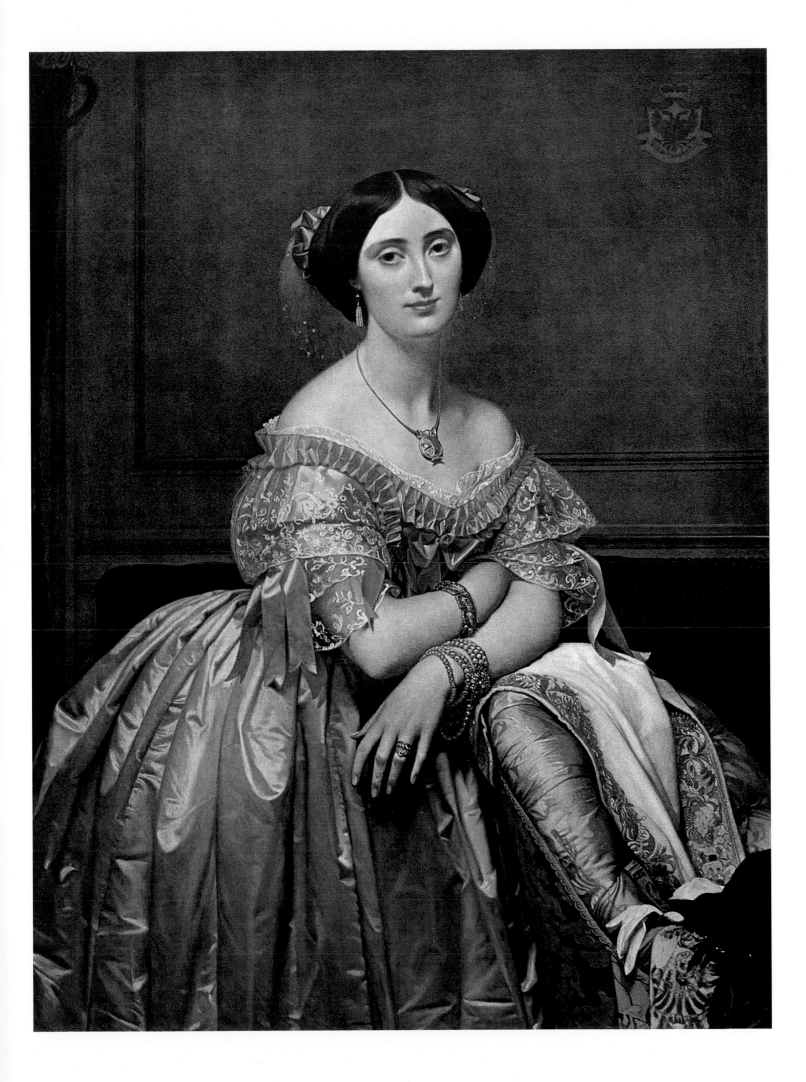

COLORPLATE 37

JOAN OF ARC AT THE CORONATION
OF CHARLES VII

Signed and dated 1854

Oil on canvas, 94¹/₂ × 70¹/₈"

The Louvre, Paris

In 1851, M. de Guisard, Director of Beaux-Arts, provided Ingres with a State commission of 20,000 francs. The artist offered two appropriately official paintings, both completed in 1854— *The Virgin with the Host* (fig. 26) and a scene from the life of Joan of Arc. In representing this heroine of French sacred and secular history, Ingres joined a half-century-old tradition of honoring the Maid of Orléans in sculpture and painting. Already in the early nineteenth century, in statues and pictures by such minor masters as Gois, Le Comte, Révoil, Lair, and Eugène Devéria, episodes from the life of Joan of Arc were displayed in public squares and in the Salons; and a critic discussing Paul Delaroche's *Joan of Arc in Prison* at the 1824 Salon even recommended her glorious career as a fecund source for artists seeking new subjects (C.P. Landon, *Salon of 1824*, I). In the early 1840's, at a time when Jules Quicherat began to publish his learned historical investigations into Joan of Arc's life (*Procès de Condamnation et de Réhabilitation de Jeanne d'Arc*, Paris, 1841–49), Ingres made a drawing that was to be engraved in the 1844 edition of *Le Plutarque Français*, a historical compendium of the lives of great French men and women. It shows Joan at the height of her fortunes, attending the coronation of Charles VII at Reims Cathedral in 1429, after the successful siege of Orléans. But later, in the painting, Ingres elaborated this scene beyond the official request for a single figure. Now Joan is accompanied by the monk Jean Paquerel, kneeling in prayer; by the equerry Doloy; and by a trio of young pages. For these additions, Ingres received an extra 5,000 francs.

Like Charles X's own coronation at Reims in 1825 or the Neo-Gothic churches that rose in France in the nineteenth century, Ingres's painting is crammed with precise archaeological details that would reconstruct the pious yet sensuous glories of a Christian past. As in his earlier view of the Sistine Chapel (colorplate 19), Ingres is intrigued here by the trappings of Christian art and ritual, whether we turn to the view in the upper left-hand corner of Gothic polychrome columns and stained glass pierced by light rays, or to the array of gold liturgical objects in the right foreground, which includes reliquaries, the jewel-encrusted royal crown resting on a velvet cushion brocaded with fleurs-de-lis, the gilded halos of a triptych by an Italian primitive painter, and the swinging censer with its rising fumes.

In keeping with this medieval environment, the mood evoked is one of intense piety, in which a militant yet saintly creature is venerated. Armed like a warrior, triumphantly holding the two-pointed oriflamme embroidered for her by the women of Orléans (with its motto, "Jesus-Maria"), Joan of Arc looks heavenward, past the golden hair, halo, and fleurs-de-lis that encircle her noble head. At the left, she is adored not only by the three pages and the monk, but also by Ingres, who has made the head of the equerry a self-portrait, as if the artist himself wished to join the worshipers. Below, this aura of Christian sanctity is underlined by the tablet on which a quotation from the Romantic writer Emile Deschamps is inscribed: "et son bûcher se change en trône dans les cieux" ("and in heaven, her stake is transformed into a throne").

If by twentieth-century standards this nineteenth-century revival of Christian sentiment may seem equivocal, it should not blind us to the visual fascination of Ingres's painting. Like the late portraits, especially *Mme. Moitessier Seated* (colorplate 38), *Joan of Arc* has an extraordinary density, in which an abundance of weighty objects is compressed into a shallow space. In this case the effect is of a strange but compelling harshness, with the most acid collisions of textures and colors. Thus, the searing red of the oriflamme's staff is sourly echoed in the smaller passages of red that decorate the prayer book, the inscription, the triptych, the altar; and the insistent metallic gleam of armor and liturgical objects is juxtaposed to surfaces of silk, velvet, flesh, and hair. These brittle dissonances are, in part, peculiar to the mid-nineteenth century—witness such Parisian Neo-Gothic churches of the 1850's as Boileau's St. Eugène or Gau's Ste. Clotilde—but Ingres has also imposed his own personality upon this French equivalent of High Victorian style. Thus, the painting betrays Ingres's genius in many details—the rhyming of the metal helmet and glove below with their fleshy counterparts in Joan's own head and hand above; the obsessive reiteration of ornamental geometries that unite foreground and background; the contraction of the far contour of Joan's head to conform to the flat circle of the halo; the shimmering clarity of the light that catches the tiniest shadows and reflections and lends the whole an uncanny realism.

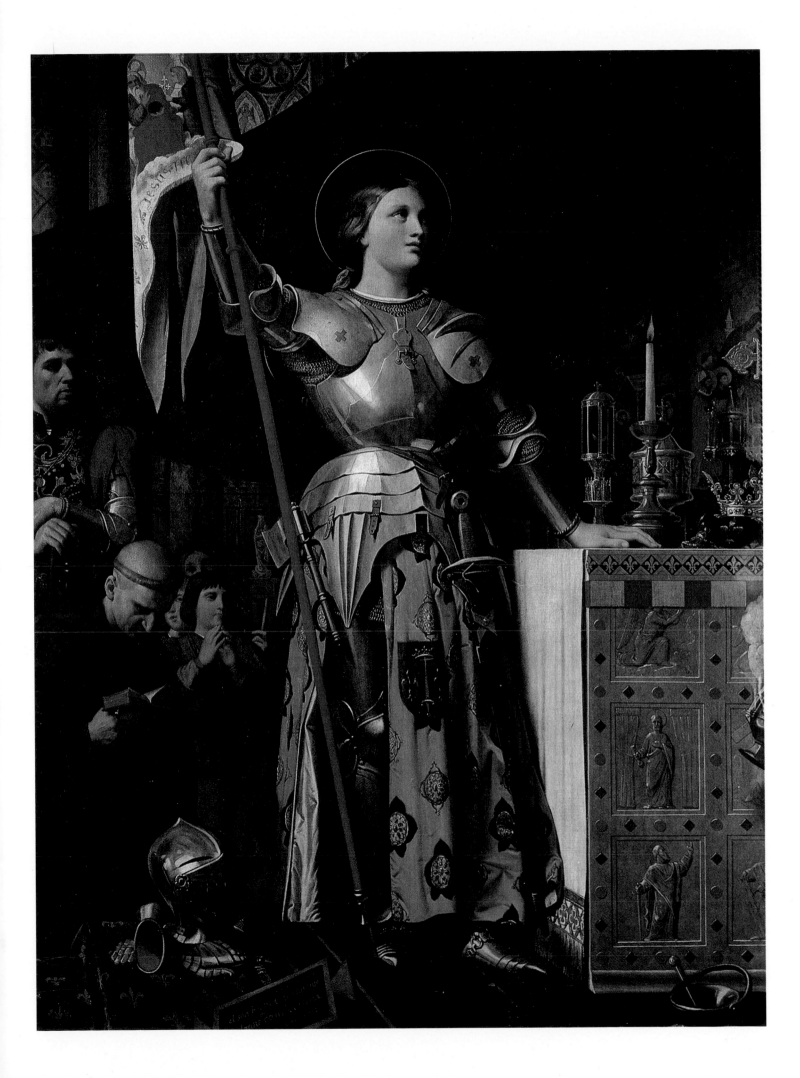

Figure 106. HERCULES AND TELEPHUS.
Roman fresco from Herculaneum.
Museo Nazionale, Naples

MME. INÈS MOITESSIER SEATED

Signed and dated 1856
Oil on canvas, 47¹/₄ × 36¹/₄"
The National Gallery, London

In 1856 Ingres at last completed the first version of the portrait of Mme. Inès Moitessier, which had been commissioned in 1844 and which was originally intended to include her daughter, Catherine. Interrupted in 1851 for the standing version (colorplate 35) and resumed in 1852, this product of some fourteen years of fitful labor remains one of the most serene and yet disturbing of Ingres's late portraits, elaborating even further the Olympian realm of the 1851 interpretation of the model. For here, Mme. Moitessier appears in a posture of equally timeless tranquility, borrowed in this case from a classical figure—the personification of Arcadia in a Roman painting well known to Ingres and his circle (fig. 106). As in the *Comtesse d'Haussonville* (colorplate 32), such references to an antique prototype of ideal harmony are again perfectly fused with Ingres's prodigious descriptive powers, so that this portrait stands at one of the high points of Ingres's late style, a combination of the most overtly sensual and material wealth with a more covert world of formal order and psychological mystery.

At first, the dense luxury of Second Empire costume and *décor* dazzles the eye, above all in the cornucopian outburst of printed roses that spills across the silk dress, and then in the compounding of this splendor through the tufted damask of the sofa, the amethyst bracelet, the glimpse of a fan and oriental vase on the Rococo console, the gilded ornament of the mirror frame. Yet ultimately this *nouveau riche* opulence is subordinated to a strange silence and calm that completely contradict the portrait's initial assault upon our senses of sight and touch. For one, the mirror image that occupies the upper half of the painting provides a dull and hazy reflection that challenges the vivid clarity of the material world below; and within this reflected realm, more rigorous patterns of rectilinear moldings, panels, candlesticks, door and mirror frames impose a remote, almost secret order on the foreground's extravagance of curves. Indeed, the formal invention of this painting is surprising even for Ingres, whether one considers the fluent linear circuits that curl around the head, slip through the fingers, necklace, and ribbons, and come to a gentle conclusion at the relaxed juncture of the gently spreading fan and left hand; or the interplay between tangible surface and mirrored depth that creates flattened echoes of rounded flesh, curling Rococo ornament, and the lace-and-ribbon flurry of a *cache-peigne* cap.

Yet this dialogue between a real world and its dreamlike, immaterial reflection is not merely visual; it also involves the personality of the sitter to an extent that transcends even the earlier mirror images in *Mme. de Senonnes* and the *Comtesse d'Haussonville* (colorplates 21, 32). A pampered creature of flesh as plump and cushioned as the sofa beneath her, she nevertheless becomes an enigmatic presence whose beauty Gautier already described in 1847 as "Junoesque" when he saw the painting in an unfinished state (*La Presse*, June 27). The final impression, in fact, is of a modern oracle presiding in the padded comfort of a mid-nineteenth-century drawing room. Her right hand, as pliable as a starfish, is posed weightlessly against her cheek and temple, as if enforcing her uncommon powers of wisdom and concentration; and her eyes, compressed forward with the total volume of the head, appear to observe us both directly and obliquely. And to enrich even more this aura of a tangible yet remote being, Ingres has cast her reflection in pure profile, a ghostly sibyl who gazes as sightlessly as a marble statue into an invisible world. Inspired by Poussin's *Self-Portrait* (fig. 31), in which a female personification of the art of painting appears amid a background of rectilinear frames, Ingres has translated such a traditional allegory into a more modern language of psychological mystery and evocation. It is hardly surprising, then, that in many portraits of the 1920's and 1930's which attempted to unveil the secrets of feminine mind and beauty, Picasso would allude (fig. 71) to both the pose and the mirror imagery of Ingres's great portrait.

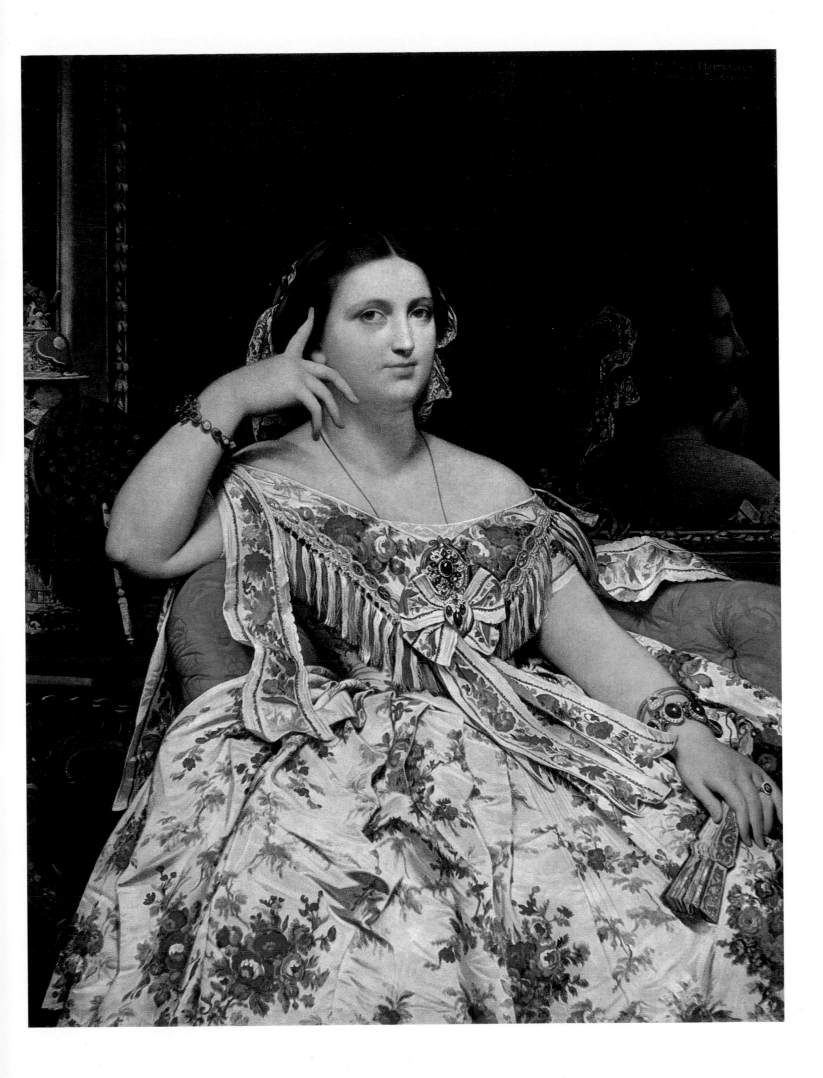

COLORPLATE 39

THE GOLDEN AGE

Signed and dated 1862

Oil on paper pasted on panel, 18¹/₄ × 24¹/₄

The Fogg Art Museum, Cambridge, Massachusetts

Grenville L. Winthrop Bequest

Himself an archaeologist learned enough to publish works on Greek vases, medals, and coins, Honoré-Théodore-Paul-Joseph d'Albert, Duc de Luynes, decided to decorate the grand hall of his château at Dampierre, some twenty miles southwest of Paris, with a Neo-Greek ensemble that was to include a polychrome statue of Athena, reconstructing that of the Parthenon, and mural paintings of a Greek subject. In September, 1839, Ingres received a commission of 70,000 francs to provide these wall decorations, and, probably in consultation with the Duc, chose a pair of murals illustrating the Golden Age and the Iron Age. With the assistance of students, Ingres began work in August, 1843, and actually resided at the château with his wife, Madeleine. These decorations, however, were never to be completed, thanks in large part to an increasingly tense and unhappy relationship between the artist and his patron. First seeing *The Golden Age* in 1844, the Duc was not only disappointed by the mural, but embarrassed by its abundant nudities; later, many of his aristocratic friends were similarly shocked. Finally, in 1850, Ingres and the Duc agreed to abandon the project, leaving *The Golden Age* in a nearly complete state and *The Iron Age* in only a preparatory one.

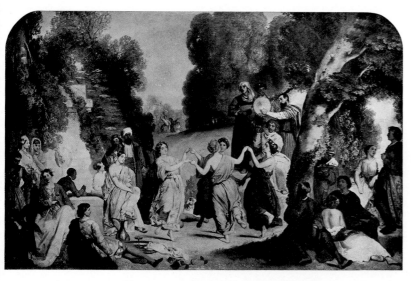

Figure 107. Louis Boulanger. DANCE OF THE MUSES (panel from dining room of Pierre Malher). 1849. *Musée Carnavalet, Paris*

Although its small size belies the monumental ambition of the wall painting, a later replica of *The Golden Age*, painted in 1862, offers a more attractive and full statement of Ingres's intention than the original mural at Dampierre. The scene takes us to that most archaic of historical periods, the mythical Golden Age, described first by Hesiod and then by Ovid. An Arcadian world of milk and honey, it offers the classical counterpart to the Garden of Eden before the Fall of Man. At the left, a party of the happy, nude populace clusters around the robed figure of Astraea (the personification of Justice), and enjoys her gifts of love and virtue. In the exact center, a scene of primitive religious rites presided over by a worshiping priest takes place around a stone altar covered with sacrificial fruit and encircled by a ring of dancing maidens, robed and nude, who represent the three Hours, the three Graces, Venus, and Hebe. At the right, the bountiful pleasures of this world are represented by a group of seated and reclining figures who have no other occupation than eating fruit, drinking milk, and being strewn with fresh flowers. In the upper distance, the giant figure of Saturn surveys the people in his happy domain. Throughout, the landscape is inhabited by gentle animals—a lamb, a dog, a rabbit, a family of deer, a horse—symbolic of such virtues as docility, fidelity, fecundity.

Characteristically for the nineteenth century's acute historical consciousness, Ingres here combines two major traditions of Western figure painting. On the one hand, the broad, symmetrical structure oriented to a lunette format deliberately revives, as did the earlier *Apotheosis of Homer* (colorplate 27), the imposing harmonies of Raphael's frescoes. On the other, the display of sensuous indolence, tinged with nostalgia for a lost classical world of erotic freedom, evokes a more Venetian tradition, and, in particular, such French variants upon it as Watteau's *fêtes champêtres* and visits to Cythera, which Ingres had studied in preparing *The Golden Age*. Moreover, the work offers a doctrinaire summary of Ingres's own faith in a classical style of ideal harmony and beauty. Thus, the painting provides almost an academic dictionary of studies after the nude, in which ideal anatomies, both male and female, are presented in a multitude of different postures and movements. These figures, in turn, are linked together in broader, more rhythmically fluent groups that are finally to be subsumed by the spacious tripartite landscape, with its two side wings of trees and its central vista of a limpid, Mediterranean blue sky and distant mountain range.

Yet these learned efforts to resurrect the noble artistic world of Raphael and ancient Greece are, in part, threatened by curious contradictions of style and conception that are not only Ingres's, but those of the nineteenth century. For one, the ideal beauty imposed on the figures and landscape is constantly countered by strong realistic undercurrents of almost photographic precision. The glassy reflection in the pond at the right; the miniaturist accuracy of the dog,

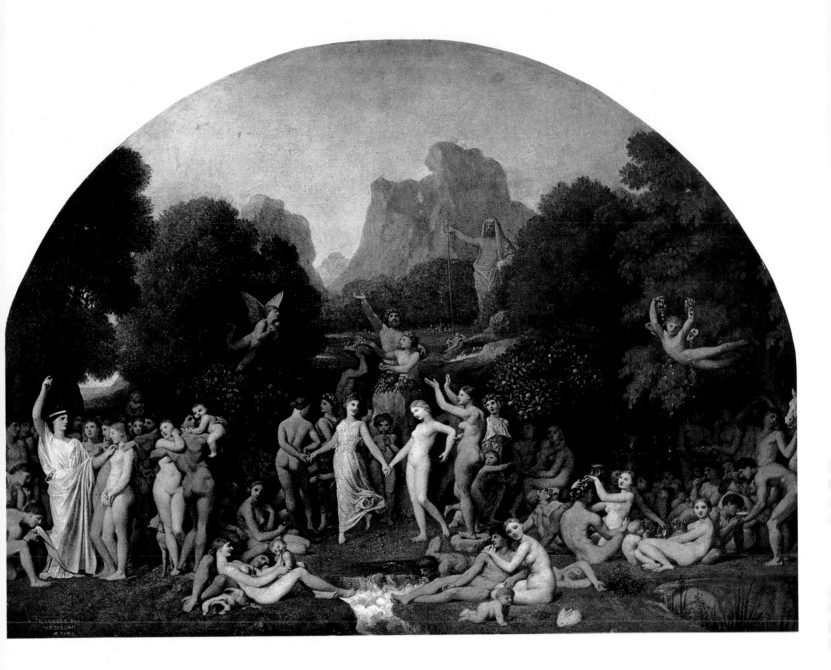

rabbit, or tiny spring flowers that bud in the grass; the occasional passages of very particularized bone and muscle structure in figures of otherwise ideal flesh—such elements betray the same materialistic viewpoint that is revealed in the painting's almost clandestine eroticism, which makes this "lot of beautiful and lazy people," as Ingres called them, members of the same self-consciously voluptuous race as the occupants of his *Turkish Bath* (colorplate 40). Moreover, the rhythmic fluency of these Renaissance figure groupings at times appears static and contrived, as if the tradition that Ingres clung to so stubbornly were truly moribund. Thus, one often tends to excerpt single figures for individual scrutiny, rather than fusing them into a total unity that absorbs the separate parts. Yet, given the historical difficulties of maintaining classical ideals in the mid-nineteenth century, Ingres's painting succeeds not only in its overall evocation of a classical earthly paradise, but in its abundance of exquisite inventions that include the taut yet delicate sinuosity of the dancing maidens, the glistening sparkle of ripe fruit and air-borne flowers, the prodigious variety of flesh tones.

Such nineteenth-century evocations of Arcadian leisure and sensuality could even be found in more consciously progressive circles. For example, the Romantic master Louis Boulanger executed a decorative panel, the *Dance of the Muses*, for the dining room of Pierre Malher, that offers an exotic counterpart to Ingres's painting—a Romantic costume party that included portraits of M. and Mme. Victor Hugo (fig. 107). But it was primarily the art of the Bouguereaus and the Cabanels of the later nineteenth-century Salons that sustained and vulgarized Ingres's classical vision against such modern, secularized translations of the Arcadian theme as Manet's *Déjeuner sur l'Herbe* or Seurat's *Sunday Afternoon on the Island of La Grande Jatte*. Yet the vitality of Ingres's conception was not to be extinguished. In both structure and theme, Matisse's great *Joy of Life* of 1905–6 (fig. 70) triumphantly resurrects, in the freshest of twentieth-century styles, Ingres's faith in the classical tradition.

COLORPLATE 40

THE TURKISH BATH

Signed and dated 1862; completed 1863

Oil on canvas, diameter 42¹/₂'

The Louvre, Paris

An erotic daydream of an elderly painter, Ingres's view of a women's bath in Turkey provides the exotic counterpart to the languorous classical nudes that populate his *Golden Age* (colorplate 39). The motif of feminine voluptuousness as disclosed uninhibitedly within the confines of Near Eastern baths and harems had always attracted Ingres, and at the end of his life he was to paint his last and most profligate variation on this theme. The scene is specifically inspired by one of the letters of the learned and adventurous Lady Mary Wortley Montagu, who, at the time of her husband's appointment as ambassador to Constantinople, visited and vividly described the sequestered sensuality of a women's bath in that city (letter of April 1, 1717). There she saw some two hundred nude women, some of exquisite beauty and whiteness of skin, all engaged in the pleasures of indolence —bathing, gossiping, taking coffee and ices, spraying perfumes, combing their hair.

Ingres had copied this passage in his notebooks as early as 1819, and he may also have known an engraving of 1781 by the Berlin artist Chodowiecki that illustrated some of the many later editions of Lady Montagu's letters (fig. 108). But it was not until the 1850's that his imagination was permitted full reign in a painting first commissioned by Comte Demidoff and then admired by Prince Napoleon, who requested another version, which was completed in 1859. The abundance of nudities shocked the Princesse Clotilde, however, much as those of *The Golden Age* had shocked the

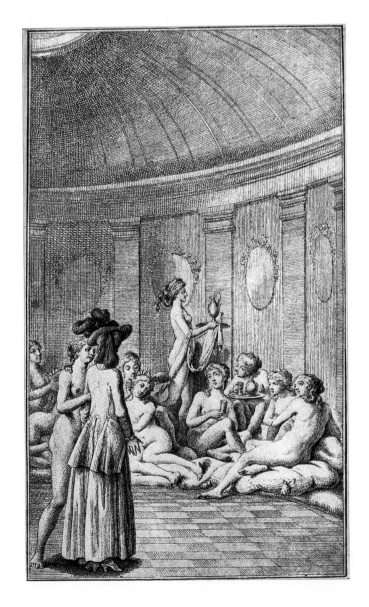

Figure 108. Daniel Chodowiecki. LADY MONTAGU VISITING WOMEN'S BATH IN SOFIA. Frontispiece for *Letters of The Right Honourable Lady Mary Wortley Montagu*, Berlin, 1781

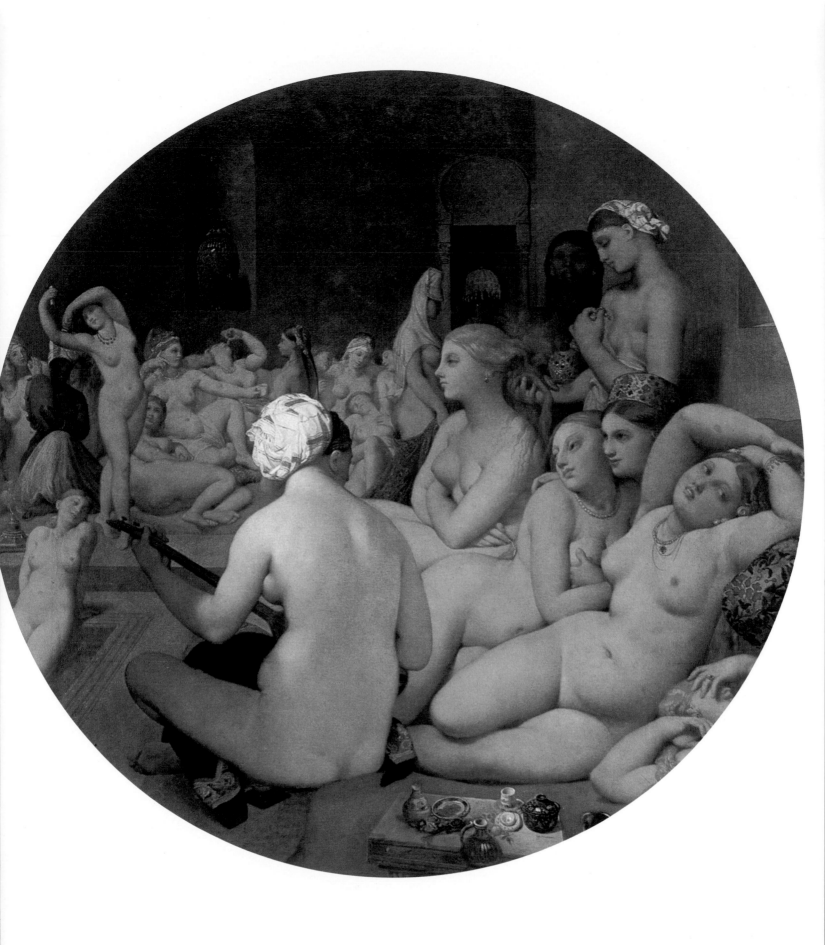

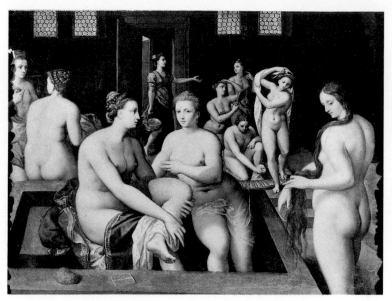

Figure 109. School of Fontainebleau. THE TEPIDARIUM. 16th century. *By courtesy of Wildenstein & Co., Inc.*

Figure 110. Jean-Léon Gérôme. WOMEN'S BATH AT BRÛSA. Salon of 1885. *The Hermitage, Leningrad*

Duc de Luynes and his friends, and Ingres was obliged to exchange the picture and then resell it. At this time Ingres transformed its original square format, still known from a photograph, to its present circular shape, signing the picture in 1862 although not actually completing it until 1863.

Like many of Ingres's late works, *The Turkish Bath* restates and elaborates earlier inventions, which include here the recasting of the *Bather of Valpinçon* (colorplate 10) in the role of a mandolinist, the translation of Mme. Moitessier's antique pose into the Buddha-like figure taking coffee in the background, the adaptation of the chained Angelica to the dancing figure at the left, and the general rephrasing of re-

clining nudes from *The Golden Age* as well as from other bathers, slaves, and odalisques. And in the head of the nude leaning against the pillow in the right foreground, the plump features of Ingres's new wife, Delphine Ramel, may be recognized. This final compendium of Ingres's variations on the female figure is matched by the painting's catalogue of sensual delights, in which, to the accompaniment of mandolin and tambourine, hair is perfumed, incense is burned, sweets and coffee are consumed, flesh is caressed, and bodies are relaxed in pagan abandon.

Yet, finally, the pornographic potential of *The Turkish Bath* is suppressed by Ingres's pictorial mastery, which transforms what might be erotic surfeit into an immutable world of magical clarity and stillness. For one, the convolutions of rounded flesh—adjusted to the circularity of the new frame—are held in check by a lean network of incisively thin planes that define the geometries of the walls, the corner of the pool, and the foreground table top. For another, the compression of volumes is so extreme here that, as in such sixteenth-century French Mannerist views of a women's bath as *The Tepidarium* (fig. 109), foreground and background figures are abruptly contracted to a unifying surface pattern that defies rational perspective. Moreover, the color range is of a chastening coolness, in which the pale grays, yellows, and blues of the architecture and the accessories discipline the orgy of pink, olive, ivory, and brown flesh. Above all, the painting is held in taut suspension by the intensity of Ingres's perception, which catches the gleam of precious jewels, metals, and silks that adorn these nudes as they do Ingres's female sitters, and which even records the shimmer of the glazes on the Oriental vase in the niche behind or on the precariously tilted fruit and ceramics of the foreground still life, whose variety of rounded, lacquered shapes echoes in miniature the display of curving flesh above. With its warped perspective, its impeccably enameled surface, its glistening transcription of light and shadow, *The Turkish Bath* resembles a world both real and imaginary, an erotic fantasy crystallized within the distorting lens of a convex mirror.

If Ingres's vision of female nudes relaxing in the privacy of a bath continues a traditional Western theme generally associated with mythological subjects, his attempt to locate such a scene in a precise historical or geographical setting is a trait more peculiar to his own century. In this light, *The Turkish Bath* takes its place among those nineteenth-century paintings that combine learned detail of architecture and costume with a sensual array of bathing nudes. It may well have been inspired by such earlier classical bathing scenes as Chassériau's careful reconstruction of a barrel-vaulted tepidarium in ancient Rome (fig. 67); in turn, it may well have provided the inspiration for such later nineteenth-century paintings as Gérôme's oblique view of a domed bath in Turkey (fig. 110), which reduces Ingres's masterpiece to the piquant exoticism of a travelogue.